A GRAPHIC MUSE

PRINTS BY CONTEMPORARY AMERICAN WOMEN

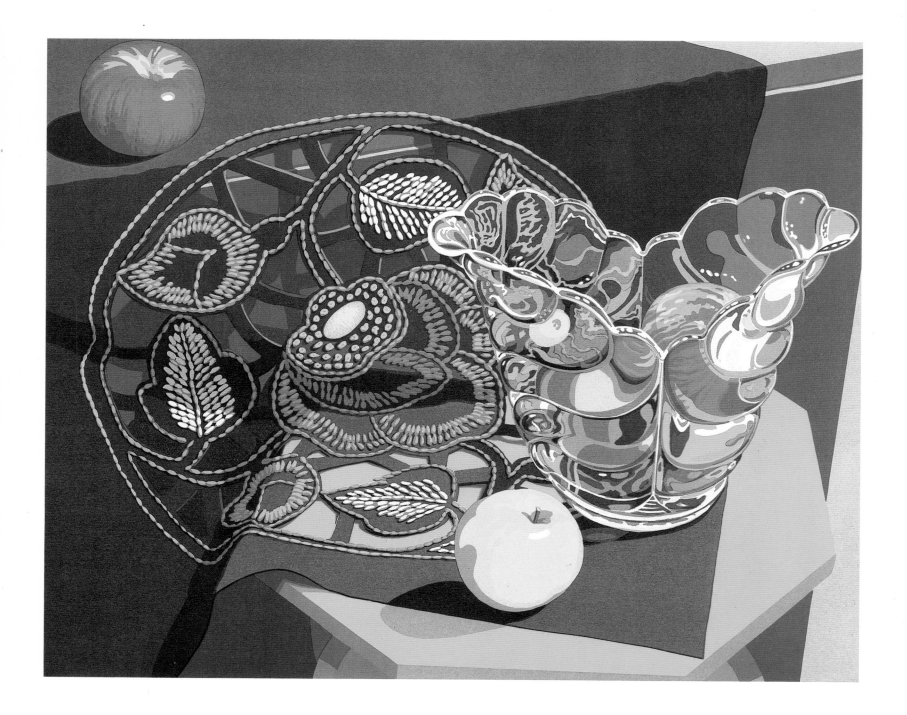

Colorplate 1

SONDRA FRECKELTON

Openwork

A GRAPHIC MUSE

PRINTS BY CONTEMPORARY AMERICAN WOMEN

RICHARD S. FIELD
RUTH E. FINE

HUDSON HILLS PRESS, NEW YORK
IN ASSOCIATION WITH THE MOUNT HOLYOKE COLLEGE ART MUSEUM

A GRAPHIC MUSE
PRINTS BY CONTEMPORARY AMERICAN WOMEN

Mount Holyoke College Art Museum
South Hadley, Massachusetts
5 October–15 November 1987

Yale University Art Gallery
New Haven, Connecticut
9 December 1987–20 January 1988

Santa Barbara Museum of Art
Santa Barbara, California
13 February–3 April 1988

Virginia Museum of Fine Arts
Richmond, Virginia
26 April–12 June 1988

The Nelson–Atkins Museum of Art
Kansas City, Missouri
30 June–7 August 1988

THE EXHIBITION HAS BEEN SUPPORTED BY
A GRANT FROM THE XEROX FOUNDATION.

First Edition

© 1987 by the Mount Holyoke College Art Museum

All rights reserved under International and Pan-American Copyright Conventions.

Published in the United States by Hudson Hills Press, Inc., Suite 1308, 230 Fifth Avenue, New York, NY 10001-7704.

Distributed in the United States, its territories and possessions, Mexico, and Central and South America by Rizzoli International Publications, Inc.
Distributed in Canada by Irwin Publishing, Inc.
Distributed in the United Kingdom, Eire, Europe, Israel, and the Middle East by Phaidon Press Limited.
Distributed in Australia by Bookwise International.
Distributed in Japan by Yohan (Western Publications Distribution Agency).

Editor and Publisher: Paul Anbinder
Copy editor: Eve Sinaiko
Index: Gisela S. Knight
Designer: Abby Goldstein
Composition: Trufont Typographers

Manufactured in Japan by Toppan Printing Company

Library of Congress Cataloguing-in-Publication Data
Field, Richard S.
 A graphic muse.
 Issued in conjunction with an exhibition organized by Mount Holyoke College Art Museum.
 Bibliography: p.
 Includes index.
 1. Prints, American—United States—Exhibitions.
2. Prints—20th century—United States—Exhibitions.
3. Women artists—United States—Exhibitions.
I. Fine, Ruth, 1941– . II. Mount Holyoke College.
Art Museum. III. Title.
NF508.F54 1987 769'.088042 87-12806
ISBN 0-933920-80-6 (alk. paper)

COVER ILLUSTRATIONS
Front: Helen Frankenthaler, *Cedar Hill*, 1983
Back: Jane Dickson, *White Haired Girl*, 1984

CONTENTS

∎

FOREWORD

■

*T*his exhibition and publication celebrate the sesquicentennial of Mount Holyoke College in South Hadley, Massachusetts. How appropriate that it also demonstrates the highest achievement of women artists and highlights an important facet of the Mount Holyoke College Art Museum collection. Readers will certainly note that a great many of the prints reproduced here were purchased by the museum through The Henry Rox Memorial Fund for the Acquisition of Works by Contemporary Women Artists. Established by Harriet Levine Weissman (class of 1958) and her husband, Paul, to honor an exceptional teacher at Mount Holyoke, the fund has served as the main impetus for this presentation. The Weissmans' support, advice, and encouragement have been invaluable to the realization of the project.

Another inspiration has been the series of outstanding printmaking workshops at Mount Holyoke, organized by Associate Professor Nancy Campbell. Her involvement in all aspects of this publication was greatly appreciated.

Any exhibition requires the commitment and effort of a great many people. The Art Advisory Committee, particularly its past chairman, Odyssia Skouras, and its present chairman, Joyce Ahrens, contributed much to its success. It would be difficult to find enough superlatives to describe the contribution of the staff of the Mount Holyoke College Art Museum. Sean B. Tarpey, the registrar; Margery Roy and Amy M. Wehle, past and present business managers; and Anne Leinster, Anne Rogers, Ruma Dútta, Joan Ferguson, Erin Hogan, Susan Butler, and Carole Starr, curatorial assistants, handled countless aspects of the project with efficiency and care. Special thanks must go to Wendy Watson, Curator, who coordinated myriad details involving the exhibition and its catalogue.

Paul Anbinder, the publisher of Hudson Hills Press, and all of his staff are in great part responsible for the fine quality of this book. The graphic designer, Abby Goldstein, deserves particular mention. David Stansbury, the photographer, was responsible for the majority of the excellent color transparencies from which the images were reproduced.

We are, of course, extremely grateful to all of the lenders to the exhibition. Not only have they generously allowed their works of art to travel on this tour, but they have been endlessly gracious in sharing information and expediting photography. To these we must add the printers and publishers of the works in the exhibition, without whom we could not have completed the necessary research and documentation. Thanks are also due to our colleagues at the Yale University Art Gallery, New Haven, the Santa Barbara Museum of Art, California, the Virginia Museum of Fine Arts, Richmond, and The Nelson–Atkins Museum of Art, Kansas City, to which the exhibition will travel.

It would be impossible to name all the other people who contributed to this effort. Renee McKee (class of 1962), Marjorie Cohn (class of 1960), the director of the Fogg Conservation Laboratory, and Catherine Baer made substantial contributions. The exhibition would not have been possible without the generosity of the Xerox Foundation; we offer our gratitude to its president and officers and to Bette Kucklick, Manager, Cultural and Community Affairs.

This publication serves not only as an exhibition catalogue but as a major contribution to scholarship in the field of contemporary prints. It has been a rare privilege to work with two such distinguished scholars as Ruth E. Fine, Curator, Department of Prints and Drawings at the National Gallery of Art, Washington, D.C., and Richard S. Field, Curator of Prints, Drawings, and Photographs at the Yale University Art Gallery. They selected the artists and works for the exhibition, advised us on acquisitions for the Mount Holyoke collection, and wrote the perceptive essays that appear here. We extend our heartfelt gratitude for their dedication to this enterprise.

Finally, we must offer a special acknowledgment to the artists themselves. It is their talent and creativity that form the basis for this exhibition and publication. We hope that this book serves as a fitting testimonial to their achievement.

T. J. Edelstein
Director, Mount Holyoke College Art Museum

ACKNOWLEDGMENTS

■

*M*y gratitude must go, first and foremost, to the artists, whose imaginations have been the inspiration for this exhibition; and to the printers and publishers, whose skills and support have helped the artists' ideas take form. For their assistance at various stages of this project I would like in particular to thank Nancy Campbell, Margo Dolan, Lamia Doumato, Megan Fox, Larry Day, Doris Simmelink, Judith Solodkin, Norman Stewart, and Krystyna Wasserman. As always, discussions about prints with my coauthor, Richard S. Field, were both fascinating and challenging. I must also thank the staff at the Mount Holyoke College Art Museum, especially Teri J. Edelstein, the director; and, at Hudson Hills Press, Paul Anbinder, president, and Eve Sinaiko, whose editorial expertise was most appreciated. For encouraging their daughters to take their work seriously, I thank my parents, Irvin and Miriam Brown Fine.

Ruth E. Fine

*W*hile my essay was largely the result of personal ruminations, synthesized at home and in private, there is a handful of colleagues and family to whom I am most grateful for help, advice, and information. I would like to thank Robert Conway of Associated American Artists, who sent me a transcript of Judith Brodsky's public remarks about women printmakers (made on the occasion of an AAA exhibition in 1986). Judith Solodkin of Solo Press in New York generously discussed her own experiences as a publisher—especially of prints by women. I benefited greatly from many conversations with my colleague at the Yale University Art Gallery, Juliana Flower, with the originator of the Mount Holyoke exhibition, Teri J. Edelstein, and especially with my coauthor, Ruth E. Fine. And I am very mindful of a debt I owe to students in my courses at Yale who have listened, argued, and written about recent printmaking over the past few years. But most of all, my essay owes much of what it has in the way of clear-headedness, a good deal of its shape, and most of its polish to two generous women: my wife, Lesley K. Baier, and Hudson Hills's editor Eve Sinaiko. Their queries, corrections, and suggestions must have mounted into the hundreds. They both kept me hard at work, integrating the incredible wealth of recent contributions made by American women into what I had, all too often, fashioned as a male-dominated history of contemporary printmaking.

Finally, I would like to dedicate this work to my parents, Sampson R. and Miriam G. Field, who have supported and appreciated many of my undertakings over the past thirty years.

Richard S. Field

1/10 V. Celmins '86

Colorplate 2

VIJA CELMINS

Untitled Galaxy

INTRODUCTION

■

*I*n 1901 the Grolier Club in New York (at that time a club for men only) placed on exhibition a collection of engravings, etchings, and lithographs by women. The collection, part of the holdings of the New York Public Library, and a gift of Samuel P. Avery, had been formed in the nineteenth century, for the most part by a woman, Henrietta Louisa Koenen. The catalogue issued by the Grolier Club lists 509 prints, dating from the mid-sixteenth through the mid-nineteenth centuries. Many of the names are unfamiliar. Indeed, Frank Weitenkampf notes in his catalogue introduction that few of the artists represented are mentioned in the standard reference books, while some are entered as men, or confused with other (one assumes male) artists of the same family name.[1]

It is clear that women artists have been interested in printmaking for generations.[2] When we consider the art of the print in the United States during the first half of the twentieth century, such names as Mary Cassatt, Peggy Bacon, Wanda Gag, Doris Lee, Riva Helfond, Marguerite Zorach, Mable Dwight, Isabel Bishop, and Caroline Durieux come easily to mind.[3]

Women have been important in administrative capacities, too. For example, Audrey McMahon was the regional director for the Works Progress Authority/Federal Art Project in New York City. There the first federally funded graphic-arts workshop was opened in February 1936, under the direction of Russell T. Limbach.[4] And a woman curator, Una Johnson, initiated the annual National Print Exhibition, held at the Brooklyn Museum since 1947. This show has come to be considered the major survey in America of recent printmaking.[5]

Four women must be credited for their crucial roles in the expansion of printmaking in this country during the post–World War II era. The first of these was Margaret Lowengrund, a committed lithographer, teacher, and critic. In the early 1950s she was instrumental in reviving a lithography workshop at the Woodstock Artists Association, after more than a decade of inactivity. About this same time Lowengrund set up a lithography workshop as part of her small New York gallery, The Contemporaries. At the gallery itself she featured prints, unusual for a dealer during this period.[6]

Lowengrund's Contemporaries Graphic Art Center soon associated itself with the Pratt Institute for financial reasons, and eventually evolved into the Pratt Graphics Center which, despite a variety of changes and pressures, continues to operate today.

Margaret Lowengrund died suddenly in 1957, the same year that another remarkable woman, Tatyana Grosman, founded Universal Limited Art Editions (ULAE) on Long Island. Grosman convinced some of the finest artists of our age to make their first lithographs and, later, works in other print media. Women who worked at ULAE included Lee Bontecou, Mary Callery, Helen Frankenthaler, and Grace Hartigan. ULAE thrived under Grosman's direction until her death in 1982. The workshop is now directed by Bill Goldston, who has worked with a number of younger artists, among them Elizabeth Murray and Susan Rothenberg.[7]

June Wayne is the third key woman whose efforts stimulated renewed interest in printmaking. As was true of Lowengrund, Wayne is an artist, and her interest is in lithography. The dearth of sympathetic lithography printers in the United States led Wayne to develop a proposal for training skilled craftsmen, while simultaneously stimulating interest in lithography among artists who primarily worked in other media. That Wayne received funding from the Ford Foundation to set up and maintain the Tamarind Lithography Workshop in Los Angeles from 1960 to 1970 was one of the crucial factors in the development of an expansive network of printmaking workshops throughout the country.[8] Gemini G.E.L. in Los Angeles, Tyler Graphics, Ltd. in Mount Kisco, New York, Landfall Press in Chicago, Cirrus Editions in Los Angeles, and Derrière l'Etoile in New York are among the shops whose roots may in some way be traced to Tamarind. Among the women who made prints at Tamarind between 1960 and 1970 are Anni Albers, Louise Nevelson, and Miriam Schapiro. Nevertheless, during this decade no women were trained at Tamarind as printers. In 1970, however, the workshop moved from Los Angeles to the University of New Mexico, Albuquerque, where it continues to be administered today with a somewhat different emphasis. 1974 saw

the graduation of Tamarind's first female master printer, Judith Solodkin, whose Solo Press now flourishes in New York City.

A fourth workshop founded by a woman has had considerable impact on printmaking in this country for the past quarter of a century. The workshop is Crown Point Press, formerly in Oakland, California, now in San Francisco, and the woman is Kathan Brown. Unlike the others, Brown's first and foremost interest has been in etching, although recently she has been involved with woodcut as well. Her imaginative undertakings have included projects with composers and performance artists as well as with painters and sculptors. Though she at first worked with other publishers, in recent years she has published all the editions that have been printed at her shop. Among the women she has worked with are Joan Jonas, Elaine de Kooning, and several others of the women represented in this book.[9]

In recent years numerous additional workshops directed by women alone or by women in partnership with men have been established.[10] That women, functioning as artists, printers, administrators, and curators, have been crucial to the recent history of prints in this country cannot be denied. To these categories must be added that of teacher, and there are numerous stimulating women teaching printmaking throughout the country. As part of her program at Mount Holyoke, a women's college, the printmaker Nancy Campbell established an innovative artist-in-residence workshop program. It was her intention to bring highly respected women artists to the campus to serve as an inspiration for her students. She intended, too, to introduce them to the collaborative aspect of printmaking, in which artist and printer work closely together to complete a work of art.

In 1984 Elaine de Kooning was the first resident artist at the Mount Holyoke printmaking workshop, where she created her Lascaux series (colorplates 31 and 32). These lithographs were printed by John Hutcheson, who also printed Joan Snyder's lithograph the following year. The dramatic imagery of Snyder's

Can We Turn Our Rage to Poetry? (colorplate 59) contrasts radically with the workshop print of 1986, the small, precise, yet limitless etching *Untitled Galaxy* by Vija Celmins (colorplate 2), who worked with printer Doris Simmelink. (Simmelink's first professional experience as a printer had been with Kathan Brown at Crown Point Press.) Sondra Freckelton's screenprint *Openwork* (colorplate 1), printed by Norman Stewart in 1986, adds yet another dimension in style, subject, and medium.

The formal, iconographic, and technical diversity of these prints may be taken as paradigmatic of the intentions of both the Mount Holyoke College Printmaking Workshop and this exhibition, which purposefully includes a range of styles, imagery, and media. The prints grouped here are meant to illuminate the excitement and diversity of women artists and their increasing importance and visibility, especially in the last fifteen years.

Few of the artists included in this publication make consciously feminist statements. This seems a reflection of the stance of women artists in general. For example, the catalogue *American Artists '76, A Celebration* documents an exhibition of the work of fifty-six women (nine of whom also appear in the present volume) held at the Marion Koogler McNay Art Institute, San Antonio, Texas, in 1976; it includes statements by almost all of them. Few suggest the artists are interested in specifically feminist content.

The intent of the exhibition is to juxtapose the work of established artists with that of some whose reputations are yet to be cemented. For some of the artists printmaking is an occasional undertaking, while for others it is the focus of their artistic activity. The exhibition and publication are intended neither as a complete survey nor as an inclusive representation of quality in the field. Many artists had perforce to be excluded, as did, for that matter, a number of master printers; this should be taken as an indication of the extraordinary quality to be found today in the art of women working in the printmaking processes.

NOTES

■

1. *Catalogue of a Collection of Engravings, Etchings and Lithographs by Women* (New York: The Grolier Club, 1901).

2. The collection was the basis for an article by Judith K. Brodsky, "Rediscovered Women Printmakers: 1550–1850," *Counterproof* (Summer 1979), 1, 3–9, 12–13. *Counterproof* is a publication of The Print Club, Philadelphia.

3. See, for example, Frances Carey and Antony Griffiths, *American Prints 1879–1979*, exhibition catalogue (London: British Museum, 1980); and Richard S. Field et al., *American Prints, 1900–1950*, exhibition catalogue (New Haven: Yale University Art Gallery, 1983).

4. See Jacob Kainen, "The Graphic Arts Division of the WPA Federal Art Project," in Francis V. O'Connor, ed., *The New Deal Art Projects: An Anthology of Memoirs* (Washington, D.C.: Smithsonian Institution Press, 1972), 155–75.

5. See Gene Baro, *Thirty Years of American Printmaking, Including the Twentieth National Print Exhibition*, exhibition catalogue (New York: The Brooklyn Museum, 1976).

6. On Margaret Lowengrund, see Clinton Adams, *American Lithographers 1900–1960: The Artists and Their Printers* (Albuquerque: University of New Mexico Press, 1983), 182–89.

7. On Tatyana Grosman and ULAE, see E. Maurice Bloch, *Words and Images: Universal Limited Art Editions*, exhibition catalogue (Los Angeles: University of California, 1978); Tony Towle, *Contemporary American Prints from Universal Limited Art Editions/The Rapp Collection*, exhibition catalogue (Toronto: Art Gallery of Ontario, 1979); and Wolfgang Wittrock, *25 Jahre Universal Limited Art Editions 1957–1982*, exhibition catalogue (Düsseldorf: Wolfgang Wittrock Kunsthandel and participating museums, 1982).

8. On Tamarind, see Virginia Allen, *Tamarind: Homage to Lithography*, exhibition catalogue (New York: Museum of Modern Art, 1969); E. Maurice Bloch, *Tamarind: A Renaissance of Lithography*, exhibition catalogue (Washington, D.C.: International Exhibitions Foundation, 1971); and Marjorie Devon, *Tamarind: Twenty-Five Years*, exhibition catalogue (Albuquerque: University of New Mexico Art Museum, 1985).

9. On Crown Point Press, see Nancy Tousley, "In Conversation with Kathan Brown," *Print Collector's Newsletter* 8 (November–December 1977), 129–34; "An Interview with Kathan Brown of Crown Point Press," *California Society of Printmakers Newsletter* (Summer 1982), 3–6; and Abner Jonas, *Kathan Brown, Publisher: A Selection of Prints by Crown Point Press*, exhibition catalogue (Athens: Trisolini Gallery, Ohio University, 1985).

10. The most recent published survey of contemporary print workshops appeared in *Print Collector's Newsletter* 6 (January–February 1983), 201–6.

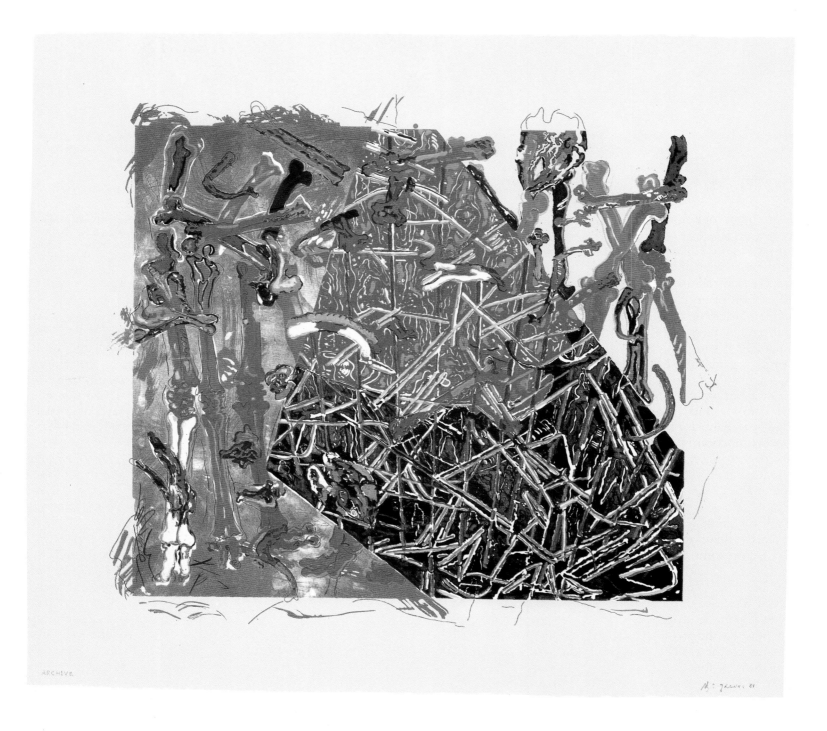

Colorplate 3

NANCY GRAVES

———————————————————

Calibrate

PRINTMAKING SINCE 1960: THE CONFLICTS BETWEEN PROCESS AND EXPRESSION

■

The Sixties: The Explosion in Prints about Printing

There can be no question that printmaking has achieved unusual significance in the past quarter-century. What has for some time been known in the United States as the "printmaking renaissance" is more complex than one would at first imagine. Most obviously it signifies the tremendous upsurge in the manufacture of important art in the form of prints—lithographs, screenprints,[1] copperplate techniques of every description, stencils, and woodcuts. It is also a recognition, in an age saturated by mass media, of the print's two fundamental roles in post-medieval culture: first, in the scientific (inductive) organization of our knowledge of the natural world, which depends upon repeated exactitude; and second, in the fostering of the notion of shared visual experience that underlies all of Western culture. Once photographic and electronic transmission provided new channels for the production of images, the print lost much of its function in the practical world. It became, instead, a useful tool with which to examine the meanings and conventions of the printed imagery of contemporary mass media. This role was fundamental to the explosion in printmaking that occurred in the 1960s.

To assume its new role and increased artistic importance, the print seems to have absorbed some of the fundamental ideas of Abstract Expressionism, which led artist and viewer alike to locate the content of a work of art in its purely visual aspects, especially in the handling of the medium itself. The resulting emphasis on individual style was at complete variance with the endless repetition of largely photographic imagery encountered in the mass media, but in the conflict lay the possibility for distance and commentary. The sensitization to the qualities of brushstroke, color, support, and shape in painting found its parallel in an increasing sensitivity to the qualities of each printmaking medium. Granted, an embarrassing amount of printmaking of the fifties and sixties was little more than play with personal and idiosyncratic textures.[2] But the stage was set for the more expansive and innovative developments of the sixties. Essentially, printmakers of the sixties sought to synthesize the Formalist concerns of the fifties with their own decade's focus on mass communications. This underlying duality provided the print with a platform from which it was able to launch its critique of contemporary popular imagery. It was the fuel responsible for the print renaissance.

Two texts were bellwethers of the new art. The first was William Ivins's *Prints and Visual Communication*, published in 1953.[3] Ivins undertook the first serious examination of the character of printed codes—how the handling of the various printmaking techniques shaped the messages that were transmitted. Ironically, his work formed the basis for the exploration of the emotional and stylistic, rather than the technical, qualities of mechanical image making. The second text was Ernst Gombrich's *Art and Illusion*, published in 1960.[4] Without recourse to any self-conscious modernisms, Gombrich sought to objectify the process of art making, and to locate its emotional content at least as much in materials and processes as in the maker's psyche. In an exemplary anti-Formalist manner, Gombrich argued that the "beholder's share" was equally important to the meanings of works of art. Such an anti-Expressionist theory of art went hand in glove with the Pop generation's dissection of popular culture, with its emphasis on mass-produced, mechanically executed imagery.

Few art historians have wished to acknowledge how much the history of art of the recent past is cradled in the image industry of our times. While the incorporation of commercial imagery (advertising and other motifs borrowed from contemporary consumerism) is a recognized element, there is as well a fundamental, deep-seated preoccupation with image making itself: with its processes, materials, conventions, personnel, and above all with the habits and expectations of a culture nurtured on the reproduction and replication of everything. Here I am touching on concerns far deeper than those of the print world's squabbles about "originality" and the proper roles of the artist and the printer in the creation of a work.[5] These more serious issues are germane to a time totally saturated with the multiplication of imagery. They question the very nature of our surrogate culture of reproductions,

one in which human feeling and behavior so often appear to be dominated by the models of the mass media.

Printing is at the very core of this domination. Not only the process, but also the very fact of visual reproduction, is at issue. Gombrich's insistence on the crucial role of the observer—that the viewer demands interpretation, the discovery of meaning—coincided with a repudiation of pure Formalism, in which everything is given by the artist and nothing, we were told, is changed by the observer's presence. So theoretical a formulation was potently seconded by Marcel Duchamp, the father of the revolt against purely "retinal" art. Lecturing in 1957, Duchamp maintained that the work of art is completed only by the use to which it is put by its public.[6] The completion of the work by the observer is demanded by most of the significant printmaking since 1960. In this essay, I will aim first to establish the fundamental ideas that powered the printmaking revolution of the sixties and early seventies, and then to discuss the developments of the last fifteen years. This analysis is of necessity largely empirical, rather than methodological. Accordingly, artists and works have been chosen and discussed principally as symptoms of essentials; in no way does this survey aim at comprehensiveness.[7] Since the appearance of women in the vanguard of artist-printmakers is a relatively recent phenomenon, only when I turn to the seventies will the artists who appear in this publication come under consideration. But rather than search for "essential" feminine qualities of any given image or work, I will explore the overall impact of the increasing number of women who have become important printmakers. Such a history, however, does not exist apart from that of the already complexly overlapping and interdependent strands of all recent art. Many of the women artists included in this book quite obviously learned a great deal from their male peers and teachers, but their own presence was, I believe, crucial to the recent amalgamation of process and expression. Certainly during the 1970s and early 1980s the role of women printmakers was essential to the ongoing reevaluation of the original synthesis of the 1960s.

■ *The Sixties: Pop and Postmodernist Printmaking—*
Rauschenberg and Warhol

By definition most prints are Postmodern. Their very essence as well as their history makes them first and foremost vehicles of communication. As Ivins pointed out, the notion of an "exactly repeatable visual statement" offered Western society the perfect model for scientific investigation; it is an idea that still informs the deepest appeal of the print. Until the invention of the photograph and ways to replicate its information, the role of the print as the bearer of objective truth was hardly challenged. And it is only in the past twenty-five years that the hegemony of photographic truth has been assaulted—largely as a result of live television. Just as the photograph revealed the fictions of the print—its networks of lines and granular dots, as well as the inescapable fact that it is a drawn image and thus presents a personal point of view—so television has unmasked the limits of the photograph—its fixed, often subjective point of view, its lack of text, its vulnerability to darkroom manipulation, and its unperceived but very real physical and chemical determinants. The camera, as an instrument that both distanced and appropriated,[8] mirrored a scientific, rational culture's wish to separate the external, objective world from that which we think of as the inner, personal, and emotional sphere. While painting since Manet and much of modern printmaking have undertaken to portray a world in which nothing is fixed, with few exceptions the photograph and its mass-media counterparts were strengthened in their role of ocular witness, able to regard and record the world in its true perspective. A questioning of the entire enterprise of photographic and reproduced imagery was undertaken only in the art of the late 1950s and 1960s.[9]

The means for such an undertaking became available only when artists decided to import commercial imagery and photography directly into their art. Whereas the collage of the teens and twenties had always drawn upon mass media, often in ironic or satiric ways, it had rarely subjected the contents of the photographic and reproductive media to so stringent an examination as was now proposed. In England Richard Hamilton, Eduardo Paolozzi, and others began to make collages from images of American Pop culture garnered from the mass media. In other words, most of their art was founded on the imaged world in which they, at least, thought Americans lived, not on documentary evidence of American life. In America, on the other hand, Robert Rauschenberg and the artists of the Happenings were collaging actual fragments of the real world onto the picture plane or into their performance spaces. As real and painted objects were piled onto the canvas, the picture plane was totally divested of the capacity to present a window into space; and theater's traditional hierarchies were uprooted as the audience merged with the stage. Whereas the English viewer could maintain an effective distance from American culture, and thus might readily understand the critical inquiry initiated by the London Institute of Contemporary Art (ICA) group, his American counterpart was too submerged in the process to have any such perspective.[10] Thus the new art was experienced as either entirely foreign or totally life encompassing (as the American artists insisted). Ironically, Alan Kaprow, father of the Happenings, gave credit to Jackson Pollock's total physical involve-

ment with the act of abstract painting as having inspired the infusion of fragments of daily life into the new art.[11] In many ways, Claes Oldenburg's store pieces, Robert Rauschenberg's Combine paintings, and Kaprow's Happenings were too specific, too tactile, too involving of the audience to achieve the aesthetic and critical distance of high art. (An echo of this will arise later in the form of Joyce Kozloff's implied criticism of Frank Stella's work.) A way was needed to symbolize what had already been made palpable. And that way was provided by the purveyor of contemporary life itself, by the medium that gave the illusion of replicating life: the photomechanical processes of reproduction.[12] It was in 1962 that Rauschenberg and Andy Warhol began to screenprint images onto their canvases.[13] Such a simple strategy allowed the seamless juxtaposition of the most varied pictorial ideas; it encouraged direct or indirect quotations from the most diverse sources, fostered an inventive play with all that could be manipulated in the making of images, and still preserved Modernist flatness. While the superficial meanings of Pop art were extrapolated from its multifarious and often outlandish borrowings and paraphrases, its deeper, symbolic significance emerged from the subtle comparisons that subverted conventional expectations and habitual responses. Warhol's inventions operated uncannily on both levels. His endless repetitions both parroted and parodied the mass media, drawing as they did on both the images and the methods of cultural saturation. Yet they raised unexpectedly subtle issues about the importance of individuation: each Marilyn or car-crash frame differed ever so subtly from the preceding one; each new format of a Jackie offered some change in texture, scale, color, or transformation of information. Warhol's genius was to be found not only in the images he chose to exploit, but in the sleight of hand with which he blended the crudely enlarged photographic information with the crudely hand-executed flats of color. All was printed in the basest of reproductive techniques, high-speed offset or coarse, undetailed screenprinting. At every turn Warhol scorned (but never eliminated) the "artistic," and it was this residue of art that eventually surfaced as the means of social commentary.

Rauschenberg, too, forced the viewer to grapple with the differences between surrogate experiences filtered through the machines of mass culture and personal interpretation conjured up by the artist's brushstrokes. One could argue that the task of these artists was to disprove Walter Benjamin's thesis that the work of art in the age of mechanical reproduction would lose its aura of mystery, by demonstrating that images spawned by the processes of our time were possessed of their own emotional auras and nuances of meaning.[14] In short, it took a printed form of art, often embedded in traditional or mock-traditional artistic forms, to manifest these new contents. Pop art kept suspended some very essential dualities, settling on neither extreme; just as it was not truly an exposé of commercialism, neither was it the champion of personal originality. In countless ways it used the media to abrade and erode the hold of Abstract Expressionism and its romantic ideas about inner expressiveness. For the mass media are impersonal in both idea and execution; even their most intimate message is in reality consumed by millions. And this numerical imperative, as we might call it, forced on the image certain conventions of easily received information, just as it forced on the means of replication certain conventions of high-speed production. In the early sixties Rauschenberg incorporated newspaper images first transferred from the very halftone "mats" (flexible plates) that had printed them in the newspapers; but he turned, blurred, repeated, smeared, colored, and even obscured them with the workings of his own hand, paraphrasing the jumble of the daily media diet.[15] There was, especially in the large, painterly, screenprinted canvases, a profoundly moving relocation of the energy of creation from the gesture of the artist within the world of his canvas to the gestures of the entire living world outside of the artist. It was this friction, this grating of different systems, styles, sources, and techniques against one another that became, in the 1960s, a hallmark of so much of what was best in American art.

■ The Sixties: Johns, Ruscha, and Lichtenstein

It would be folly to claim that these essentially Pop artists reintroduced subject matter to art when countless hundreds of artists had never departed from some form of focus upon the natural world. What each did, however, was to refute the sacred American lessons of Abstract Expressionism in a fashion that stood the enterprise of high art on its head. Rauschenberg embodies an eternal struggle (a principle of the previous generation) between the hand and the machine, an opposition that is muted but subtly powerful in both the structure and the execution of Warhol's seemingly pointless variations. But in Jasper Johns's work the issues are translated to another level of endeavor: the means of art compete with, interfere with, and transform the identities of the subjects. In his prints, which are so much less tangible than the paintings, the nature of depiction itself is questioned (a theme that is seized upon with astonishing lyricism in the recent work of Jennifer Bartlett). In the first 1960 Flags, for example, Johns allows the means and the medium to displace the question of replication: is it a flag, a picture of a flag, or a drawing whose idea (that is, its structure) derives from a flag? From his very first prints in 1960, Johns exploited the qualities of the lithographic medium to change our

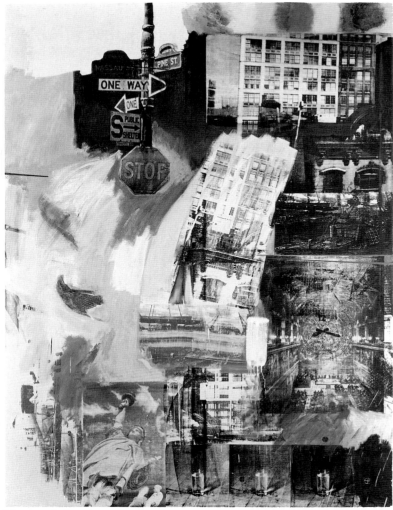

Figure 1. Robert Rauschenberg (b. 1925). Estate, 1963. Oil and printer's ink on canvas. Reproduced courtesy the Philadelphia Museum of Art, Given by the Friends of the Philadelphia Museum of Art

perceptions of one image: the ink and paper tones of *Flag I* (black ink on white paper) become those of *Flag II* (white ink printed on tan kraft paper), and these are further complicated in *Flag III* by the scratching of another flag pattern into the existing one and by additional alteration of the printing (white lines scratched into gray brushstrokes, printed on white paper).[16] Each successive work changes our ideas about the preceding and thereby calls into question the very nature of our ideas about art, replication, and language: how we name and use things as well as their images.

Because these issues were so embedded in collective forms of

picturing the world, especially in reproduced and replicated forms, the arts sponged up the means, images, and languages of printing. This was the most fundamental reason for the print boom in the 1960s. The socioeconomic factors were secondary. The market for prints was a reflection not only of an unquenchable demand for the higher-priced work in paint and three dimensions, but also of the public's desire to own something that was itself a form of high-tech replication, one that combined the hand and the machine in precisely the manner that informed the leading works of art of the day.

Responding to similar urges, artists eagerly integrated elements of chance into predictable and mechanical matrices. Perhaps the most notable was Rauschenberg's working method, in part adapted from Abstract Expressionism (figure 1). Invariably, Rauschenberg seized the possibilities of the moment and utilized whatever raw materials the immediate environment provided. The "flatbed picture plane" (as Leo Steinberg called it) encouraged the painting to become a gathering place of dissimilar elements unified only by the determinants of the unconscious and the choices staked out at the beginning of the project.[17] What was so unexpected and original was the way in which the printing processes unified the personal gestures of the hand and the impersonal precision of the machine; one long sweep of the squeegee, like a magical brushstroke, transferred any photographic image onto the canvas. It was the very opposite of the Abstract Expressionist's total immersion. Yet how effortlessly it combined the photographic image with the artist's gesture! Warhol not only incorporated the predictable and regular codes of the halftone images, but gave almost free rein to accidents of printing, the unexpected idiosyncrasies of personal intervention and decisions.[18]

The contrasts that abounded in the art of the sixties served to continue an older Surrealist sensibility, but no longer for purely poetic ends. Now, each element was calculated to undermine the others, to call attention to the arbitrariness of all systems of image making. In Johns's *Pinion* (1963–66), for example, the photographic halftone details listed (typically) from his painting *Eddingsville* are played against other kinds of printed illusions: the bodymarks left as Johns imprinted himself on the stone[19] and the cleverly drawn illusion of a wire hanging down in front of both the other elements. Johns's *Coathanger* lithographs (1960) and James Rosenquist's *Spaghetti and Grass* (1965) and *Bunraku* (1970) are typical examples of Pop art's preoccupation with the languages of illusion. Each makes very plain that the same means can be used to evoke enormously dissimilar illusions of objective phenomena, provided that the viewer is willing to believe in (use) them.

In its attitude toward illusion, Pop art was deeply anti-Modern-

ist. Not only did it insist that the world beyond the frame must be incorporated into its art, either by chance or design, but it insisted that the structures of art were synonymous with the structures of all illusion-making systems. The success of a work of art, therefore, was dependent upon the reactions of the observer, thereby undermining any purely Formalist approach. At the same time, much of the Modernist position was actually co-opted by the Pop artists. The very emphasis on exploration of the fundamental means of art furthered the Modernist enterprise, while the adoption of purely painterly devices, smooth surfaces, and palpable colors and the wholesale borrowing of Modernist styles and devices assured that even the enterprise of high art came to be viewed as a communications game, complete with its own conventions, languages, and illusions, as dependent upon the willing spectator as Michael Fried had thought it independent.[20]

Compared to Abstract Expressionism and Color Field painting, Pop art was playful, astringent, and intellectual. In its effort to be involved in a critique of both art and life, it always ran the risk of romanticizing the commercialism of our society. Many dared to flirt with such ideas: Rosenquist, Tom Wesselmann, Edward Ruscha, Roy Lichtenstein, and, in England, Alan Davies, Tom Phillips, Hamilton, and Paolozzi, among others. Many of these artists carefully dissected elements of commercial culture. Ruscha's prints of gas stations and liquid words embodied something special about the sixties—a sensitivity to the auras and personal qualities of objects and to the feelings engendered by the style and look of depicted words that was part of the overall awareness of meaning and emotion in mundane encounters.[21]

In Ruscha's *Mocha Standard Station* of 1969, as in much Pop printmaking, conventions of process were put to the service of content: for example, the exploitation of perspective to articulate the clean, controlled distances of a marvelously sanitized environment (even the murky reddish layer of Los Angeles pollution seems a happy part of this vision of the best of all possible worlds). The process of screenprinting lent itself to this enterprise with such aptness that it seemed invented for the decade.[22] Its smooth, machinelike surfaces composed the perfect analogue for the modernistic, commercial finish and impersonality of the contemporary object world. Screenprinting's capacity for making totally nongestural marks, first exploited by Josef Albers in his purely formal *Homage to the Square* prints of the early sixties, isolated emotion in the object world rather than in the artist's vision. Even the reified words of Ruscha's 1970 screenprint *SIN* and color lithograph *LISP* seemed to contain and radiate their own associative feelings. Their appeal was in their cool, in the tension between the suggestion of

emotion and their distance from it, as in Lichtenstein's *POW!* of 1966.

Lichtenstein's images were the quintessence of designed cool. Throughout the sixties his works paraphrased, borrowed from, and were based on the conventions of printed imagery. The screenprints and offset lithographs from the middle of the decade are icons of the fine arts' involvement with mass media. Words and sounds are raised to the same stylized refinement as the surgically delineated forms of the enlarged cartoon characters. By replicating imagery that had already been stringently processed for reproduction, that had already been fine tuned for its mock-emotive appeal, Lichtenstein came closer than anyone to exposing the underlying contents of mass media.[23]

It was precisely in his Formalism that Lichtenstein found a way to reiterate the seriousness of his art, first by "cleaning up" (as he put it) the forms of the cartoonist's vocabulary, and then by gradually infiltrating his own inventions with allusions to the art of the past. Toward the end of the sixties, the work became more programmatic and intellectualized. The two print series based on Monet's haystack and cathedral-façade paintings were really about pure information and color painting. By the early seventies, Lichtenstein had moved into an extremely formalistic and conceptual position with his Mirrors, whose success in printed form far outdistanced that of their painted versions. The Mirrors seized upon the optical properties of halftone dots, not for their ability to summon up an image of something specific (a mirror), but for their formal and purely illusionistic properties. The gradated dots of the mirrors and the carefully shaped forms of the frames created illusions of pure reflectivity. What was depicted was the essence of optical subjectivity, wholly dependent upon one's processing of the visual data. With brilliant economy, Lichtenstein's dots thereby fused the world of purely visual art with that of crass commercial illusionism.

Such equating of the forms of illusion with the conceptualization of the surface informs much of the art of the seventies, and in surprisingly disparate ways, from Chuck Close's portraits to Audrey Flack's still lifes. It embodied, at the very least, a return to the lessons of pure abstraction and Color Field painting, as well as a growing assimilation by Pop of Minimalist and Conceptual tendencies. While the heyday of Pop art was definitely past, the sixties had witnessed a continuing hegemony of American painting and the emergence of a dazzling display of technical and stylistic inventiveness in printmaking. Once again American artists had stolen the Continent's thunder, and with good reason: America was preeminently the land of mass media.

How might one summarize the printmaking innovations of the sixties? Above all, the new printmaking redefined the relationship of the artist to his or her medium. There were no rules, no fixed notions of originality. The artist was free to work in whatever medium he or she chose, be it heavily dependent upon the knowledge and labor of others, or totally autographic. Further, the artist was completely at liberty to enter and leave a process as he or she saw fit. In a similar fashion, the artist more often than not appropriated subjects and styles as well as processes and techniques from the commercial sector. Thus the print had become an entirely new kind of collaborative venture.

Although the democratic ideals of printmaking—large editions at low prices—invariably were vitiated by the very commercialism the art celebrated, the new printmaking did experiment with high-speed processes such as offset lithography and commercial screenprinting.[24] Despite the general tendency to publish only limited editions, the idea of the masterpiece, the unique expression of genius, was held up to scrutiny, if not outright ridicule. The role of appropriated imagery, as well as the use of the skills of others, offered a serious challenge to the supremacy of the artist's hand and gesture espoused by the previous generation.[25] Yet such rejection of authorship was itself undermined by the same capitalistic mythologies that clung tenaciously to the idea of individual expression. Ultimately, the art that offered the densest of meanings and the most succinct form was the most highly valued and the most clearly identified with the star system of all post-medieval art.

Through isolation and comparison (collage), the hidden emotional contents of all visual media were scrutinized and made to yield their affects. Printing techniques were no longer the handmaidens of subject and form, but had become the focus of meaning. The great workshops of the sixties, beginning in 1957 with Tatyana Grosman's Universal Limited Art Editions (ULAE) in West Islip, New York, truly understood the nature of this revolution. While older ateliers were dedicated to providing the best in technical support (a given craft available to embody the artist's ideas), ULAE intuitively searched for a higher level of rapport between artist and printer (a craft whose characteristics were to become part of the content of the work of art).[26]

The great prints of the sixties invariably were concerned with the nature of illusions. Not only were these at the core of consumerism (one consumes illusions—prints of the sixties were amazingly sensuous and synesthetic), but they were the basis for the development and identification of new symbolic languages, the facility human beings have for taking one thing for another. Language, therefore, was the focus of the new printed art. The print, be it classical etching or photo-screenprint, was no longer a vehicle for narrative or expression. In fact, almost every artist took pains to divert personal expression, to make his or her art defeat such meanings. Similarly, depiction, or description, gave way to quotation and process. Because the message was so often located in the medium and in the viewer's habitual reactions to known media situations, the subject of art became increasingly "things the mind already knows."

The best-known visual codes were naturally those of the photograph. The sixties subjected the styles of photography and its supposed truth value to extensive scrutiny (though the next generation would delve even more deeply into photographic syntax).[27] While the use of photographic elements provided new subjects and a language foreign to the fine arts, it brought the arts of the sixties into intimate contact with the life of its own day. And it dramatized the most important leitmotif of the new printmaking, the one that subsumes all of the underlying dualities of sixties art, the opposition of hand and machine. At root, it gave symbolic form to the question of the survival of humanist values in a machine age. The suggestion of the equivalence of hand and machine seemed to sound the death knell for Expressionism, for all ideas of high art and exclusivity of subjects or styles.

As Marshall McLuhan claimed, the contents of a new medium (and the focus of Pop art was on media) worked expressly to reorganize the old: Pop art proposed to teach the contemporary viewer the means for adjusting—nay, enjoying—the visual rush of so ephemeral and seemingly detached an existence as that of contemporary life. It is easy to understand how printed media, with their long chains of removal from the original source in the world, were so essential to this rearrangement of the viewer's psyche to a state of emotional detachment and even denial. But the invigorating and celebratory aspects of Pop art wore thin. Its blatant optimism and bold assaults on our visual sensibilities were soon betrayed by the political events of the late sixties. The playful nature and jolting conflicts of Pop art gave way to even greater detachment, as art became more formalistic and intellectual, on the one hand, more physically literal on the other.[28]

One of the most significant results of Pop art's return to the object was the reintroduction of the real world into art. Although Pop's concern was the man-made environment alone, it nevertheless provided both an example and a method for those artists whose primary commitment was to the natural world. The art of the Realists, which subscribed to the transcription of natural motifs before it bothered with the syntax of production, had been relegated to a subordinate position by the onslaught of total abstraction on the one hand and by the preoccupation with media paraphrases on the other. Yet the same intellectualization that had fed the exploration of media conventions and language systems had also, virtually unperceived, effected important changes in traditional Realist values. The conceptualization of Realism adopted a number of guises.[29] The first of these was embodied in Philip Pearlstein's dedication to the model. In a time of abstract and Pop painting, Pearlstein's example was of enormous significance. But his art only seemed traditional. Few have adequately understood how closely Pearlstein was associated with Andy Warhol, his colleague at the Carnegie Institute in Pittsburgh.[30] Through some intuitive sympathy, both envisioned processes of making art that placed the artist in a remarkably neutral position: Warhol through the exploitation of photomechanical processes and those who executed them, and Pearlstein by the transformation of his own hand and intellect into a virtually unmediated recording mechanism. Both shunned personal statements, and both attempted to shift the burden of interpretation, or lack of it, onto the viewer—often in the presence of highly charged subject matter.

Pearlstein's printed studies of the nude, begun in the late sixties, were as reductive in their sparsity of means as they were limited in their portrayals of anonymous models. Most critics have labored to be oblivious to the subtle sensuosity and implied eroticism of Pearlstein's models: a chic, Formalist, asexual approach. Yet it is the tension between the sensuous qualities of these images, including their printerly structures, and their more dispassionate, topographic neutrality, that is so intriguing. Pearlstein's works are filled with such seductive discontinuities—uncomfortable disjunctions, croppings, changes of focus, and contrasts of texture and surface—constantly disrupting the viewer's desire to explore them in more human terms. These same qualities inform his more recent aquatinted landscapes. Works such as *Sacsahuaman* are abstractions only to the extent that the journey of the viewer's eye, rather than his or her emotions, is determined by Pearlstein's working method.[31] Both the exploration of the subject and the develop-ment of the plates evolve from a given central module or motif, not totally dissimilar to Frank Stella's approach in the early Black Paintings. Once determined, the work proceeds in a quasi-mechanical manner from point to point, refocusing with each shift of the artist's attention. Unexpectedly, the resulting visual pathways have much in common with the constantly changing thrusts of Abstract Expressionist painting.[32]

It was Alex Katz who seemed the most cool and contemporary of the older Realists. Almost exclusively concerned with the portrayal of his friends and a handful of familiar surroundings, Katz's images are sharply reductive of both means and content. Taking up printmaking in the late 1960s, Katz quickly proved to be one of those who intuitively exploit the technical possibilities that correspond to the content of their imagery. Where Pearlstein limits his attention to the phenomenological detail at hand, Katz self-consciously focuses his on defining the character of each mark. Thus all of Katz's marks are keenly honed but dampened and understated gestures that both deny the artist's expression and limit access to the sitter's psychological state.[33] Even the landscapes, composed as they are of relatively flat strokes of the crayon or brush, withhold any hint of the artist's pleasure in description or enjoyment of the natural world. In many works, from the first interiors to the recent bather woodcut *The Green Cap*, executed in Japan in 1985, feelings escape only into color and shape, the perfection of which is more often central to Katz's enterprise than the drawing.

Pearlstein's and Katz's detached approach to their subjects was of paramount significance to Realist artists of the seventies. But it was in the traditional genre of landscape, rather than portraiture, that many of these artists, particularly women, found their vehicle and, eventually, their printmaking outlet.[34] A non-Romantic approach to the landscape, especially as practiced by Fairfield Porter (figure 2), provided breathing room for those who had turned away from the Expressionism of the fifties and yet felt stifled or shut out by the media styles of Pop art and the impersonal structures of Minimalism. Many who had been trained during the hegemony of Abstract Expressionism in the 1950s were searching for a more traditional, subtly personal style. An art devoted to the emotions engendered by the act of painting was too assertive on the one hand, and too restrictive on the other. Landscape, however, allowed the artist to combine the sensibilities of place with those of surface. And for the female artist in particular, it was a subject with which one could unite that which was experienced as external with that which was felt as internal. It is in emphasizing this point that Ruth Fine, in her discussion of Yvonne Jacquette

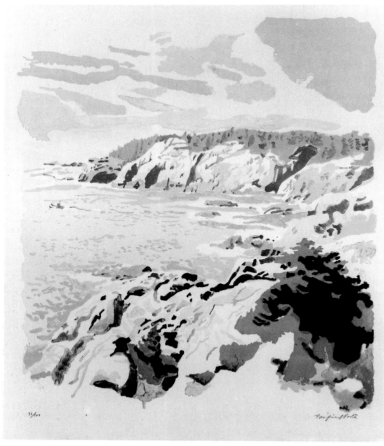

Figure 2. Fairfield Porter (1907–1975). Isle au Haut, 1975. Lithograph. Reproduced courtesy Brooke Alexander, New York

the relatively cool handling of their subjects—the indistinct, watercolorlike forms of the Maine coast combined with flat, organic, tendril shapes in Porter; the variegated, painterly strokes that unify sharp contrasts of foreground and background in Freilicher; the vast linear webs of light and traffic that find their counterpart in the agitated, multidirectional strokes in Jacquette's night scenes; the shimmering fragments of leaves and water in Welliver's woodland scenes; the patchwork of woodcut planes that comprises Feldman's aerial views. The second group proceeds with greater self-consciousness, often by imposing concrete signs of the intellectual processes of making art between the viewer and the subject.

The conceptualization of Realism is most clearly revealed in prints, where the artist often experiences pressure to think in terms of large, discrete shapes. Printmaking inevitably emphasizes mark making, with the consequence that the processes of building an image become far more accessible to the viewer. As printmaker, the Realist must first think about marks; as painter, he or she is far more likely to concentrate on qualities of space, light, and atmosphere. Either way, the focus is on one's inner feelings about the objective world and how to develop a personal, yet relatively neutral language of representation that seems inseparable from those muted feelings. For example, Aline Feldman has looked to the techniques of Japanese craftsmen as well as to the color woodcuts produced in Provincetown, Massachusetts, during the teens in order to articulate her exhilarating, decorative aerial visions.[35] But, as in *Hawaiian Memory (Kauai)* (colorplate 19), she also provides a more Modernist unity, first by inserting the foliage, seen close up, at the bottom of the image, and second by emphasizing the natural qualities of the wood. Over each panel of the print, Feldman casts a subtly subjective veil by bringing up the sensuous wood grain (unifying all the color fields, since each was originally part of the same block). Feldman's best works are activated by these simultaneously perceived changes of perspective; even the naturalistic detailing of the landscape is reduced to wittily abstracted woodcut markings.

Susan Crile's prints, though muted by comparison, share much with Feldman's, including their aerial perspectives and integration of abstract and descriptive passages. Yet even in a more conceptual print, such as *Buskirk Junction* (colorplate 15), the rural overtones of the title and the simplified forms of the composition recall the idealized Regionalist landscapes of the 1930s. This resonance between past and present, between an older Realism and a newer, more material sensibility imparts an unexpectedly peaceful and contemplative aura. Jane Dickson, too, has found much of her inspiration in the American past. Her evocative etchings recall

(page 96), indicates the importance of Joan Mitchell's painting for those who wished to infuse essentially Abstract Expressionist forms with feelings about the natural world. For all this, the new landscapists took pains to preserve much of the emotional cool of the sixties, specifically in their tendency toward simplification of form and in their laconic and restrictive use of materials.

Jane Freilicher, Aline Feldman, Yvonne Jacquette, Sondra Freckelton, Neil Welliver, and, lately, Jennifer Bartlett, Sylvia Plimack Mangold, Susan Crile, Susan Shatter, and Jane Dickson have all found resolutions to the essential conflict between the urge to represent the natural world and the Modernist pressure to concentrate on the means of that representation. The first group tends to evolve sets of nonsystematic and nonphotographic marks from

those of John Sloan, Edward Hopper, Martin Lewis, and Armin Landeck, although her colorism and insistently rough surfaces suspend the pathos of the older artists. Like Feldman and Crile, Dickson often prefers to look down on her cityscapes, but with the unexpected effect of increased intimacy. Just as her rough surfaces dissolve the complex forms of the city into an overall glow of colored lights, so her steep perspectives discard intervening detail and establish a surprisingly subjective version of an older American Social Realism.

Yvonne Jacquette's printmaking and drawing also evoke a soft-edge view of the urban world, one that again favors personal impression over media paraphrase or Super Realist photographic language. But like Crile, Dickson, and others, Jacquette's recent art contains an echo of earlier American depictions, namely the great night photographs of Manhattan by Berenice Abbott. Now these dazzling, clear-eyed views of New York at night are viewed through a nexus of brushstrokes, superimposed rhythmic layers of hatching that function something like Dickson's coarse aquatint, to diffuse the image and to impose the gentle presence of the artist between observer and observed.[36] That sense of intervention, of finding poetic equivalents in the marks of printmaking for the forms and structures of landscapes, is also apparent in the lithographs and aquatints of Susan Shatter. In *Vertigo*, for example, the precipitousness of her view down into Black Canyon almost takes the viewer by surprise. Shatter's careful and unusual modulations of shape and color provide a visual path that ends in a blinding drop into the abyss just at the observer's feet. Hers is a most artful contrivance to summon up, without ever being emphatically descriptive or totally abstract, an image of the powerful forces that have molded the natural landscape.

Steep perspectives may not be a specifically feminine characteristic of recent art, but they do carry an emotional charge not frequently encountered in landscape images by male artists. A need for adamant emotional denial was clearly not as operative among women artists, especially the Realists in this publication. I would argue, furthermore, that if the art of the 1960s—Pop, Color Field, Minimal, and Conceptual—generally eschewed the emotional excesses of the fifties, the women of the sixties and seventies sought ways to maintain some vestige of contact with their feelings, frequently in association with fairly conservative subject matter, including the still life. Inevitably, any mention of the conservative carries with it the implication of regression, a turning away from the Modernist definition of art. But the idea that art must always seek new and increasingly reductive languages based upon those of the recent past has been challenged by Postmodernism in general,

and by women specifically. The very notion of a logical succession of styles exerted a pressure that many feminist artists regarded as an anathema to their own creativity. The movement away from style is perhaps the most telling hallmark of women's painting and printmaking of our times. In a very real sense, landscape provided an escape from style and from the attendant excesses of Expressionist and media formulations. As Jane Freilicher put it, "To strain after innovation, to worry about being 'on the cutting edge' (a phrase I hate), reflects concern for a place in history or for one's career rather than for the authenticity of one's painting."[37]

■ *The Seventies: Realist Printmaking II*

The second wave of Realist printmaking was riveted to the exploration of photographic illusion and meaning, and thus maintained far closer links with the concerns that had fueled Pop art during the 1960s. While Rosenquist's offset prints of the early seventies, particularly such large endeavors as *Off the Continental Divide* (1973–74), had included passages that appeared photographic, their contents related more to the conventions of high-tech public media and consumerism than to the character of photographic image making itself. Even Pearlstein's canvases of the early 1970s seemed photographic to many. With the ascendancy of Richard Estes, Chuck Close, and the stable of New Realists gathered at O. K. Harris Gallery, however, a new photographic literalism emerged. Such early New (or Super) Realists as John Salt, Robert Bechtle, Audrey Flack, John Baeder, and Ralph Goings strove for painted surfaces devoid of syntax.[38] The printmaking of most of this group was restricted to photographic color-offset reproductions of their paintings, often signed and published in limited editions, but hardly consonant with anyone's idea of "original" printmaking.[39] But one series of prints did manage a radical departure from straight, photomechanical reproduction, the portfolio *Documenta 1972*, a group of lithographs published by Shorewood Atelier in New York in 1973. While it meant that the slick Photorealist surfaces were compromised, each artist contributed a work printed from a fully hand-drawn matrix.[40]

Of greater significance were those who set out to analyze and reveal photographic syntax and style. Among makers of prints, Richard Estes was the pioneer. His *Urban Landscapes I* portfolio of 1972 was a stunning synthesis of photographic Realism and commercial screenprinting conventions (figure 3).[41] Estes' prints comprised an object lesson in the fabrication of illusion. Each element of each reflection is reduced to discrete areas of opaque, planar color, befitting the flat, stenciled screenprinting medium. The art-

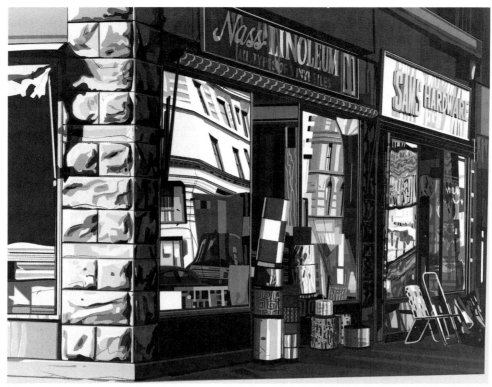

Figure 3. Richard Estes (b. 1936). Linoleum, 1972. Screenprint. Reproduced courtesy the Museum of Art, Rhode Island School of Design, Providence, National Endowment Fund

ist and his printer reverted to well-established 1930s conventions to portray eye-catching, thirst-appealing, glistening-wet bottles of advertised beverages, from alcohol to orange juice. The tensions between these totally uninflected, almost Katzesque, forms and the sparkling optical events suspended the viewer between the two planes of an Estes image and gave the lie to the apparently photographic exactitudes of the representation.[42]

Other Realist printmakers, such as Chuck Close and Don Eddy, evoke quasi-photographic images with draftsmanly marks, once more spreading the viewer's attention between mutually exclusive or at least disparate systems. By showing that a surface full of the most mundane marks, from painterly smudges to austere hatchings, from fingerprints to papier-mâché squares, could emulate photographic vision—focus, reflections, and exactitude of detail, as well as typical points of view and optical distortions—these artists exposed the myth of photographic verisimilitude. More to the point, however, they demonstrated that representation is de-

pendent upon a bargain between the sender and the receiver of codes, that illusions are both made and accepted out of an endless variety of materials. The upshot, of course, is that art and representation are equated; each is a picture of the world composed of its own relatively abstract and arbitrary elements.[43]

Among the women printmakers, virtually none has taken up the intellectualized analysis of photographic vision of an Estes or a Close. Rather, there have been a handful of prints with a somewhat related approach by Janet Fish, Patricia Sloane (similar to the close-up color photographs of circa 1980 by the New York photographer Jan Groover), and especially Sondra Freckelton. Her *Plums and Gloriosa Daisies* (colorplate 23) was hand drawn but executed on the offset press to assure hairline registration and vivid opticality. However facile the observation that Freckelton is one of many women artists to have turned to domestic surroundings and images of growth and beauty for her art, it is in fact the essence of Freckelton's accomplishment that the viewer feels deeply attracted,

surrounded, and comforted (the space of the print is, after all, established by the many colored planes of the quilt). What draws us in, however, is the artist's consummate control of color and shape as optical abstractions. Such seductiveness reaches even greater intensity in Freckelton's pochoirs and screenprints, such as *Blue Chenille* (colorplate 24).

Ultimately, the same sense that conjoins the sensuousness of art with that of the natural world informs the work of Vija Celmins. Her work, too, is painstakingly evocative of the surfaces of things, but it has become increasingly imaginative. In a microcosmic reflection of recent artistic change, Celmins's prints have moved from a concern with photographic illusionism to far grander metaphors of cosmic structure. Carter Ratcliff has astutely described this shift in Celmins's content: "It seems that she wants to remind us of the mind's primary use for the world, which is to put it to work as a model for a world of the mind's own devising. This is how the mind wins out over the eye, not by arguments about the nobility of thought, but by treating what is seen as if it were a form of thought."[44] The prints from the early seventies conjured finely textured and minutely variegated substances—sand, water, stars—consciously contrasting the structures of nature with those of drawing on the one hand, and those of photographic reality on the other. Unable to perceive these three modes simultaneously, the viewer is forced into a sequential examination, comparing, in a Johnsian manner, what one knows with what one sees in a continuous game of changing focus. In her more recent work, these seemingly neutral subjects become symbolic studies of cultural constructs, as in *Concentric Bearings B* and *Alliance* (colorplates 10 and 11). No longer are the primary meanings of these stars, galactic clouds, ships, and airplanes located in the play between manual and photographic imaging; a new sense of wonder has infiltrated these works, especially those that compare natural with man-made imagery. How may one avoid the associations inspired by the images of *Alliance*, between the schematic of a sailing ship, a ship of exploration, and the gaseous galaxies called the Clouds of Magellan, after Ferdinand Magellan, the first explorer to circumnavigate the earth? Even the rigging of the ship, with its Feininger-like structure, recalls the diagramming of the constellations. It is in this context that the seeming infinitude and precision of Celmins's painstaking technique become physical analogues for the heroic exploration of the vast reaches of the unknown. As Ratcliff points out, it is in the viewer's mind that the small scale of these marvelous prints expands to embrace the essence of human striving. Certainly these prints must have provided some of the impetus for the stun-

ning, but formally conservative, *Deep Sky* aquatints by James Turrell (1984), the slightly more expressionistic intaglios by Robert Wilson (1984), and the more challenging etchings and aquatints by David True (1985), all of which return to late-nineteenth-century Symbolist sources in an effort to reinfuse contemporary art with an imaginative aura.[45]

■ *The Seventies: Minimalist and Conceptual Prints I—Paperworks*

The conflicting strands of intellectualism that marked the late sixties and early seventies are too complex to elucidate here.[46] Minimalism seemed to carry the dicta of Greenberg and Fried's reductivism to their logical ends, yet so much of the actual work drew from natural and mass-produced forms, rather than those deduced from the conditions of painting, that the purist idealism was doomed from the start. Artists such as Eva Hesse, Donald Judd, Sol LeWitt, Robert Morris, and Dorothea Rockburne exploited the properties of machine-made or naturally occurring materials, and they arranged these to elicit from the viewer either a structuring of the work (as the viewer moved, so did his or her perception of formal relationships) or an empathetic response to the physical characteristics of the materials. In fact, the perception of gravity, tension, strength, texture, and color as integral aspects of materials rather than as abstract qualities became the central focus of anti-illusionism around 1970.[47] These two currents spawned several counterparts in the prints of the period, most notably the revival of etching and the appearance of the new medium of paperworks. In an effort to integrate the reductiveness of Formalism with an exploration of the materials and processes of making, paperworks emerged as a most logical and appealing form of printmaking in the early seventies. Although a moment's reflection discloses that these objects have little connection with the printing or replication of images, their essentially flat form and paper structure led them to be classified as prints. And many of those who produced them were well known for their printmaking, especially Robert Rauschenberg, whose Cardbirds (1969), Pages and Fuses (1973), and Bones and Unions (1975) series of constructions involving mass-produced and handmade paper turned national attention to the new paperworks.[48]

Although many paperworks were produced by men—Roland Poska, Bob Nugent, and Alan Shields, for example—many of the most subtle and lasting accomplishments were produced by the women who were attracted to paperworks in unusual numbers. The extraordinary sensitivity to the sculptural and structural

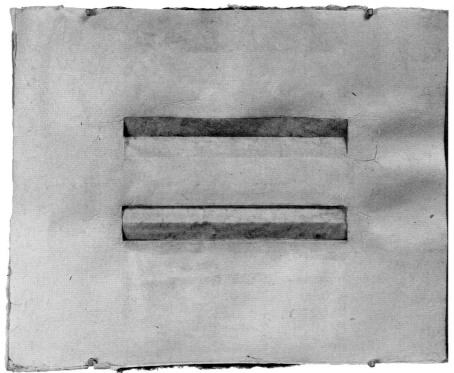

Figure 4. Winifred Lutz (b. 1942). Night Edged Reversal, *1978. Handmade paper relief, abaca and procion-dyed abaca. Reproduced courtesy the Mount Holyoke College Art Museum, South Hadley, Massachusetts, The Susan and Bernard Schilling Acquisition Fund*

qualities of the materials, an intricate infiltration of space and texture, and a deeply felt interconnection between those materials and specific feelings, memories, and places seem to have been a predominantly female contribution. Critics latched onto this confluence of women and handwork with predictable results. For some, a natural feminine preoccupation with detailed, textured, and handmade materials had found its way into the arena of the fine arts, much as have the high crafts of weaving and quilting. For others, this traditional image of the diligent nineteenth-century woman occupying her hands with quillwork, collage, or sewing was the very antithesis of the independence from domesticated roles sought by the feminist movement of the late sixties.[49] While recent years have showered disdain upon those who claim that in the art produced by women there are sexually relevant differences which are not simply a matter of cultural determination, there have been serious arguments advanced for recognition of those traits that seem to perpetuate a masculine cultural hegemony. One need only recall the recent Freudian-based critiques of the so-called male priority of sight over the other senses.[50] Accordingly, there may indeed be deep-rooted psychological as well as political explanations for greater female participation in forms of art that have strong tactile components.

While the interest in paperworks has already crested, the contributions of artists like Caroline Greenwald, Winifred Lutz (figure 4), Howardena Pindell, and Michelle Stuart are substantial and permanent. In their art, the Modernist emphasis on the essentials of materials is movingly metamorphosed into pronounced astylistic and intensely personal auras. While the male artist working with paper tended to lend priority to visual structures, the female seized the more haptic, intimate, felt potentials of the medium.[51]

Few artists, however, attempted to integrate printed marks and paperwork. For Rauschenberg, the paperwork habitually was anchored in its objecthood—its wholeness—or in its association

with printed imagery. One always feels that the image is encased in or merged with the materials in unique fashions. This was particularly true of the Hoarfrost series (1975), consisting of images printed on varied diaphanous layers of hanging fabric. Shields's work, on the other hand, was far more related to the appeal of specific materials and their structured interrelatedness, anticipating to some degree the interest in weaving, quilting, and pattern painting.[52] Other male painters involved with paper, mostly through the efforts of Ken Tyler, were intrigued with the possibilities of reifying color by sculpting and dying masses of pulp. By the mid-seventies Kenneth Noland, Ellsworth Kelly, and Frank Stella had each fabricated continuous, relief-like structures that uncannily fused painting with sculpture.[53]

Such preoccupations with categorical and predominantly visual thinking operated at some remove from the approaches taken by most women paper artists. Greenwald carefully layered incredibly thin and differentiated fragments of exotic papers, often infiltrating these schists with bits of the natural world, while conjoining several with imbedded lengths of string or twisted paper.[54] Stuart's work, on the other hand, was much more intellectually structured by references to specific sites and natural phenomena. For her, paper acted as a tangible surrogate for that matrix of thought which combined the tactile and ideational memories of particular experiences. While her works (paintings? sculptures?—they are certainly not prints!) have all the appeal of handmade paper objects, they are a sophisticated mapping of ways of thinking about and codifying the world. In this, they are unique and original amalgams of the two poles of the period, process and concept.[55]

■ The Seventies: Minimalist and Conceptual Prints II— The Revival of Etching

The second impact of Minimalism upon printmaking was felt in the revival of etching. While lithography and screenprinting were at the center of the sixties whirlwind of printmaking, the opening of ULAE's etching workshop in 1967 (initiated by Jasper Johns's *First Etchings*) marked a significant departure from the hand–machine, private–public, artistic–commercial dichotomies. The etched line recorded the slightest tremors of the artist's hand, the planes and washes of aquatint were at once tangible surfaces and veils of spatial tone, and the bite of the plate's edges into the paper established the subtlest sculptural relief. The very language of etching was personal and gestural but severely controlled, intimate but vastly detailed, richly textured but tending to frugality. Whereas screenprinting and lithography quite naturally fostered a deposi-

tion of multiple layers of ink from variously processed printing elements, etching from the mid-sixties to the mid-seventies tended toward simplification of process and image.

The question of the etching "revival," like that of any revival, is actually one of perception.[56] It would be false to claim that etchings were not widely executed during the 1950s and early 1960s, but correct to admit that the major artists of the day failed to find etching a sympathetic vehicle for their work. The revival, then, consisted of the infusion of new contents into an older vehicle. There really were no technical innovations. In fact, combinations of hand- and photoetching had become reasonably common during the sixties, thanks largely to the influence of Pop art and the availability of Kodalith films and plates. When Johns compared his sparse, wirelike etching of *Ale Cans* (1967) with a photoengraved image of its sculptured prototype printed on the same sheet, the originality he claimed for the etching was not technical but cerebral. The difference Johns brought to the medium lay in his will to distill its essential, conceptual languages: in *Ale Cans* two pictorial images, both with their own plate marks, each recall and question a different kind of reality—precisely the same issues raised by the original sculpture, *Painted Bronze*, in 1959. In a move that was to inform virtually all of his subsequent printmaking, Johns then reprocessed his plates, not altering his original drawing but laying over and around it planes of aquatint that drastically changed the projected materiality and figure–ground relationships of the depicted objects. Almost immediately the new, Conceptualist possibilities of etching began to attract older Pop practitioners such as Rosenquist, Jim Dine, Hamilton, and Paolozzi. In their hands, etching was again coerced into the sixties mold of comparative linguistics.

But it was soon evident that the purist, reductive qualities of etching made it the ideal medium for artists of the time, equally serving such Realists as David Hockney,[57] Philip Pearlstein, and Alex Katz, and such Minimalist/Conceptualists as Robert Ryman, Brice Marden, Robert Mangold, Sol LeWitt, Fred Sandback, and Mel Bochner. Ryman's *Seven Aquatints* of 1972 stand out as the purest and among the most enduring Minimalist etchings, echoing the basic tenets that informed the 1966 exhibition "Primary Structures."[58] While they are honed down to the very ingredients of copperplate aquatints, the number of variables and choices they represent is considerable. In each the plate mark delineates the boundaries of a pictorial space within, but not at all separate from, the paper, which also varies in size, color, texture, and shape. Within the plate mark is the slightly raised field of the smoothly calendered paper, and within that, the pictorial elements: a plane

or a few parallel brushstrokes of lift-ground aquatint comprise the image. But each mark or set of marks varies in shape, texture, or grain, and, most importantly, in its relation to the plate mark, and to hand-written inscriptions of edition size and artist's signature, normally nonpictorial elements. Such work draws heavily on the viewer's knowledge of printmaking and his or her commitment to respond to small changes of focus, not unlike the earlier tests of viewer acuity and concern proposed by Johns and Warhol.

LeWitt's early prints laid far less claim to the preciosity of the graphic arts than Ryman's. They were generally illustrative of his impersonal structures: lines combined in a logical sequence of processes that yielded ever more complex pictorial situations. His own prescription for art—"the idea that becomes a machine that makes art"—not only invokes the cool, process orientation of the sixties, but makes it very plain that art is first and foremost a matter of intellect. While LeWitt's prints often appear to be concerned with optical phenomena, that effect is generated far more by the idea than by the hand. The complexity of LeWitt's prints took an amazing turn when he, as had Ryman, Marden, Mangold, and Bochner before him, turned to Kathan Brown's Crown Point Press in Oakland, California. Brown specialized in the most undisturbed of aquatints, the most palpable yet the least painterly. Nowhere did her surfaces admit gesture or undefined pictorial activity—the perfect field for ideas. LeWitt's prints now became complex structures of white line on black ground, generated by instructions inscribed directly in the aquatint itself. The rich bonding between perceived form and verbal description in *Lines to Specific Points* (1975) was both intimidating and beautiful.[59]

The importance of Conceptual art for many of the women in the present publication cannot be overstated. Many had just emerged into the art world in the years around 1970 and instinctively grappled with Minimalist and Idea art. But only established artists like Dorothea Rockburne, Agnes Martin, Edda Renouf, and Pat Steir were able to turn to prints; others had to wait until the later seventies.[60] Steir's first prints, such as those in the Wish series of 1974, not surprisingly reflect many of the techniques and motifs of Pop publications—the stacks of color chips, the diagrammatic comparisons of drawn and mechanical imagery, the slick rainbow rolls, and so forth. But underlying these superficial borrowings was a deeper commitment to the wellsprings of art and their reverberations in language. *Abstraction, Belief, Desire* of 1981 (colorplate 60) moves well beyond the pure intellectualism of a LeWitt or the illusions of Pop; while alluding to these male styles and devices, Steir's print introduces an idiosyncratic, personalized set of images that have been enmeshed in layers and layers of work, signs of

mental cogitation and physical evolution. It is a conceptual piece overlaid by the struggles of an Abstract Expressionist.[61]

Such a characterization might apply to many of the prints reproduced in this volume. Might it not be argued that Steir's dilemma actually encapsulates an essential feminist quandary, one that seems to have been more squarely faced in work since 1975 than before? The wish to fuse several stylistic options rather than settle for any single one certainly informs the art of Jennifer Bartlett, Joan Mitchell, Sylvia Mangold, Nancy Graves, Vija Celmins, Yvonne Jacquette, and others; and invariably the major struggle is to surmount the seemingly huge distance that separates the conceptual from the gestural. Howardena Pindell's etching *Kyoto: Positive/Negative* (colorplate 46) betrays, I think, very similar ambivalences. While its title suggests the figure–ground dichotomies of the sixties and early seventies, there exists an extraordinary painterliness in the layering of etching (orange), lithography (pink), papers (red and buff), punch-outs, and embedded fibers. And these ambiguities are heightened by Pindell's words, numbers, curvilinear arrows, and other marks that fuse suggestions of mental and biological creativity. As a result the experience of the work moves beyond the usual play of intellectual and visual concerns into more primitive, haptic realms of touch, relief, texture, and subtle but real matters of positive and negative spaces. The rewards returned by close attention to Pindell's prints are located precisely in these simultaneous appeals to diverse modes of feeling and cognition.

The tensions between intellectual and visual activities were never more rigorous and intense than in the art of Mel Bochner. Anyone who has become immersed in his pieces, especially *(toward) Axiom of Indifference* of 1971–73, has come to understand one of the fundamental artistic ideas of the years around 1970: the experience of sculpture as a conjunction of interior (mental) and exterior (physical) space.[62] In a way, Bochner's work was surprisingly akin to contemporary earthworks, the experience of which was mainly imaginative, confined as it was to photographic reportage rather than direct confrontation. Prints by Dennis Oppenheim, for example, provided not only photoengravings of a given site work, but also verbal instructions and diagrams for its execution, a contour map of the location, and perhaps documentation of one or more incidental occurrences during the execution of the work. By comparison, Bochner's prints were spare and entirely hand executed. The format of the prints in the portfolio *QED* (1974) forces the viewer to compare sensuous arrays of aquatinted figures with the arithmetic structure underlying the same image. The screenprint *Range* makes such conflicting systems congruent

by generating a pattern through the application of a set of rules to repeated sequences of colored numbers (zero through nine). Such works were very literal illustrations of Wittgenstein's notion that languages themselves are like pictures of the world.[63] One could maintain that the entire Conceptual movement was still another outgrowth of the interest in the printed image, this time in the uses of verbal, rather than visual, languages. Certainly the spatial, systematic, and relational aspects of Conceptual art continued well into the seventies and, in an unexpected manner, found their way into some of the most creative and sensuous prints.

The notion that art could consist of intellectual ideas projected onto actions taken in the physical world led in two directions.[64] The first was that of Fred Sandback. His string sculptures—spaces demarcated by planes defined solely by a few taut strings—were so subtle that, to be effectively experienced, they required total submission to the terms of the artist. In his prints similar demands were made of the observer. Sandback's portfolio of 1976, *Four Variations*, for example, consisted of atmospheric drypoint lines scratched into subtle planes of aquatint (with or without the plate mark to delimit space). Each line by itself could be apprehended as a spatial device, rather than merely as a one-dimensional mark; and each pair of lines could be perceived as a transparent plane cutting through and activating the neutral aquatint ground. Sandback's prints were the spatial equivalents of Ryman's Minimalist sculptural endeavors.[65]

But all of these subtle, wonderfully executed efforts were eclipsed by Dorothea Rockburne's *Locus* series, begun in 1972 and signed in 1976 (colorplates 47 and 48). In these works were fused all the concerns of the early seventies.[66] In one group of objects, Rockburne combined the tactility and layeredness of paperworks, the concern with logic and intellectual processes of Conceptualism, and the exacting imaginative projections of Minimalist sculpture. Each of the six prints of the *Locus* series was made from a single sheet of heavy Strathmore Bristol paper, subjected to a most unorthodox series of operations: a first printing in gray etching, two foldings, a second printing in coarse white aquatint, and a final wiping. The first printing marked the crossing of the sheet's diagonals and other calculations relating to the folding operations. Each sheet was then folded twice, not through the center but at calculated distances from it. Then, in its folded state, the thick paper was run through the printing press with a deeply and coarsely pitted aquatint plate. The glossy white ink deposited by this plate not only transferred these coarse textures, but embossed, to varying degrees, each of the folded planes lying beneath the plate, "deeply traumatizing the initial smoothness" of the paper.[67] In addition, the heavy pressure of the press forced each overlapping edge or fold to leave its own imprint on the surfaces above and beneath. The artist then hand-wiped the paper to give added texture and sheen to the inked passages, and the sheet was left to dry in the folded configuration (as each sheet still remains in the portfolio). Only for exhibition are the sheets unfolded so that they may become three-dimensional objects.

As do Bochner's three-dimensional pieces, Rockburne's prints have the power to invoke a sensual complexity from the most unassuming operations. While the spines of the two folds excite tension against each other when the sheet is open, it is the ghostly records of the folding, embossing, and printing that urge the viewer to reconstruct the spatial events of its making. Even the two folds embody a reversal: the second fold is divided into concavity and convexity, thereby advancing into the viewer's space on one side of the first fold and receding into the interior of the work on the other. Similarly, in *Locus No. 1*, for example, the blind imprint of the upper half of the first fold (the upper right quadrant, initially folded under the rest of the sheet) has embossed the paper positively in the upper left quadrant, but negatively in the lower right (due to its having been folded a second time before it went through the press). The imprint from the aquatint plate, received only by the sheet in this doubly folded condition, also pressures the sensitive viewer to reconstruct the complex process of making. The layered transmissions of edges and textures are pried apart when the sheet is unfolded for exhibition, and it becomes ever more difficult to understand that the aquatint was directly printed, in one pass through the press, only in the upper right and lower left corners, and in the little triangular sliver along the lower right fold. Less perceptible are other, more ghostly traces of the aquatint plate, filtered through intervening layers of paper.

Such facts articulate the interior rigors to which the paper was subjected. Only by projecting oneself into the folding, unfolding, and printing, only through a sense of the tactility of the spines and the aquatinted, calendered, and embossed surfaces of the paper, may one discover the intimacy of these works. Though intellectually conceived, the *Locus* series suspends cognition among the visual, haptic, and verbal processes. If Johns's printed flags were concerned with recording the changes of a relatively fixed idea, Rockburne's *Locus* series focuses on the viewer's changing perceptions of a relatively fixed recording.

The urge for sculptors of all persuasions to experiment in prints reached unexpected heights during the seventies.[68] Some, as we have seen, found parallels to their conceptual, ideational pieces; others sought analogues for the physical qualities of their three-

dimensional works. While there were some precedents for the latter—the wonderful etchings and aquatints of Lee Bontecou from the 1960s, for instance[69]—those who sought to unite the painterly potential of printmaking with the experience of three-dimensional work were led by Richard Serra. The series of lithographs he executed at Gemini G.E.L. in Los Angeles in 1972 bore fruit scarcely recognized even by recent writers on prints. Beginning with drawings after his own sculptures, such as *Circuit* (figure 10) and *183rd Street and Webster Avenue*, Serra attempted to compress his knowledge of their mass and weight with his experience of their space and form as seen from one point of view. The lithographic crayon was repeatedly passed over, dragged into, or loaded onto the stones (or plates), creating murky, heavy, insistent shapes whose repetitions quivered with threatening force and instability. The lithographic stones, in their turn, were printed more than once, in order to achieve as great a deposit of pigment as possible. As a result, the vigorous drawing, fluctuating planes, and heavy, nearly monochromatic inking imparted a presence heretofore unseen in printmaking. These were not like the machined, pristine, multiple objects and prints of the sixties. The subtle but powerful intimations of space, weight, mass, bending, and movement that emerged endowed these lithographs with extraordinary energy. But their power was subject to a discipline typical of the best work of the 1970s, a discipline born of the cognitive tensions between the immediacy of the surface as shape and painterly mark, on the one hand, and, on the other, the viewer's intuition (through knowledge of Serra's sculpture) that these forms could be projected into an imaginary space. In retrospect, the aggressive, autographic nature of Serra's prints was a bellwether of the coming reappraisal of Abstract Expressionism.[70]

Among others who experimented in the same vein were Michael Heizer, Bryan Hunt, Lynda Benglis, Barry Le Va, Ellsworth Kelly, and Nancy Graves. Their prints were also analogues for sculptural projects and created similar intellectual tensions between the print as object and print as surrogate for the prototype stored away in the viewer's (and artist's) memory. Heizer exploited the scarred and corroded surfaces of scrap metal for the discs and segments of his Scrap Metal Drypoints of 1978–79, which recall his huge outdoor drawings as well as his granite sculpture.[71] Hunt used long trains of aquatint to find an equivalent for his frozen waterfalls; Benglis created a collage of cut plates and monotype in unexpected emulation of the soft, globular forms of her cast pieces; and Graves, in her recent intaglios, has used a linear and painterly layering of the materials of etching and collage to suggest the skeins of material that draw together the spaces of her sculpture (see colorplates 3 and 27). Other artists have found more formalized equivalents for their three-dimensional work: Le Va has generated perfectly crafted planes and lines of color aquatint to make tangible the abstract spaces of his projected architectural sculptures; Kelly makes surfaces in subtle relief that embody the precision of form, texture, and location notable in his sculpture.[72]

■ *The Seventies: The Return of the Painterly Print*

The growing dissatisfaction with the stylistic extremes of the sixties gradually fostered a resurfacing of Abstract Expressionist ideas. No matter how strongly artists had turned away from the art of the fifties, it had always served as a touchstone for advanced American art. Serra's lithographs were a symptom of this reevaluation and, in a lesser fashion, so were Johns's screenprints from the same time.[73] An artist who is continually exploring the traditional as well as the new aspects of print media, Johns, with almost deliberate perversity, reverted to the painterly potential of the screenprint, which had been eschewed throughout the sixties.[74] His *Screen Piece* of 1972 depicts precisely the conflict of the moment. In its combination of screened passages (literally derived from various grades of screen materials), stenciled words (which make it clear that photographic screens had also been employed), and hand-painted washes, Johns revealed the range of disjunctive techniques at his command. Similar disparities appeared elsewhere. The artist's hand made a surprising comeback in Andy Warhol's *Mao Tse-Tung* portfolio of 1971, in Richard Hamilton's etchings of the period, and in many of the prints shown in Brooke Alexander's exhibition "Hand Colored Prints" in 1973.[75]

The disparities surfaced again, even more dramatically, in the four panels of Johns's *Untitled*, 1972, one of which inaugurated the artist's baffling crosshatched work of the next ten years. In what might be called painterly structures,[76] Johns continued to find new resolutions to the problems he shared with Stella—the antinomy of surface structure and spatial illusion, of events that move across and those that move into the picture. Stella's reaction to the impersonal qualities of sixties printmaking was manifest in the step-by-step evolution of his own work, especially in its increasing decorativeness. Beginning with subtle infiltrations of texture beneath the geometric forms of the screenprinted *York Factory I* in 1971, Stella's prints took on not only the growing brushiness of his larger paintings (for example, the French Curves), but also the fragmented and recycled character of his constructions. The emergence

series of 1976–77 (offset lithograph, screenprint, and applied glitter) to the Swan Engravings of 1981–85 (etching and engraving) and Circuits prints (etching, engraving, screenprint, woodcut) of 1981–84.[77]

While Johns's juxtapositions were characteristically side-by-side,[78] Stella more and more incorporated his into each image. He began to combine different printmaking techniques within one work, a direction encouraged more by Ken Tyler than by any other printer. These new complexities of surface and form, contemporaneous with the appearance of paperworks (in the mid-seventies), differed from any remnants of painterly abstraction appearing in the print world in the 1960s.[79] The new works of Stella and Johns preserved structural elements derived from Minimalist and Conceptual models, and in so doing, offered new directions in which many other artists were to travel.

Perhaps the most interesting result was the number of women who were drawn to this loosening of Formalist and intellectual austerity. Painterly pattern now began to achieve a high level of beauty and seriousness without the necessity of the complex critical apparatus to which the art world had grown accustomed during the preceding decade and a half. One thinks particularly of the handful of prints by Joyce Kozloff, from her unnoticed beginnings at the Tamarind Institute in Albuquerque, New Mexico, in 1972 through her work at Crown Point Press in Oakland ten years later. Her lithograph of 1979, *Is It Still High Art? State III* (colorplate 34), directly challenges the mystique surrounding Stella's and Johns's prints (figures 5 and 6).[80] Its title ironically asks whether an art derived from historical ornament may be regarded as seriously as an art derived purely from the abstract conventions of painting itself.[81] While Kozloff's patterns possess the flatness and palpable hue demanded of sixties high art, and the use of the printing press appears totally consonant with the concept of a continuously extending surface, the predictability of form and optical flatness are constantly compromised by the subtle and unpredictable modulations of the colors. So deceptive are these little disturbances that they appear to undermine the regularity of the pattern, destroying all Modernist pretensions. Does this willfulness, and its basis in historical resonances—the relationship to Near Eastern ornament and printed prototypes, such as Owen Jones's *Grammar of Ornament*—deprive Kozloff's art of its serious purpose?[82] Does the ingratiating constituent of the art of a Kozloff or a Miriam Schapiro not consist in this very withdrawal from high Modernism in favor of a Postmodernist position of intimate, personal treatment of invented, derived, or deduced motifs? But it was not just Kozloff

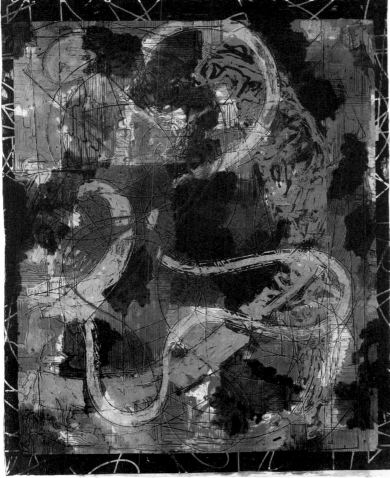

Figure 5. Frank Stella (b. 1936). Estoril Five II, 1982. Etching and relief on multicolored handmade paper. Reproduced courtesy Tyler Graphics Ltd., © Copyright Frank Stella, 1982

of drawing in his prints of the seventies is not unlike the surfacing of drawing in Jackson Pollock's paintings of 1950. In Pollock's case, underlying figures in black seemed to move upward through the layers of pigment in each successive painting. In Stella's, geometrically drawn and cutout forms underwent a gradual metamorphosis, first taking on painterly surfaces, and finally breaking up into kaleidoscopic compositions whose elements were as capriciously shaped as the decorative motifs they often bore. But this was a long process, one that stretched at least from the Exotic Bird

Figure 6. Jasper Johns (b. 1930). Corpse and Mirror, 1976. Screenprint. *Reproduced courtesy Simca Print Artists, New York*

and the pattern painters who abandoned the derived styles, structures, and flat grids of the 1960s and early 1970s. During the later seventies both Johns and Stella were moving rapidly away from these same vestiges of impersonal Formalisms.[83]

As I have implied, these changes did not mark a turning back of the clock. One need only look at Robert Kushner's work, with its amalgamation of wit, decoration, chic, and carefully plotted periodicity and reversals to comprehend the modernity of the new trends. Kushner's almost excessively exuberant ornament prints were begun at Judith Solodkin's Solo Press in New York City. Printed with consummate skill, their richness of color, line, and collaged elements betrays a new willingness to make and publish works of pure, visible joy. And the skills for the production of ravishingly beautiful works were on the increase throughout the seventies, partly because of the numerous smaller, more accessible print workshops that sprang up in the heart of New York and elsewhere. Here was initiated a slightly altered rhythm of collaboration between artist and printer, one that was not bound by

discrete, extended visits, but that thrived on slow, long-term development of single prints. It was also a time of maturation for a new group of artists, younger than those who had been working in the sixties and early seventies. In many cases they were asked to take up printmaking by some of these smaller, enterprising shops. That many of the new artists and printers were women may only be a quirk of the moment; in any case, this new initiative led to the production of many of the most important and innovative recent prints.[84]

One of the most daring groups of prints of recent years has arisen from Elizabeth Murray's collaboration with Maurice Sanchez. Her work is not informed by a logical exploration of a set of formal ideas or technical procedures, as was the case with many earlier artists. Nevertheless, in her very first prints, *Untitled, States I–V* of 1980 (colorplate 43), she amalgamated the organizational structure of two of Johns's first printmaking projects: *0 through 9* and *0–9*, both begun in 1960. Murray's goal was to record a series of changes in a motif confined to a single stone (like *0–9*), all the

while preserving the past forms as traces beneath the present image (like *o through 9*). While Johns's stenciled numerals urged a sequential reading of numerical and visual change from print to print, or from figure to figure, in which the eye extracted each from a mass of sensuous curvilinear marks, Murray's drawing was absolutely abstract, though equally sensuous. It did not rely on tensions between cognitive (reading or counting) and aesthetic (formal) tasks, but offered an organic metaphor equally appropriate to the notion of change. Murray's motif was biomorphic, evoking physical growth and inner development, just as Johns's more systematic undertaking had alluded to linguistic progression and mental function. The evolving sensuousness of Murray's five lithographs indicated a direction taken by much recent art: a liberation from a priori structure, a liberation from the confines of intellectual production, and a release of the hand from the uninflected mark. In other words, both the means and the ideas of printed imagery have changed to admit allusions to matters of far greater personal import. The artist herself has talked of her intimate feelings for work that clearly revealed its own process of development (not unlike the pregnancy she was experiencing at the time).[85]

Murray's *Inside Story* is also part of a series that evolved from the simple motif of the cup. Gestural and idiosyncratic rather than borrowed from the mass media, totally personalized rather than serialized, it is a uniquely charged image of overflowing energy, both feminine and masculine (Murray's own associations with the cup motif are cited in Ruth Fine's discussion, page 119). Ironically, it has the scale and individuation of form of a Robert Motherwell aquatint and the painterly color and graphic tensions of a Sam Francis lithograph, but not their dogmatic flatness. Murray's work invites participation, involves and even enfolds the willing observer in the biology of its forms, the distinctiveness of its colors, and the looming perspectives of its fluid spaces. Murray's is an art that seeks sensuous involvement, differently from, but not unlike, that of Rockburne, Nancy Campbell, Pindell, and Graves.

■ *Transition: The Conceptualization of Style and the Continued Importance of Landscape*

No artist has more successfully or self-consciously integrated the multiple currents of the past twenty years than Jennifer Bartlett. Her work acknowledges all of the analytic and conceptual modes that informed the art of her youth, displays a growing personal lyricism, and reveals an intense awareness of the nature and process of her materials. Her compulsion to immerse herself in the process of making, especially in the forming of the matrices of print-making, her willingness to use herself as the machinery of art, and her ability, at other junctures, to make use of others to carry out tasks she has designed recall many of the habits of the sixties. Even more striking has been Bartlett's almost constant need to exhaust the possibilities of every process, including the systematic exploration of styles. It is all the more remarkable that one so indebted to the past has managed, step by step, to formulate a totally liberated art.

In her earliest prints, the series of six intaglios *Day and Night*, 1978 (colorplate 4), Bartlett shared much of Kozloff's struggle between geometric predictability and lyrical irregularity. The grid and the pattern of etched or drypoint strokes dominate the limited organizing motifs of the cityscape, its color and lighting, and its suggestion of time of day. I have elsewhere described[86] how Bartlett explored the possibilities of a simple motif such as that of the house in *Graceland Mansions* (colorplate 5), adopting, among others, a favorite strategy of Duchamp and Johns, rotation. In *Graceland Mansions* Bartlett rotated the point of view from which her house motif was presented, varied the angle of the light (time of day), and exploited five printmaking techniques, pairing each technique with changes in the character of her marks and the quality of her colors. For the woodcut (fourth section from the left), she demanded an even greater physical and intellectual attention to the process of making. There, the idea of rotation was applied as well to the alignment of the groups of parallel lines that made up the several sections of each block (some for background, others for various facets of the house). In each successive color block, the sections themselves remained fixed but the orientation of the lines was rotated according to a preconceived scheme. What is even more astounding is that the artist did all of the physical work, imposing on the conceptual the manifestations of the individual: the signs of struggle, the imperfections of materials and process, and the personal decisions that must invade so ambitious an undertaking.

Bartlett charted a course through the seventies that appropriated the exuberance of a Kushner, the intellectual rigor and underlying sensuousness of a Rockburne, and the decorative, hierarchical, yet exotic overtones of a Kozloff. The tasks set by the In the Garden series of drawings, paintings, and prints (colorplate 6) extended what had been broached under the guise of technique into the territory of style. Ironically, style became the subject of rigorous permutations. In Bartlett's hands, style was not merely fused with technique, as in the sixties, but was made its equivalent. These pictures dissected every conceivable change in point of view, lighting, time, and atmosphere, and were derived from nature, from memory, from other studies, and from photographs; in them

the artist rang the changes of medium, technique, and style. No set of circumstances, no means, no styles were privileged above any other, with the result that Bartlett challenged the very notion of dominant period style that had so clearly determined the art market of the recent past and the habits of art history in general.

When Bartlett turned to render her In the Garden drawings into prints, it was with a similar spirit of relativity. Work, craft, and conceptual processes continued to be the focus of artistic decision making. The screenprint *In the Garden #118*, 1982, makes a double comparison: two views of the garden are contrasted horizontally, while each is duplicated and superimposed on itself—not unlike the many series of diptychs initiated by Jasper Johns's *Two Maps I* of 1965–66. Yet the dark, agitated Van Gogh-like brushiness of the Bartlett stands worlds apart from the felicitous execution of her *In the Garden #116*, 1982–83, whose two halves juxtapose radically different handlings of screenprinting techniques (pointillist versus fluid, watercolorlike washes); the two views were even taken from almost diametrically opposed positions. *In the Garden #40*, 1983, confounds our expectations of style and technique further. Again two views are presented, but this time in four pairs. The drawing of each pair is either hard- or soft-edged, from crayonlike to washy to opaque, but each of these is rendered through the medium of screenprinting or woodcut. The contrast between such a lyrical, Matissean motif (pool, statue, and cypresses) and the rigorously demanding program of variation is bewitching, creating tensions very much on the order of those found in Johns's and Rockburne's work. But now these endless comparisons offer a new challenge, one that calls into question all of the traditional expectations of art-historical categories of style and technique. Bartlett's work fails to offer its own definable "style" but instead appropriates all styles and techniques to a new language game.

Was this not also implicit in Kozloff's notion of "high style"? And was this idea not lurking in that *cause célèbre* of 1974, Lynda Benglis's *Artforum* advertisement, in which the artist posed provocatively nude, proffering a massive penis as if she were appropriating some male prerogatives? Were not these strategies similar in that both sought to deny cherished, allegedly male hegemonies in the field of art? To hold up for scrutiny the collective notions of style and media that had so dominated the art of the fifties and sixties (and the language of the historians, critics, dealers, and curators) was to challenge the very foundations of Modernism, which had become more linguistic than visual. Nevertheless, a critical view is not a destructive one; it is clear how much the new art of the seventies and early eighties has been nourished by the innovations of what preceded it. Certainly, Bartlett's four-part

color aquatint *Shadow*, of 1984, as sumptuous a work as the history of prints has witnessed, is couched in the same notion of seriality as were the prints of *Graceland Mansions*. Only now, "point of view" is a function of willful choice rather than programmatic or informational dictates. For all its beauty, *Shadow* is not about the artist's feelings; interpretation and expression play no more role in Bartlett's work than they had in Pearlstein's or Bochner's. To borrow a word from Clement Greenberg, Bartlett's lyricism is "homeless," relatively detached from the objects it clothes. The artist has seduced the viewer but only to leave him or her pondering the possible significance of each of the four panels. The similarities among these polyptychs work to defeat the notion of defining, knowing, and valuing; there are only endless chains of perception, recollection, and comparison.

Like Jennifer Bartlett, Sylvia Plimack Mangold launched her career as a Conceptual artist of sorts, but her roots were also in the Photorealism of the early seventies, as is amply demonstrated by her early prints of floors, mirrors, and rulers (for example, *Flexible and Stainless*, 1975). Mangold's new Realism of the late seventies, however, was as lyrical as it was conceptual, and as obviously hand executed as it was antiphotographic. Almost Whistlerian in its soft, murky luminescence, Mangold's 1980 lithograph, *View of Schumnemunk Mt.* (colorplate 38), combines drawn and stumped crayon with delicate gray and blue washes overlaid by a thin purplish veil. The small, yellowish lights shining through the color-laden atmosphere of deepest twilight evoke a human presence. Despite the beckoning of these distant beacons, the illusionistic masking-tape border provides a gently ironic reminder that the landscape is but a work of the artist's imagination, conceived in the studio and artificially dislocated and truncated on the lithographic stones. Yet this framing role is in part denied, as the very black that overlaps the tape is itself penetrated by the forms of the landscape.[87]

The beholder is pinioned by these gentle but persuasive reminders of both reality and studio. Nowhere in printed art of the preceding years may one find so moving a synthesis of the lyrical and the conceptual. It is surprisingly absent from the prints of earlier Realists, from Freilicher or Katz, for example. Where earlier artists had conceptualized the means of Realism, Mangold is at pains to reveal both the physical and the conceptual distances that separate reality and art. Once she has staked out these contexts, Mangold is able to claim a greater personal share of the viewer's world without departing radically from the uninflected cool of modern painting. The spareness of her more recent *Nut Trees (Red)* of 1985 (colorplate 39) establishes an even closer rapport between the conceptual experience of the drypoint and aquatint surfaces on

the one hand, and the description of natural forms and textures on the other. With admirable and moving economy, the arid atmosphere fits both form and content. Compared even to the evocative spirit of Fairfield Porter or Neil Welliver, Mangold's emotions are always projected deeply into the space of the work; the conceptualization of Realism never obscures her feelings about nature. Mangold does indeed ready the comfortable armchair that much art prepares for its viewers, but she never fails to remind us of its location . . . in her studio.

■ The Eighties: A Reexamination of the Identities of Technique and Gesture

If the seventies appeared to be a pluralistic decade, the eighties seems to be an eclectic one. The arts have greedily reached out to embrace older styles and formulations. Work that resonates with echoes of the past has gradually replaced that implacable demand for stylistic innovation that had marked American art since Abstract Expressionism. Stylistic allusion, as bearer of feeling and historical meaning, has cooled the obsession for information and media analysis that had dominated the sixties and early seventies. Yet in the United States at least, the conceptual frameworks of 1960–73 have continued to impede the return to undiluted personal expressionism. The intellectual basis of art that demands the viewer's participation remains. In printmaking, as in painting, the American flavor is marked by an essential love of duality and irony. No longer may any one thing fulfill our expectations of art. Further, the techniques of printmaking, so intimately tied to the meanings of the prints of the earlier Pop generation (think of Warhol's *Flowers* or Lichtenstein's *Haystacks*), have since tended to recede to their traditional place as handmaidens of expression.

It was expected, by 1980, that the artist would be fully immersed in the making of his or her plates, blocks, or stones, just as it was anticipated that the fine print would reveal a total perfection of technique. For example, in her incredibly rich prints of the past few years, Bartlett and her collaborator (Pat Branstead of Aeropress in New York) seemed driven to surpass the limits of previous printmaking. So painterly are these aquatints, so perfectly fused are the colors, that the older notion of media identity was virtually eclipsed. In Judith Goldman's phrase, "the medium isn't the message anymore."[88] Perfection of means alone no longer plays a large role in the meaning of prints; it is a pre-existing condition. The printmaking processes have become so highly sophisticated that they are often pushed beyond their own expected identities to a degree of intense individuation.[89]

Such changes and conflations of media identities are especially characteristic of artists working with Ken Tyler in Bedford Village, New York.[90] One is even reminded of the "mixed media" label so often applied to the complex, undisclosed intaglio techniques employed by professional printmakers during the fifties and sixties.[91] But even a cursory comparison of prints by any of the Tyler artists and those of some of the successful intaglio printmakers of the fifties and sixties reveals profound differences in scale, personal style, and formal sophistication. Without laboring the point, one need only note the degree to which earlier printmakers mistook texture and technique for gesture and painterliness. By contrast, the works of Steven Sorman and Nancy Graves sing with luminous color, resonant space, and graphic discipline of great breadth and conviction. This revitalization of the mixed-media approach had its beginnings in the paperworks of the mid-seventies, especially those of Alan Shields, and possibly, as well, in the combined techniques encouraged by Tyler when he was the master printer (and director) of Gemini G.E.L. in Los Angeles.[92] Sorman, like Stella, developed an unprecedentedly free approach to printmaking, in which he combines laminates of paper with every printing process, in addition to monotype and handwork.[93] While we have not emphasized monotype in our overview of recent printmaking, it has had an enormous revival in the past dozen years.[94] The addition of monotype and handwork to any print (rather than the use of monotype alone) serves many ends. The work takes on unique aspects—not insignificant at a time in which artists are adopting any available means to infuse their work with greater autographic and personal character. It further heightens that ambiguity and conflation of means which have become so important to recent printmaking. Thus the release of printmaking from the cool, controlled, and mechanistic qualities of the sixties and early seventies, and the introduction of perfected gestural printing in color greatly increased the sheer enjoyment of its sensuous aspects. This was as much furthered by Tyler in the middle seventies as he had fostered the pristine, machinelike surfaces of an earlier generation. In Tyler's hands, what most of us had regarded as polarized approaches to printmaking were united as "high-tech wizardry"[95] and impromptu, personal, painterly marks.[96]

The possibility of mixed-media projects lured those who had long practiced relatively straightforward printmaking: in addition to Howardena Pindell at Solo Press and Pat Steir at Crown Point Press, Nancy Graves and Helen Frankenthaler began working with Ken Tyler, often combining various printmaking techniques with painterly, handmade infusions. But even artists who avoided technical complexity, like Robert Motherwell, Joan Mitchell, and

Elaine de Kooning, reveled in the heightened perfection of technique to advance their own personal styles.[97] Mitchell's 1981 lithographs *Bedford II* and *Flower I* (colorplates 40 and 41) are part of a series that is still dominated by the sense of stroke, but in which gestural qualities give way to texture, to space, and to the suggestion of the forms and layers of the natural world. What is beautiful about these works is their multiple transparencies—of color and light on the one hand, and of space on the other. Once again, as was the case with so many of the more Realist landscape prints, the viewer is aware of looking through the sensuous means of art to a celebration of the warm joys of the natural world.

The distinctions between mark making and drawing, random graphicisms and periodic pattern, accident and intention, figure and ground, inside and outside have been wellsprings of art from the beginning. Aspects of this will to represent, to separate (but not decisively) figure from ground, man from beast, and fact from fantasy, are also central to Elaine de Kooning's Lascaux series, published by Mount Holyoke College in 1984. While quite obviously inspired by prehistoric drawings, the figures emerge from the chthonic mass of brushstrokes and washes in a manner appropriated from the primitivism of Abstract Expressionism, the style with which de Kooning matured.

Although considerably more abstract in both conception and execution, Nancy Campbell's prints are informed by a very similar sensibility of looking through layers of marks and probing for meaning. Physically they are composed of layers of drawn lithographic marks and planar screenprinted passages, which act as translucent foils for each other. The overprintings, subtle overlappings, and smudges compound the spatial qualities, even suggesting atmosphere; the titles themselves are drawn from James McNeill Whistler's paintings *Cremorne Gardens* (1872–77) and Mary Cassatt's aquatint *The Fitting* (1891). What begin as quite modest, understated works expand and enrich as the viewer grows conversant with their languages. In this sense, they are unlike Mitchell's or de Kooning's grander, gestural prints and more closely resemble those by Pindell and Graves, which are meant to be seen at close quarters.

Each of Nancy Graves's prints has proceeded from a specific project, and each of those projects has been nurtured by a different set of artistic and intellectual circumstances. One set of color lithographs, for instance, was composed of abstract markings that characterize certain mappings of the moon's surface. *Ngetal*, a mixed-media print of 1977 (colorplate 27), is completely nonfigurative, but its incredibly reified textures—bits of wool-, wire-, and ribbonlike aquatint that play against coarser, screenlike passages, all printed in deep, palpable colors—achieve a three-dimensional spatial activity solely through optical rather than geometric events. If Campbell's spaces are layered, compact, and essentially pictorial, Graves's are virtually sculptural. A work of similar sculptural sensibilities is Judy Pfaff's color woodcut *Yoyogi II* of 1984 (colorplate 44). Though densely structured, it is an uncanny analogy for the tangible materials and invaded spaces of her sculptural environments. The richness of these and many other recent prints is in their ability to compress the experience of three-dimensional art into the flat plane of the paper, thereby offering a unique experience of disembodied expansiveness—an escape from physical involvement (much like the differences between Johns's object-laden paintings and his prints, or between Serra's sculptures and his lithographic views of them). Among recent prints, many of the most intriguing have become purely optical, purely mental. But the possibility of such effectiveness, like that of *Ngetal* and *Yoyogi II*, depends on absolute technical perfection, that is, on the clarity and transparency of every color, shape (including the shape of lines), and texture.

■ *The Eighties: The New Figuration, the Return of the Woodcut, and the Rise of Painterly Expressionism*

Not every major work of the last few years has demanded or utilized the extraordinary technical capabilities of contemporary printers. Philip Guston's Gemini prints, begun only in 1979, are almost entirely crayon drawings—transfer lithographs executed with the expertise of Gemini craftsmen to preserve the heavy, deliberate, and slightly clumsy character of Guston's line.[98] Together with a few works by a handful of artists—Nicholas Africano, Kim MacConnel, Jonathan Borofsky, and Susan Rothenberg—they introduced a surprising new narrative strain into printmaking. They satisfied a deep yearning for a return to palpable content rather than mere figuration. For too long the print world had seemed mired in an obsessive concern with good printing, tactile surfaces, and slick design, whether abstract or representational. The older, usually Expressionist subjects appeared tired and cut off from life (the inevitable process of academicism). Where was the human content? It was not to be found in the clichéd forms of Surrealism or in the highly personal but traditional languages of David Iskawich, Peter Milton, or even Dennis Corrigan, despite their charm and humor.[99] At the same moment, the heavy-handed but symbolically sparse and nearly cryptic mythologies of German artists were just beginning to be translated into print media.[100] Even R. B. Kitaj had abandoned his arcane, historically rich screenprints

Figure 7. Philip Guston (1913–1980). Elements, 1980. Lithograph. Reproduced courtesy the Mount Holyoke College Art Museum, South Hadley, Massachusetts, Gift of Renee Conforte McKee

because he now felt that their near-total dependence upon ready-made materials and photographic processes made them profoundly inferior to drawing, to what could be evoked by the hand. Much of the new narrative interest, in fact, blossomed as an equal partner to the new emphasis on drawing, one that far outdistanced the attempts of the earlier seventies.

In some way, Guston must have felt this same compunction, for his lithographs convey a groping for meaning, a weightiness of purpose (like Serra's insistent impastos), and, above all, an imagery of pathos, humility, and struggle that is at once totally personal and totally universal (figure 7). The works were remarkably consonant with Guston's forms and themes of the thirties and yet somehow magically contemporary. Stripped down to bare essentials, their dreamlike imagery made a more direct appeal than any of the media-analysis, conceptual-abstraction, or physical-process pieces that had held center stage for the past twenty years. Ironically, they did preserve an element of popular, almost comic-book style, but one no longer cleaned up and streamlined. Guston's solutions were brilliant and moving because he was able to invent meaning rather than style or technique. His images of heads, shoes, rocks, nails, coats, and trousers, which had already appeared in his paintings of the late sixties, were drawn with a line that was conceived of the same humble and unsophisticated impulses as the subjects themselves. In short, Guston's lithographs hammered the final nail into the coffin of media studies.

Emphatically personal references have continued to emerge in the art of the last ten years. In 1980 Brooke Alexander made a decisive sea change, departing from his established course of publishing Realists. His new tack included exhibiting and then publishing works by some of the most innovative narrative Expressionists of the day.[101] By 1982 the new art had clearly invaded the print world, especially in the guise of the woodcut.[102] The woodcut revival was another instance of technical revisionism, a last gasp of media consciousness. Without doubt, it was the last printmaking technique to be reexplored.[103] The woodcut represented a return to a taste for primitivism, to a medium that often spawns a language that is direct, simple, fresh, honest, anti-illusionistic, and redolent with traces of the very first centuries of printmaking, with

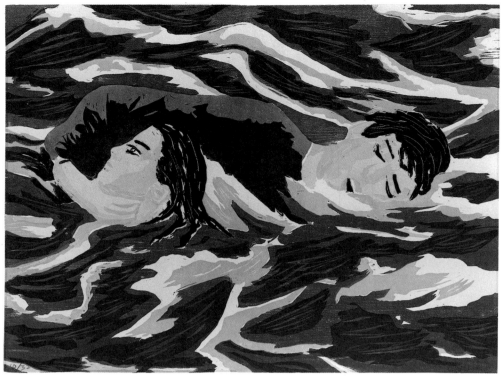

Figure 8. Richard Bosman (b. 1944). The Rescue, *1983–84. Woodcut. Reproduced courtesy Yale University Art Gallery, New Haven, Connecticut, Fleischer Fund*

the mysteries of the Symbolists, and with the anguish of the Expressionists. In that sense, it parallels Guston's strivings after direct, gut-felt communication. The woodcut is also a medium of the night world in which such artists as Paul Gauguin, Edvard Munch, and Ernst Ludwig Kirchner, or Richard Bosman, Louisa Chase, and Susan Rothenberg can bare their souls, their unconsciouses. In the world of prints, the woodcut was one of those marketplace conspiracies that actually coincided with recent art's profound shift away from the polished, highly impersonal prints of the previous twenty years.[104]

Typical of Bosman's work is *The Rescue* of 1983–84 (figure 8), with its overtones of the high drama of Théodore Géricault and Eugène Delacroix,[105] its recollections of the handling of woodcut by the German Expressionists,[106] its allusion to contemporary pulp novellas and popular illustration,[107] and its recollection of the painterliness of Willem de Kooning's Abstract Expressionism. As was the case with Bartlett's *Graceland Mansions* woodcuts, the medium is worked to leave evidence of the artist's struggle against its

physical resistance. In Bosman's hands, this struggle may become an analogue for the life-threatening situation depicted. As was so often the case with Lichtenstein's comic-book scenes, the drama unfolds for someone else; the viewer remains a bystander, without a clue to the artist's emotions. As in Guston's work, it is the clumsiness of form that suspends pathos and achieves for the image a measure of dignity. Thus, even in their return to art's expressionistic and narrative roots, Bosman and his American counterparts often perpetuate the emotive distancing of an older generation. The viewer's ever-smoldering desire for interpretation and participation is held at bay with both humor and an underlying seriousness. One senses a telling contrast with the art of the previous generation, for instance, between the assurance of Alex Katz's suave aquatint *The Swimmer* of 1974 (figure 9) and the inarticulate desperation of Bosman's woodcut swimmers, caught in the choppy wooden seas of 1983–84.

While many avant-garde American and European artists have taken up the woodcut since 1980, most have followed too literally

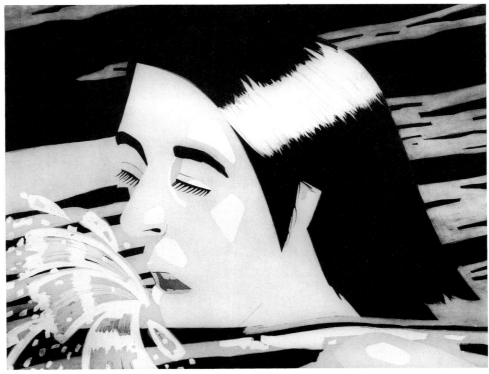

Figure 9. Alex Katz (b. 1927). The Swimmer, *1974. Aquatint on German etching paper. Reproduced courtesy Brooke Alexander, New York*

the lessons of their German Expressionist forebears. In the hands of Anselm Kiefer, Georg Baselitz, Roger Herman, Brad Davis, Jim Dine, Richard Mock, and many others, there remains a strong residue of the wish to associate anguish of execution with the subject portrayed. This is even true of Bosman's work, despite his efforts to operate at some emotional remove from his subjects. But there are others, often far more original and contemporary, who have found alternative ideas for the woodcut, never much removed from its basic language, but somehow more formalistic, painterly, or optical. If we do not venture all the way back to Josef Albers's still-fascinating woodcuts of the 1930s and 1940s, the most fundamental contributions were made by the painterly surfaces Helen Frankenthaler brought to the technique.[108] The moving accomplishment of her woodcuts was the total amalgamation of color with surface and space. Through a most subtle manipulation of the grained, stained, shaped, and incised planes of the mahogany planks with which she printed, Frankenthaler achieved a reification of color that rivaled anything previously achieved in printmaking, including the very different but equally moving surfaces of Motherwell's *A la Pintura* of 1968–72 (printed, as were Frankenthaler's works, at ULAE). The image in *East and Beyond* (colorplate 21) is essentially that of the mirror, the sawed, marked, and colored plank of mahogany plywood reflected in the soft texture of the handmade Napalese paper. The forms hover in this glowing optical illusion, perpetually resisting all figure–ground readings while remaining completely aloof from two-dimensional flatness. If anything, the optical sensuality of Frankenthaler's woodcuts succeeded more than her stain paintings in freeing color from its representational or relational functions.

Frankenthaler's sensuous example may have inspired younger artists like Susan Crile, Louisa Chase, and Judy Pfaff, all of whom are also indebted to the decorative trends of the seventies. Although some of Susan Crile's works were mentioned in the context of American landscape printmaking, their fusion of deep space with the flat, decorative aspects of pattern-painting and eventually with the literal directness of the woodcut brings her much closer to

the Conceptually grounded Realists of the eighties. With a proclivity—similar to Mangold's and Bartlett's—for gentle spatial dislocations and for subtle conjunctions of materials and imagery, Crile's lithographs and woodcuts manifest a growing tension between the topographic or naturalistic and the abstract. Her earlier abstract work, such as the lithograph *Expansion* of 1981 (colorplate 16), owes as much to Matisse's color cutouts as to Frankenthaler's color shapes. Crile's combinations of curvilinear and angular shapes are nuanced in a very personal manner—subtle tensions between convex and concave that continue to operate on the viewer in woodcuts like *Renvers on Two Tracks* (colorplate 14). Though far less rigorous and programmatic than Bartlett's garden views, Crile's recent landscape woodcut *Buskirk Junction* (colorplate 15) also shuns a definable style in favor of a more subtle personal signature: only the expanding and contracting curvilinear rhythms suggest the artist's identity. Otherwise, her task is one of tempering flat abstraction with the carefully controlled, atmospheric sensuousness of the brown-printed grain and the few deftly chiseled details, which are neither gesture nor description but a combination of both. As with so many of the prints under consideration here, the viewer is pulled into close contact with the formal elements, only to realize that another view is possible.

Consider for a moment the contrast such a work makes with the highly structured prints of Richard Estes. His city reflections are assertively illusionistic, yet totally Modernist in the insistent flatness of the forms of which they are composed. Unlike Crile, Estes seeks an aggressive confrontation with and control over the viewer, locating him or her within the space of the picture. The means of printmaking are clearly discernible yet breathtaking in their almost Cubist fluctuations. One senses an artist operating within clearly defined boundaries of style and content. In the works of Crile and Mangold, on the other hand, such matters are handled more suavely; above all, the junctions between form and content are far less abrupt. Coming a decade later, their work is free of conventional habits peculiar to a particular medium, and, by extension, there are no traces of commercialism, either in the appeal to near-photographic illusionism or in the use of manmade, urban subjects. Whereas Estes' prints examine the substance of art through the nature of reflections, Mangold's and Crile's works pose similar questions through reflection on the natural world.

The first woodcuts executed by Louisa Chase varied between interior, cavelike forms and great panoramic auroras, the former emphasizing the more linear, decorative tendencies, the latter the coloristic trends of the seventies. More recent works like *Chasm* and *Red Sea* of 1983 (colorplate 13) are filled with Gustonesque mythological forms and signs of a formal and spatial simplicity that is totally consonant with the primitivism of the medium. But Chase's primitivism, including the fragmentation of the human body, is mitigated by the flowing, curvilinear qualities of her forms and spaces (settings that distinguish her immediately from such Italian colleagues as Mimmo Paladino, who leans toward an iconic use of signs and an ex-votolike distribution of his fragments). The power of these large woodcuts does reside in their scale, but their intrigue derives from Chase's clever ploy of defusing mystery and foreboding with playful graphic marks and sonorous color. How desperate are these drowning figures? How threatening are the singly and doubly voluted waves? How much primitive dread can one infuse into a scene whose basic language is composed of transparent color scribbles and hatchings?[109] Despite the element of play in her images, Chase senses that it is in the process of her work that she finds and locates her intentions. In fact, few artists have as clearly expressed their recognition that the meaning of their imagery is so informed by the physical facts of its creation: "The physicality of the work, of the gesture, is so much closer to the uncontrollability of the feeling than a symbolic depiction."[110]

Judy Pfaff, who has only just begun to make prints, was one of the artists who participated in the Japan project, in which Crown Point Press sends Americans to Japan to work in concert with craftsmen steeped in the traditions of the Japanese woodcut.[111] Once again artists chose to appropriate and exploit the skills of others, in this case—significant for the eclecticism of the 1980s— the historical tradition of Japanese *Ukiyo-e* prints. Some artists simply accepted the translation by other craftsmen of a gouache modello onto woodblocks, while others intervened personally in the printing, to the degree they felt necessary. For Pfaff the sculptor, *Yoyogi II* (colorplate 44) appears to have been born of the same impulses as her "drawn," three-dimensional constructions. She has forced the wood to yield to the same painterly and spatial ideas as do her sculptures, blending her own sensibilities with those of the craftsman. With the possible exception of Wassily Kandinsky's *Kleine Welten* woodcuts of 1918, few color-woodcut undertakings equal Pfaff's in complexity or density. Her monumental image (though not at all on the scale of a Roger Herman or a Georg Baselitz) is teeming with pictorial activity. If *Yoyogi II* is a throwback to the excesses of the CoBrA group (Karel Appel, Pierre Alechinsky, and their circle), the artist has imposed a new sense of order, control, and structure on the unbridled impastos of the

1950s. This she has accomplished by her utilization of the slight slowness or awkwardness of the woodcut forms, and her invocation of an explorable, but wholly empirical space.

Such a variety of hard and soft forms was not confined to Pfaff's woodcuts, but was an aspect of that bravura approach to technique that characterizes so much recent printmaking. Francesco Clemente's three woodcut portraits (also part of the Crown Point Press Japan project) appear so like watercolors that howls of "reproduction" have resounded from many conservative quarters. The fact is, however, that they bring into focus a fairly frequent occurrence in recent printmaking: the execution of works in one medium that seems to rival another. Take, for example, many of the prints executed by Jennifer Bartlett, Susan Rothenberg, and others in the years around 1980. They challenged the whole notion of media identity, bending aquatints to do more precisely the kinds of washes heretofore confined to lithography, comparing the marks of screenprinting to those of the woodcut, and building up unheard-of complexities of texture, from Freckelton's pochoirs (as opposed to lithographs) and Nancy Graves's etchings to Frankenthaler's *Cedar Hill* (colorplate 22, also executed in Japan as part of the Crown Point project). The denial of the expected is one of the subversive principles of advanced art. And printmaking of recent days has embraced the development of an extraordinary eclecticism, which not only surpasses, but also departs from its prototypes. In a reversal of the trends of the sixties and seventies, which strove so hard to contrast the equal but different identities of handmade, hand-printed, and technologically produced marks, recent work has often sought to obliterate those differences for all but the most sensitive observers.

Aside from the ultrarefined woodcut techniques of Clemente's untitled *Portrait*, its ability to function as an apparition—ghostly, neurotic, and impingingly Mannerist—marks it as a work of recent times. "Mannerism" is used here in the sense of involuted and hyper-refined (the flesh almost dissolves into pools of color before our eyes), as well as self-consciously eclectic (vaulting over the most recent styles to the distortions of Francis Bacon or the self-flaying images of the German Expressionists). How distant seem the cool portraits by Katz, the media portraits by Warhol, or the analytic heads by Chuck Close! The idiosyncratic, personal quality of Clemente's work is akin to that of many recent European Neo-Expressionists such as Sandro Chia, Mimmo Paladino, Jörg Immendorff, and Enzo Cucchi, all of whom adapt a private iconography to an art that has moved away from *de rigueur* flatness and sometimes from a definable style. But there are distinctions to be made, perhaps from an admittedly American viewpoint. A Paladino etching, for example, seems totally eclectic, deriving its classical linearism and floating figures from William Blake's engravings, Odilon Redon's lithographs, and other conservative sources. His work represents a total abandonment of Modernism in any form and easily satisfies a craving for a new Symbolism; the same might be claimed for Chia's prints.

Another aspect of recent Mannerism is its self-conscious Expressionism. Few women painters or printmakers have adopted the obviously primitivizing figuration of the Italian and German Neo-Expressionists.[112] Although Rothenberg flirts with it, her images never really dominate the pictorial languages in which they are couched. But Joan Snyder is an exception. Her work is filled with images recollecting the drawings of children, the untutored, or the insane. The color lithograph *Can We Turn Our Rage to Poetry?* (colorplate 59) is replete with naive scribbles, bold stick figures, and abstract passages from fifties printmaking. So clearly is it conceived in two halves that the viewer's quest for interpretation is validated, though one would be hard put to find a narrative reading. Rather, it is in the transmutation of a painterly fifties style, tapping its inherent emotionalism, that Snyder conjoins her signs and words. Her reliance on older, painted and painterly formulations of the fifties is even clearer in her woodcuts, such as *Things Have Tears and We Know Suffering* (colorplate 57). As Ruth Fine has pointed out, there is a conjunction of the tactility of the cutting, the impastos of the applied color, and the implied primitive intimacy of touch (rather than sight) in the nursing infant's relationship to its mother's breast.

Rothenberg's images do not deal with such explicitly universal themes. Ironically, however, her deeply disturbing mysteries seem less arbitrary. This is the case because her figures, which make even deeper allusions to Abstract Expressionism's painterly and mythic character, appear to spring directly and without mediation from her surfaces. The viewer is not confronted with a plethora of pseudonarrative symbols, but is made to feel, as Clifford Ackley observed, that the images emerge from the substance of the materials, that they are inextricably related to the artist's physical activity, much as was the case with Richard Serra's lithographs (figure 10).[113] This felt connection with the physical act and Rothenberg's willing incorporation and shaping of chance are mainstays of the best American printmaking of the past quarter century. Such values are the legacy of Abstract Expressionism and have, in one way or another, remained a constant touchstone throughout a period of rapid stylistic and psychological change. As have her con-

Figure 10. Richard Serra (b. 1939). Circuit, *1972. Lithograph. Reproduced courtesy Gemini G.E.L., Los Angeles*

temporaries Terry Winter, Donald Sultan, and Elizabeth Murray, Rothenberg actively seeks analogies in lithography, aquatint, and even woodcut to the surfaces she achieves in her paintings. And despite the bold potency of her imagery—horses, bones, spectral heads and beings—Rothenberg's consummate ability to draw these figures out of her materials makes her an exceptional print-maker. Because Americans do not have a longstanding, historically conditioned prejudice that views printmaking as a craft devoted to the repetition of imagery, they approach the task far more directly: the materials must yield their own solutions to artistic demands, rather than simply translate or, worse, replicate an idea by means of preordained codes. Thus a Rothenberg woodcut like *Head and Bones* of 1980 (colorplate 53) emits an uncanny phosphorescence in which the image floats in the medium, part white, part black, but always suspended behind a painterly veil of irregularly chiseled white marks. Of all recent artists working in wood, she has best been able to reach back to the elemental aspects of the night world of Gauguin's and Munch's Symbolist woodcuts. She has under-stood that the fluidity of their forms corresponds to an inner

irrationalism, that the veil of softly defined flecks of light relates to the underworld, the past, and the primitive—that is, the uncon-scious.[114] In a similar manner, Rothenberg's aquatints, which con-sist of such soft, translucent surfaces, surpass all expectations of the medium, conjuring a world of painterly marks foreign to the print lover. These prints are not just feats of technical mastery, but unique and uncategorizable, vastly different from those of past generations.[115]

In her newest prints from ULAE and Gemini, Rothenberg's imagistic drawing reaches heroic proportions. Nevertheless, there are subtle limits to the role she permits that imagery to play. In part it is a matter of Rothenberg's own sensibilities and intentions: she has no inclination to articulate her meanings through Neo-Expres-sionist signs or symbols. The figuration of works like *Breath-man* (colorplate 54), *Boneman*, or *Stumblebum*, all of 1986, is still felt to be merged with the ground, somehow impalpable and suspended as if it were a figment of the imagination. But there may well be another factor, that is, a deep reluctance to identify totally with a single idea, style, or process. I think it characteristic of most

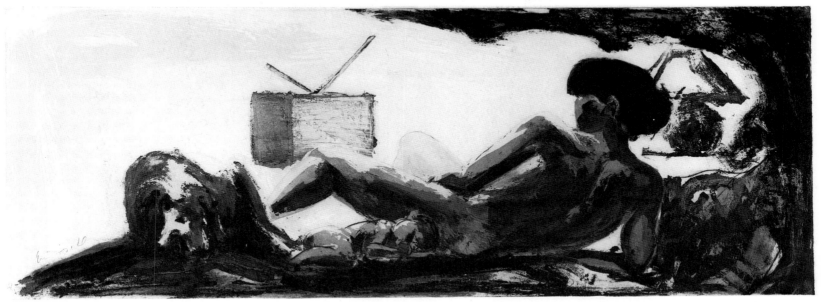

Figure 11. Eric Fischl (b. 1948). Untitled, *from* Floating Islands, *1985. Aquatint. Reproduced courtesy Yale University Art Gallery, New Haven, Connecticut, Fleischer Fund*

women artists, at least those we have chosen to discuss here, to prefer a middle ground, a gentler art not committed to the extreme positions that one finds, for example, in Pollock's drips, Johns's flags, Warhol's photographs, Serra's plates, LeWitt's instructions, Bochner's stones, or Julian Schnabel's anguish. Even at her most comparative, Jennifer Bartlett is both lyrical and unwilling to impose a single stylistic position. And even at her most tortured, Rothenberg refuses to inflict a definite emotional message. She and many of her colleagues prefer to return to that enduring Symbolist (and Postmodern) principle: that to suggest is better than to name. An art that clothes its ideas in sensuous form gives full reign to the viewer's imagination.

■ *Conclusions*

The single most apparent irony of this book is its timing, namely that it appears at the end of a period of considerable upheaval in the art world. Recent Neo-Expressionist art has more than diminished the luster of the artists shown here; it has stolen the limelight and obscured their contributions. And it has done so in precisely the manner of the American male—through self-promotion, self-exposure, confrontational stance, and highly identifiable style. Although much of the new art is exciting, original, and moving, it is also the result of a power play, one that reaches back to the mythic residues of Action Painting and Pop art. The resulting art has a distinct flair for brutal contrasts within the confines of a single work.

Robert Longo's Men of the City lithographs, for example, consist of large, single figures whose simple techniques—photographic and hand-drawn structures—and seemingly popular sources owe enormous inspiration to Warhol's work of twenty years ago. That Longo uses photographs as a basis for his work and commercial artists as his hands, and often contrasts drawn with silhouetted passages, links him strongly with the sixties. But where Warhol's photo–hand oppositions and banal sources totally screen out the artist's interpretations (as well as our own), Longo blatantly fuses extraordinary opposites (dance/torture; life/death) in a similar deadpan, commentaryless structure. Eric Fischl's myths

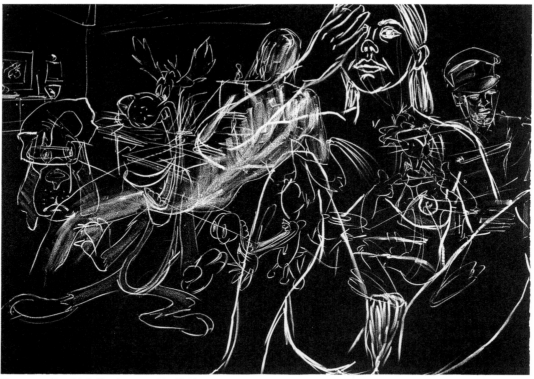

Figure 12. David Salle (b. 1952). Until Photographs Could Be Taken from Earth's Satellites. *Aquatint. Reproduced courtesy Mary Boone Gallery, New York*

are less exacerbated but similarly jolting. In his two portfolios of color aquatints, *The Year of the Drowned Dog* and *Floating Islands* (see figure 11), Fischl fuses fragmented, threatening narratives, taboo subjects, and ingratiating allusions to idyllic painters of the past—Giorgione, Velázquez, and Gauguin, for example. In what should be regarded as an archetypical strategy—as a central content, even—of recent American painting, the viewer is drawn by Fischl's beautiful surfaces and historical allusions only to be distanced by his allegedly ominous or sordid subjects.

David Salle, too, utilizes vast borrowings from popular, lowbrow, or pornographic imagery. Whereas his paintings exploit the most disjunctive kinds of side-by-side juxtapositions, the prints layer images in multiple, often transparent deposits, so that their complexities recede into depth. His portfolio of aquatints *Until Photographs Could Be Taken from Earth's Satellites* (figure 12) is more lyrical than many of the paintings because it offers such complex readings. The perception of figures printed one over another stimulates comparable layers of historical and cultural associations in

the viewer's mind. Such thoughts do not occur serially, as Salle knows, but in a continuous unfolding of superimposed meanings; in the prints space becomes the visual analogue for thought itself. In fact, the complex experience of Salle's interlaced fantasies is not at all dissimilar to the more purely formal and sensuous readings associated with Rockburne's *Locus* series. But Salle splits the viewer's reactions further; he aims to stretch classical unities as far as possible, by subverting our expectations of pictorial and moral decorum.

Ironically, the originality of these new works may owe a sizable debt to the tendencies staked out by many of the women included in the present book. It was they who insisted on the relevance of subject matter, especially landscape and still life (less frequently the figure). It was they who steadfastly opposed the systematic, abstract, and illusionistic techniques of the sixties and early seventies in favor of personal narrative and feeling (understated, to be sure). For style and technical bravura, they substituted a point of view that often nudged the viewer into closer psychological proximity

to the work. Their appreciation for the Modernist surface was more haptic than visual, up to and including the reification of color (Freckelton and Frankenthaler), just as their images clearly explored the textures and materials of both image and means (Dickson, Celmins, Crile). Even Rockburne and Bartlett at their most Conceptual can never forget the intimate appeal of touch. This same simultaneity of near and far operates not in disjunctive modes that create a sense of tension (Estes and Johns, for example), but in modes that are mutually reinforcing. Jacquette, Graves, Campbell, Mangold, Pfaff, and Rothenberg explore the meanings of superimposed forms and spaces.

While one cannot demonstrate that the woman artist of the early 1970s was more inclined to borrow from the past than her male counterpart, it was an attitude that went hand-in-glove with her desire for independence from straitjacketing stylistic categories. For some it led to the adoption of a blatantly feminine array of subjects and forms (à la Judy Chicago), but for others, like Frankenthaler, Freckelton, and Murray, that impulse was intuitively wed to the abstract, coloristic, or conceptual strands of contemporary art.[117] The most fundamental contribution of the feminist consciousness to recent painting and printmaking, however, was its undermining of the tyranny of the privileged style and, at times, media identity. The analytic and systematic emphasis so typical of the male-dominated art scene was deliberately sabotaged by the intuitive and the haptic, but also by the conscious denial of stylistic hegemony (in Bartlett, above all). Where the male artists of our day have adopted polarized attitudes in their exploration of art making, oscillating between analytic and systematic approaches on the one hand, and expressive and mythic involvements on the other, most women artists have chosen neither extreme and have sought a middle ground, forging their own universally appealing solutions. It could even be claimed that whereas the men revel in the conflicts generated by contrasting pictorial elements, the women are frequently more subtle and less addicted to a strategy of public confrontation. As Freilicher observed, the pursuit of consciously original style was felt to be foreign to the best interests of art; certainly it was one that numerous women have found less compelling and less the source of truly moving and beautiful art.

It is no wonder, then, that so many of the artists presented in this book have persisted in the vein of personalized and softer abstraction—more painterly drawing than formal painting—often with strong overtones of naturalism. Their work embodies the relationship that had always existed between Abstract Expressionism and landscape painting, between the inner and outer worlds of nature.[118] Without question, many of these developments coincided with Barbara Rose's predictions for painting of the eighties: an art born of inner vision, somehow carrying on the traditions of a lyrical abstraction (Abstract Expressionism stripped of its macho associations) that traced its roots back to the fifties and had appeared as an undercurrent throughout the sixties.[119] But is not this wistful return to the fifties at best only one aspect of the art of our times? While it does inform much recent printmaking, it totally overlooks the continued conceptual, narrative, and expressionistic underpinnings of the most vital painted and printed work of recent years. It has been the particular task of women, moreover, to confront what must still be regarded as a fundamental American, if not universal, problem: the anxiety born of our essential dualities. Pat Steir perhaps best defined how this condition affected American painting when she wrote, "Separation between thinking and emotion is a stupid person's way of defining the way things are."[120]

NOTES

■

1. I prefer this British term to the two American designations. "Silk-screen" is acceptable, but it implies the use of a silk fabric. While bolting cloth (fine silk used to sift flour) was in fact used during the early days of the medium, probably through World War II, print-makers currently use a variety of synthetic fabrics. The neologism "serigraph," coined by Carl Zigrosser and others in 1940, is a particularly dated term that cannot be used in our context. It was specifically invented to distinguish between so-called fine-art screen-prints (conceived and hand executed by the artist in a limited edition) and commercial productions, with their large runs and use of work-shop techniques and mass-production methods—above all, photo-graphic stencils.

2. A great many national and international exhibition catalogues have documented the historical printmaking background against which this essay is set. These include those of the National Print Annual Exhibitions at the Brooklyn Museum (1946 to the present), the two nationally circulated exhibitions "American Prints Today" (1959 and 1961), and the prominent juried exhibitions at Bradford, England; Fredrikstad, Norway; Grenchen, Switzerland; Ljubljana, Yugoslavia; Paris; Santiago, Chile; San Francisco; The Hague; Tokyo; and Turin.

3. William M. Ivins, Jr., *Prints and Visual Communication* (Cambridge, Massachusetts: M.I.T. Press, 1953).

4. Ernst H. Gombrich, *Art and Illusion: A Study in the Psychology of Pictorial Representation* (London: Phaidon, 1960).

5. Conservatively resolved in this country by the publication, under the auspices of the Print Council of America, of Carl Zigrosser and Christe Gaehde's *A Guide to the Collecting and Care of Original Prints* (New York: Crown, 1965). The point of view there advanced was that the "original" print must derive from a surface that had been worked in its entirety by the artist, without recourse to other craftsmen or processes. While it was conceded that the artist might employ a printer to pull the edition, that edition had to be a limited one, regardless of the process employed. The great sin was the use of photography or any photographic techniques.

6. Duchamp's ideas on "completion" were germane to many discussions in the fifties concerning how artists determined when their works were finished. His short lecture entitled "The Creative Act" is published in Gregory Battcock, ed., *The New Art: A Critical Anthology* (New York: E. P. Dutton, 1966), 23–26.

7. Such a complete view of recent printmaking is not yet really feasible, in any case. Nevertheless, the following books, taken collectively, provide a reasonable overview: Gene Baro, *Thirty Years of American Printmaking* (New York: The Brooklyn Museum, 1977); Pat Gilmour,

The Mechanised Image: An Historical Perspective on Twentieth Century Prints (London: The Arts Council of Great Britain, 1978); Frances Carey and Antony Griffiths, *American Prints, 1879–1979* (London: The British Museum, 1980); Riva Castleman, *Printed Art: A View of Two Decades* (New York: The Museum of Modern Art, 1980); Judith Goldman, *American Prints: Process and Proofs* (New York: Harper and Row, 1981); Andrew Stasik, ed., *American Prints and Printmaking, 1956–1981*, issued as *Print Review 13* (New York: Pratt Graphics Center, 1981); James Watrous, *A Century of American Printmaking* (Madison: University of Wisconsin Press, 1984); Riva Castleman, *American Impressions: Prints since Pollock* (New York: Alfred A. Knopf, 1985); Alexander Dückers, *Von Beuys bis Stella* (Berlin: Staatliche Museen Preussischer Kulturbesitz, 1986); and Clifford S. Ackley, *70s into 80s: Printmaking Now* (Boston: Museum of Fine Arts, 1986). So far as the present author is aware, only two exhibitions have been devoted to surveying prints by women: Judith K. Brodsky and Ofelia Garcia, *Printed by Women, A National Exhibition of Photographs and Prints* (Philadelphia: The Port of History Museum at Penn's Landing, 1983); and Susan Teller, *Prints by Women* (New York: Associated American Artists, 1986).

8. Best described in Susan Sontag's *On Photography* (New York: Farrar, Straus and Giroux, 1977).

9. One should not, however, forget the Surrealist photographers of the 1930s in Paris and Berlin. See Nancy Hall-Duncan, *Photographic Surrealism* (Cleveland: The New Gallery of Contemporary Art, 1979).

10. See Lawrence Alloway's account of the development of English Pop art in Lucy Lippard, *Pop Art* (New York: Praeger, 1966), 27–67.

11. Alan Kaprow, "The Legacy of Jackson Pollock, *Art News* 7:3 (October 1958), 24–26, 55–57.

12. It was in 1953 that Ivins wrote, "At any given moment the accepted report of an event is of greater importance than the event, for what we think about and act upon is the symbolic report and not the concrete event itself." (*Prints and Visual Communication*, 180). The interaction of reporting and printmaking has a long history, but the use of mass-media imagery in painting can be traced at least as far back as Manet's *Execution of Emperor Maximilian* of 1869.

13. See Rainer Crone, *Andy Warhol* (New York: Praeger, 1970). Despite my direct questioning of both artists (in 1970 and 1971), I have not been able to establish which of the two first utilized screenprinting stencils for painting.

14. I have placed special emphasis on this point in my recent catalogue, *Richard Hamilton: Image and Process* (London: The Tate Gallery and Stuttgart: Edition Hansjörg Mayer, 1983).

15. The two extant catalogues of Rauschenberg's prints are hardly up-to-date: *Robert Rauschenberg: Graphic Art* (Philadelphia: Institute of Contemporary Art, 1970), with an introduction by Lawrence Alloway; and Edward A. Foster, *Robert Rauschenberg: Prints, 1948/1970* (Minneapolis: The Minneapolis Institute of Arts, 1970).

16. On Johns's printed flags, see my article, "Jasper Johns' Flags," *Print Collector's Newsletter* 7:3 (July–August 1976), 69–77. Also *Jasper Johns: Prints 1960–1970* (Philadelphia: Philadelphia Museum of Art, 1970); and *Jasper Johns: Prints 1970–1977* (Middletown, Connecticut: Wesleyan University, 1973). Most of the other pertinent literature on Johns's prints is cited in the bibliography of Richard Francis, *Jasper Johns* (New York: Abbeville Press, 1984).

17. Leo Steinberg, "Other Criteria," in *Other Criteria* (New York: Oxford University Press, 1972), 55–91; and Douglas Crimp, "On the Museum's Ruins," in Hal Foster, ed., *The Anti-Aesthetic: Essays on Postmodern Culture* (Port Townsend, Washington: The Bay Press, 1983), 44–47.

18. Almost all artists incorporate serendipitous elements in their work. Two rather well-known examples are the fostering of sloppy printing in Warhol's earliest prints (see my "Contemporary Trends," in *Prints: History of an Art* [Geneva: Skira, New York: Rizzoli, and London: Macmillan, 1981], 203); and Rauschenberg's lithograph *Accident* of 1963 (see the recent exchange between Clinton Adams and Pat Gilmour in *Print Collector's Newsletter* 17:4 [September–October 1986], 138–39). See also John Loring, "Bad Printing," *Print Collector's Newsletter* 6:1 (March–April 1975), 1–3, 21.

19. The question of space, real and imagined, is complicated even further by the printing processes here. Note that the surface of the image is really like a mirror, pairing Johns's physical action on the stone (the real image known only through our imaginative reconstruction) with the printed marks transferred from stone to paper (the virtual image known only through our acceptance of the language of illusion).

20. By 1970 Eduardo Paolozzi had begun to include Modernist American painting in his collages, taking it to be as much a communicator of American culture as our advertisements, mass-produced ephemera, and toys. Fried's most exclusive statement was contained in his essay against Minimalism (and "theatricality"), "Art and Objecthood," *Artforum* 5:10 (Summer 1967), 12–23.

21. See Edward A. Foster, *Edward Ruscha: Young Artist* (Minneapolis: The Minneapolis Institute of Arts, 1972); and A. Boyle, *Graphic Works by Edward Ruscha* (Auckland, New Zealand: Auckland City Art Gallery, 1978).

22. For a discussion of contemporary uses of screenprinting, see my *Silkscreen: History of a Medium* (Philadelphia: Philadelphia Museum of Art, 1971–72); and "Silkscreen: The Media Medium," *Art News* 70:9 (January 1972), 40–43, 74–75.

23. The best articles on Lichtenstein's earlier works are still: Gene Baro, "Roy Lichtenstein: Technique as Style," *Art International* 12:9 (November 1968), 35–38; Richard Hamilton, "Roy Lichtenstein," *Studio International* 175 (January 1968), 20–24; Lawrence Alloway, "Roy Lichtenstein," *Studio International* 175 (January 1968), 25–31; and Diane Waldman, *Roy Lichtenstein, Drawings and Prints* (New York: Chelsea House, 1970).

24. One publisher, Dorothea Leonhart of Munich, did set out to make editions numbering in the thousands. Her productions of around 1970 included works by Richard Hamilton, Friedensreich Hundertwasser, Dieter Roth, and Peter Phillips. In the United States, Warhol published unlimited editions of his cow wallpaper.

25. Perhaps the most eye-catching and Modernist appropriation of commercial techniques was the so-called rainbow-roll, or blended inking. Its high-water mark was reached in Johns's *Numerals* of 1967, printed at Gemini G.E.L. As new and as daring as this invention appeared, it had been in use in commercial lithographic and screenprinting shops for many decades.

26. The story of various workshops has been told often. Many references will be found in Bruce Davis's short essay, "Print Workshops at Mid-Century," in Ruth E. Fine, *Gemini G.E.L.: Art and Collaboration* (Washington, D.C.: National Gallery of Art and New York: Abbeville Press, 1985). See also Joann Moser, *Atelier 17: A Fiftieth Anniversary Retrospective Exhibition* (Madison: Elvehjem Art Center, 1977); Gene Baro and Donald Saff, *Graphicstudio, U.S.F.: An Experiment in Art and Education* (New York: The Brooklyn Museum, 1978); and Pat Gilmour, *Ken Tyler—Master Printer—and the American Print Renaissance* (New York: Hudson Hills Press and Canberra: Australian National Gallery, 1986).

 Collaboration presents thorny problems. Leaving aside the many "traditional" printmakers who abhor the notion, the relationship between artist and printer can range from slavish to exploitive, to almost independent. Every artist of note has had to establish his or her special kind of collaborative relationship. See Garo Antreasian's major article on the subject, "Some Thoughts about Printmaking and Print Collaborations," *College Art Journal* 39:3 (Spring 1980), 180–88; and Pat Gilmour's two articles, "Symbiotic Exploitation or Collaboration: Dine and Hamilton with Crommelynck," *Print Collector's Newsletter* 15:6 (January–February 1985), 193–98; and "Thorough Translators and Thorough Poets: Robert Kushner and His Printers," *Print Collector's Newsletter* 16:5 (November–December 1985), 159–64.

27. It has not been sufficiently noted that the enormous interest in the history and collecting of photography followed hard on the heels of Pop art's media analysis.

28. For a view of the developing Formalist elements of Pop art, see Suzi Gablik and John Russell, *Pop Art Redefined* (New York: Praeger, 1969).

29. This phrase, "conceptualization of Realism," was coined by Philip Pearlstein as a title to a College Art Association panel discussion, January 1978. It is further elaborated in "Realism vs. Existentialism," *Allan Frumkin Gallery Newsletter* 5 (Spring 1978), 4–6.

30. On Pearlstein generally, see Russell Bowman, *Philip Pearlstein: The Complete Paintings* (New York: Alpine Fine Arts, 1983).

31. On the significance of Pearlstein's landscapes and their relation to works by Fairfield Porter, Jane Freilicher, and others, see Jeryldene Wood, *Interiors and Exteriors: Contemporary Realist Prints* (New Haven: Yale University Art Gallery, 1986).

32. See my essay in *Philip Pearlstein: Prints, Drawings, Paintings* (Middletown, Connecticut: Wesleyan University, 1979).

33. On Katz as a printmaker, see my and Elke Solomon's, *Alex Katz* (New York: Whitney Museum of American Art, 1974); and Nicholas P. Maravell, *Alex Katz: The Complete Prints* (London and New York: Alpine Fine Arts, 1983).

34. Few women artists have worked with the human figure, and fewer with the kind of confrontational portraiture that muted specific psychological readings by the use of competing pictorial devices (for example, Warhol, Alfred Leslie, Jack Beal, Katz, and Pearlstein). The few that did take up portraiture, however, were not at all interested in the formal or photographic conventions of recent paintings; rather, they sought to overturn the conventions of traditional portraiture: the male sitter clothed, particularized, and accompanied by social attributes; the female sitter nude, idealized, and inviting a more erotic examination. The tensions in the paintings of Alice Neel and Sylvia Sleigh, for example, were embedded in challenging these (male?) approaches. Nonetheless, so individualized were their portraits in both face and figure, and so conscious did their works make the viewer of looking, staring, and transgressing, that their images were unsuitable for so intimate (or so commercial) a venture as the print. See Linda Nochlin, "Some Women Realists," *Arts Magazine* 48:8 (May 1974), 29–33, for the most insightful commentary on recent feminist challenges to the conventions of portraiture.

35. These artists, largely women, included Blanche Lazzell, Ethel Mars, and Marguerite Zorach. See Janet Flint, *Provincetown Printers: A Woodcut Tradition* (Washington, D.C.: National Museum of American Art, 1983).

36. See Carter Ratcliff, "Yvonne Jacquette: American Visionary," *Print Collector's Newsletter* 12:3 (July–August 1981), 65–68, for a detailed discussion of Jacquette's methodical approach to making an image.

37. 1986 interview with Robert Doty published in Robert Doty, ed., *Jane Freilicher Paintings* (New York: Taplinger, for the Currier Gallery of Art, 1986), 50. Freilicher continues: "As a matter of fact, I don't think my paintings are very 'realistic.' They have references to things in nature, but they have their own objective life as paintings, not as imitations of other things."

38. Ivins's idea that syntax only resulted from the presence of perceptible marks and codes was now seriously challenged. For here were supposedly syntaxless, photographlike works that were nonetheless full of identifiable traits and attitudes. Could photography have a syntax? Was it really purely transparent truth, after all?

39. See *Photo-Realist Printmaking* (New York: Louis Meisel Gallery, 1978). Even less than Claes Oldenburg's offset lithographs have these works been taken seriously. Yet the supposed absence of syntax will one day, I am certain, be seen as a time-bound misperception. After all, it was at just this moment that Estelle Jussim's book *Visual Communication and the Graphic Arts* (New York: R. R. Bowker, 1974) appeared and pointed out the flaws in William Ivins's thesis that the photograph was an image without syntax (and thus a logical terminus to the road of reproductive printmaking from 1400 until the advent of photography in 1839). In contradistinction to the many thousands of color reproductions manufactured each year, the offset prints after Photorealist paintings represent a very special case. At their best they carefully replicate a work of art that might be called a careful replication of a slightly idiosyncratic photograph of a commonplace subject. While we argue only for a modest value, as objects these offset prints offer an ambivalence of purpose not entirely removed from the ambiguities in Jasper Johns's sculptured replications of the previous decade.

40. Contributing artists were Robert Bechtle, Don Eddy, Franz Gertsch, Ralph Goings, Richard McLean, Stephen Posen, John Salt, Ben Schonzeit, and Peter Staiger. See John Loring's criticism of this undertaking in "Photographic Illusionist Prints," *Arts Magazine* 48:5 (February 1974), 42–43.

41. Ten screenprints were executed by Editions Domberger of Stuttgart, West Germany, and published by Parasol Press, New York.

42. The sandwiching of the viewer (or artist) between depicted spaces offers strong parallels to Lee Friedlander's urban photographs of the same time. Ironically, however, it was Jim Dine's etchings that were paired with Friedlander's photos in a now somewhat forgotten portfolio entitled *Photographs and Etchings*, published by Petersburg Press, London, in 1969.

·43. Numerous experiments to probe the limits and essence of photographic meaning were carried out in the years around 1970. Perhaps the most esoteric analyses of photographic qualities were contained in John Baldessari's portfolios, such as *Raw Prints*, six color lithographs with collaged photographs, published by Cirrus Editions, Los Angeles, in 1976. Unfortunately, the relationship between art and photography during the sixties and seventies has not been adequately explored, but the reader is referred to Charles Newton, *Photography in Printmaking* (London: Victoria and Albert Museum, 1979); and George L. McKenna, *Repeated Exposure, Photographic Imagery in the Print Media* (Kansas City, Missouri: The Nelson-Atkins Museum of Art, 1982).

The enormous contribution of women to the making and the criticism of photographs is beyond the scope of both this essay and the Mount Holyoke exhibition. But I would be amiss not to mention at least that the confluence of text and image, assiduously cultivated in the art of the sixties and photography of the early seventies has deeply inspired many women photographers, such as Barbara Kruger. One thinks particularly of the example set by Duane Michals's haunting sets, which were composed of unassuming straight shots accompanied by very matter-of-fact texts. These texts, seemingly as dispassionate and removed as the photographic process is said to be objective and documentary, are incredibly charged emotional statements that activate the deadpan images. The importance of the personal, biographical, and emotional content of Michals's work of the seventies has rarely been acknowledged, much less regarded as a potent stimulus for more recent expressive painting and printmaking.

44. Carter Ratcliff, "Vija Celmins: An Art of Reclamation," *Print Collector's Newsletter* 14:6 (January–February 1984), 193–96, especially 194.

45. Carter Ratcliff, "James Turrell's 'Deep Sky,'" *Print Collector's Newsletter* 16:2 (May–June 1985), 45–47; Jacqueline Brody, "Robert Wilson: Performance on Paper," *Print Collector's Newsletter* 16:4 (September–October 1985), 117–24; and Gerrit Henry, "David True: Poetry as Print," *Print Collector's Newsletter* 16:4 (September–October 1985), 124–26.

46. The best overall surveys are still the essays gathered in Gregory Battcock's four anthologies, all published in New York by E. P. Dutton: *The New Art* (1966); *Minimal Art: A Critical Anthology* (1966); *Idea Art: A Critical Anthology* (1973); and *Super Realism: A Critical Anthology* (1975). See also Robert Pincus-Witten, *Postminimalism* (New York: Out-of-London Press, 1977).

47. On Process art of the late sixties, see in particular James Monte and Marcia Tucker, *Anti-Illusion: Procedures/Materials* (New York: Whitney Museum of American Art, 1969).

48. The best references are Paulette Long and Robert Levering, eds., *Paper: Art and Technology; The History and Methods of Fine Papermaking with a Gallery of Contemporary Paper Art* (San Francisco: World Print Council, 1979), a collection of sixteen essays and entries by various artists, publishers, conservators, historians, and critics; and Pat Gilmour and Anne Willsford, *Paperwork* (Canberra: Australian National Gallery, 1982).

49. See Lucy Lippard's refutation of this needless generality (one often adopted by women as well) in "Sweeping Exchanges: The Contribution of Feminism to the Art of the 1970s," *College Art Journal* 40:1/2 (Fall/Winter 1980), 362–65.

50. For an example, see Laura Mulvey, "Visual Pleasure and Narrative Cinema," *Screen* 16:3 (Autumn 1975), 6–18, reprinted in Brian Wallis, ed., *Art after Modernism: Rethinking Representation* (New York: The New Museum of Contemporary Art and Boston: David R. Godine, 1984), 360–73.

51. See Kenneth Frampton's essay on Postmodern architecture and the haptic sense, "Towards a Critical Regionalism: Six Points for an Architecture of Resistance," in Hal Foster, ed., *The Anti-Aesthetic: Essays on Postmodern Culture*, 16–30.

52. The intensely varied activities of Shields are chronicled in Howardena Pindell, "Tales of Brave Ulysses: Alan Shields Interviewed," *Print Collector's Newsletter* 5:6 (January–February 1975), 137–43.

53. Vivid accounts of Ken Tyler's involvement with paper are contained in Joseph E. Young, "'Pages' and 'Fuses': An Extended View of Robert Rauschenberg," *Print Collector's Newsletter* 5:2 (May–June 1974), 25–30; Judith Goldman, *Art off the Picture Press: Tyler Graphics Ltd.* (Hempstead, New York: Emily Lowe Gallery, Hofstra University, 1977); Judith Goldman, *Kenneth Noland: Handmade Papers* (Bedford Village, New York: Tyler Graphics Ltd., 1978); and Pat Gilmour, *Ken Tyler—Master Printer—and the American Print Renaissance*, 85–99.

54. See Jane M. Farmer, "Poems of Land and Sky," *Print Collector's Newsletter* 10:3 (July–August 1979), 77–79.

55. See William Wilson, "Michelle Stuart's 'Green River Massachusetts, Variations': The Mapping of Time, Place, and Season in Books without Words," *Print Collector's Newsletter* 8:5 (November–December 1977), 135–36; and Lucy Lippard, *Strata: Graves, Hesse, Stuart, Winsor* (Vancouver: Vancouver Art Gallery, 1977).

56. The same remark could be made of lithography and screenprinting. In each case, the techniques had continued to be practiced but, for the most part, in private by individually trained artists; others still journeyed to Paris to make lithographs or etchings. Each revival was accompanied by the growth of workshops on this side of the Atlantic, coinciding with the breakdown of the taboos against collaboration. The outstanding precursor was, of course, Stanley William Hayter's Atelier 17, which was located in New York during the World War II years and in Paris before and after. Prior to Hayter, Tatyana Grosman, and June Wayne, American shops like those of Charles White, George Miller, Anderson and Lamb, and Bolton Brown provided excellent but artistically limited, unexperimental opportunities to make black-and-white prints. On the rise of etching in the late sixties, see my *Recent American Etching* (Middletown, Connecticut: Davison Art Center, Wesleyan University, 1975).

57. Hockney's early etched set of *A Rake's Progress*, issued in 1961, was a bellwether of the new interest in this barest of media. See Andrew Brighton, *David Hockney: Prints 1954–1977* (Nottingham, England: Midland Group Gallery and Petersburg Press, 1979).

58. The exhibition had a catalogue, *Primary Structures* (New York: The Jewish Museum, 1966). On Minimalist printmaking see Naomi Spector, "Robert Ryman: 'Suite of Seven Aquatints,' 1972, and 'Nine Unique Aquatints,' 1972," *Bulletin 70: Art and Project* (Amsterdam: 1973); and "Robert Ryman: 'Six Aquatints,'" *Print Collector's Newsletter* 8:1 (March–April 1977), 10–12; Hugh M. Davies and Riva Castleman, *The Prints of Barnett Newman* (New York: The Barnett Newman Foundation, 1983); and Nancy Tousley, *Prints: Bochner, LeWitt, Mangold, Marden, Martin, Renouf, Rockburne, Ryman* (Toronto: Art Gallery of Ontario, 1976).

59. LeWitt's work is never very distant from Duchamp's *Notes from the Green Box* and its relationship to his *Large Glass*. The interaction of the printed word and printed imagery in recent art has given rise to only a smattering of writing. Yet its corollary, that verbal formulations affect our perceptions, is a given; it was one of the fundamental problems addressed by Minimalist art; see Barbara Rose, "ABC Art," *Art in America* 53:5 (October–November 1965), 57–69; and Harold Rosenberg, "Art and Words," *The New Yorker* (March 29, 1969), reprinted in Gregory Battcock, ed., *Idea Art*, 150–64.

60. It was Robert Feldman of Parasol Press, the major publisher of Minimalist prints in New York, who gave Rockburne, Martin, and Renouf an opportunity to take up printmaking.

61. See Elizabeth Broun and Jan Howard, *Form, Illusion, Myth: Prints and Drawings by Pat Steir* (Lawrence, Kansas: Spencer Museum of Art, 1983).

62. Remarkably interpreted in Bruce Boice's "The Axiom of Indifference," in *(toward) Axiom of Indifference 1971–73* (New York and Paris: Sonnabend Gallery, 1974); see also Brenda Richardson, *Mel Bochner: Number and Shape* (Baltimore: The Baltimore Museum of Art, 1976).

63. In the *Tractatus*. For further discussion see Rosalind Krauss, "Jasper Johns," *The Lugano Review* 1:2 (1965), 84–113; also, Rosemary Miles, *The Complete Prints of Eduardo Paolozzi: Prints, Drawings, Collages 1944–77* (London: Victoria and Albert Museum, 1977), 23–27.

64. While LeWitt, in his "Paragraphs on Conceptual Art," *Artforum* 5:10 (Summer 1967), 79–83, declared that "the idea becomes a machine that makes art," the most visible example of such an attitude emerged a bit earlier (and more ironically) in Jasper Johns's *Device* paintings of 1961–62.

65. See John Loring, "Judding from Descartes, Sandbacking, and Several Tuttologies," *Print Collector's Newsletter* 7:6 (January–February 1977), 165–68.

66. See Carter Ratcliff, "Dorothea Rockburne: New Prints," *Print Collector's Newsletter* 5:2 (May–June 1974), 30–32.

67. I am deeply indebted to Alexandra F. Castelli who, as a Yale undergraduate in my course on contemporary printmaking (1981), presented what I still regard as the single most accomplished essay on Rockburne's prints. The above-quoted phrase is hers.

68. See my and Daniel Rosenfeld's *Prints by Contemporary Sculptors* (New Haven: Yale University Art Gallery, 1982).

69. See my *Prints and Drawings by Lee Bontecou* (Middletown, Connecticut: Davison Art Center, Wesleyan University, 1975).

70. Serra's newer prints (for example, *Back to Black*, 1981) are equally assertive, reflecting the spatial disruptiveness of such site sculptures as *Tilted Arc* of 1981. Others—really multiples and not strictly prints—made from cast aluminum with paint-stick surfaces, derive from wall pieces that appear to penetrate from one real space to another (as in two floors of a building). See *Richard Serra at Gemini* (Los Angeles: Gemini G.E.L., 1981), a publication with a significant statement by the artist; and Melinda Wortz, "Richard Serra: Prints," *Print Collector's Newsletter* 17:1 (March–April 1986), 5–7.

71. See the very lucid descriptions in Ruth E. Fine, *Gemini G.E.L.: Art and Collaboration*, 99–101, 227.

72. Especially *Large Gray Curve*, an embossed screenprint of 1974, and *Wall*, an etching and aquatint of 1979; while the latter is Serra-like in form, its diminutive size and absolute perfection reflect a far more intellectual, premeditated approach. See Fine's description of Kelly at Gemini in *Gemini G.E.L.: Art and Collaboration*, 127–43.

73. Serra once told me that his first Gemini lithographs could hardly have been undertaken without his having first studied Johns's *Numerals* (also made at Gemini), which could be likened to a serialized inventory of lithographic marks.

74. The exhibition "Silkscreen: History of a Medium" at the Philadelphia Museum of Art in 1971 offered the full range of screenprinting before and after 1960. While a few photoscreens did contain gestural marks, the only painterly surfaces were those in prints of the fifties and earlier.

75. Carter Ratcliff wrote the introduction to the catalogue, which reproduced works by Marjorie Strider, Jack Beal, Richard Haas, Susan Hall, Sondra Freckelton, Enrique Castro-Cid, Janet Fish, Theo Wujcik, Neil Welliver, Red Grooms, Yvonne Jacquette, Bob Camblin, Billy Al Bengston, Edward Ruscha, Lowell Nesbitt, Susan Crile, James Boynton, Jorge Stever, John Dowell, Edward Moses, Jo Baer, Joe Goode, Richard Tuttle, Sylvia Plimack Mangold, William Clutz, and James Rosenquist.

76. As opposed to the Flags, which imposed structure on painterliness.

77. On Stella's prints, see Richard H. Axsom, *The Prints of Frank Stella 1967–1982* (New York: Hudson Hills Press and Ann Arbor: The University of Michigan Museum of Art, 1983); a revised edition, to be published by Hudson Hills Press, is now in preparation.

78. The three sections of *Scent* (1975–76) are lithograph, linocut, and woodcut, side-by-side, each section differentiated by subtle variations in texture and concealed repetitions of the overall pattern.

79. For example, prints by Grace Hartigan, Sam Francis, Robert Motherwell, Helen Frankenthaler, or Willem de Kooning.

80. The implied comparisons might well be with Johns's hatched prints, like *Corpse and Mirror* (screenprint, lithograph, and intaglio versions of 1975–76), and with a whole range of Stella's prints, from his first Black Series through the more flamboyant Eccentric Polygons, completed in 1974.

81. See Patricia Johnston, Hayden Herrera, and Thalia Gouma-Peterson, *Joyce Kozloff: Visionary Ornament* (Boston/Boston University Art Gallery, 1986); and Amy Goldin, "Pattern and Print," *Print Collector's Newsletter* 9:1 (March–April 1978), 10–13.

82. Owen Jones, *The Grammar of Ornament* (London: Day and Son, 1856). Was it purely by coincidence that just at this time in the late seventies, Ernst Gombrich was completing his own study of ornament, *The Sense of Order: A Study in the Psychology of Decorative Art* (Ithaca: Cornell University Press, 1979)?

83. See Amy Goldin, "Patterns, Grids, and Painting," *Artforum* 14:1 (September 1975), 50–54; and Rosalind Krauss, *Grids: Format and Image in Twentieth Century Art* (New York: Pace Gallery, 1979).

84. I am very much indebted to discussions with Judith Solodkin for clarifying my thoughts on this subject. Kushner, Kozloff, and Pindell all worked at Solo Press during the late 1970s.

85. For a most insightful conversation about these prints, see Jacqueline Brody, "Elizabeth Murray, Thinking in Print: An Interview," *Print Collector's Newsletter* 13:3 (July–August 1982), 74–77. I would also record my appreciation to a Yale undergraduate, Linda M. Greub, who, in the spring of 1981, interviewed Murray and wrote about these prints.

86. "Jennifer Bartlett: Prints, 1978–1983," *Print Collector's Newsletter* 15:1 (March–April 1984), 1–6.

87. One is reminded of the conceit of M. C. Escher's lithograph *Print Gallery* of 1956, in which a Möbius-style print engulfs the entire exhibition in which it hangs, the viewer included.

88. See Judith Goldman, "Printmaking: The Medium Isn't the Message Anymore," *Art News* 79:3 (March 1980), 82–85; and Ronny Cohen, "The Medium Isn't the Message," *Art News* 84:8 (October 1985), 74–80.

89. See "Printing Today: Eight Views," *Print Collector's Newsletter* 13:6 (January–February 1983), 189–200. Despite interesting aspects of this round-table discussion, the focus is decidedly parochial, concentrating on practical, financial, and ethical matters. Technical metamorphosis of media identity is an idea that does not rouse much sympathy in printers; for them, it is just another rung in the ladder to technical perfection.

90. Somewhat outside the scope of this essay but germane to the spirit prevailing at Tyler's, was Richard Hamilton's *Trichromatic flower-piece*, executed in 1981 in Bedford Village. The artist painstakingly (and perhaps compulsively) made four completely hand-drawn color separations—cyan, magenta, yellow, and black—of the sort required for a commercial four-color process reproduction. That they were executed in pure aquatint only increases the staggering accomplishment. Hamilton's print is no more a watercolor than it is an aquatint; it emerges as a hybrid of the two, as unexpectedly unique in its surface as it is troubling in its subject (see my essay cited in footnote 14, above).

91. See Gabor Peterdi, *Printmaking: Methods Old and New* (New York: Macmillan, 1959); and Stanley William Hayter, *New Ways of Gravure* (2nd ed., New York: Oxford University Press, 1966). The articles in the now-defunct annual *Artist's Proof* documented this trend in American and European printmaking particularly well.

92. Lichtenstein, Stella, Ken Price, and Kelly, for example, employed various combinations of screenprinting, lithography, and embossing in the early seventies.

93. See Mason Riddle, "Steven Sorman: New Monoprints and Variant Editions," *Print Collector's Newsletter* 16:1 (March–April 1985), 11–12; and Pat Gilmour, *Ken Tyler—Master Printer—and the American Print Renaissance*, especially 80–134.

94. A very important stimulus was provided by three major exhibitions and their catalogues: Eugenia Parry Janis, *Degas Monotypes* (Cambridge, Massachusetts: Fogg Art Museum, 1968); my *Paul Gauguin: Monotypes* (Philadelphia: Philadelphia Museum of Art, 1973); and Colta Ives et al., *The Painterly Print: Monotypes from the Seventeenth to the Twentieth Century* (New York: The Metropolitan Museum of Art, 1980); and the example of artists like Matt Phillips, Michael Mazur, and Mary Frank, among others.

95. Clifford S. Ackley, "Frank Stella's Big Football Weekend," *Print Collector's Newsletter* 13:6 (January–February 1983), 207.

96. It still remains to judge the real import of Frank Stella's most recent work: whether his printmaking will remain the moving accomplishment we consider it or whether it will not be perceived as a kind of metaphor for American corporate success—a machismo based on large scale, sumptuous color, simple, bold forms, machinelike structures, and a quasi-mechanical method of perpetuation and fabrication. For a probing attack on Stella's constant recycling of motifs into ever grander and more grandiose productions, see Carter Ratcliff's acerbic article, "Frank Stella: Portrait of the Artist as an Image Administrator," *Art in America* 73:2 (February 1985), 94–106.

97. See Stephanie Terenzio, *The Prints of Robert Motherwell*, with a catalogue raisonné by Dorothy Belknap (New York: Hudson Hills Press and the American Federation of Arts, 1984); and Barbara Rose, *Joan Mitchell, Bedford Series* (Bedford Village, New York: Tyler Graphics Ltd., 1981).

98. See the three pamphlets, all entitled *Philip Guston*, issued by Gemini in 1980, 1981, and 1983, the first with an essay by John Coplans, "The Private Eye of Philip Guston," n.p.

99. Among other American printmakers who struggled with the problem of content in the later seventies, the following might be mentioned: David Barker, William Weege, William Heydt, William Walmsley, William Wiley, Mark Leithauser, Kenneth Kerslake, and Warrington Colescott.

100. See Dorothea Dietrich-Boorsch, *German Drawings of the Sixties* (New Haven: Yale University Art Gallery, 1982) for the first American text to take up the emergence of a new German art in the sixties. Also see Alicia Faxon, "German Expressionist Prints: A Persistent Tradition," *Print Collector's Newsletter* 14:1 (March–April 1983), 3–4; Alfred Kren, "Aspects of German Prints after 1945," *Print Collector's Newsletter* 14:1 (March–April 1983), 5–8; and the series of Dietrich-Boorsch's interviews with German artists in the pages of the same periodical from 1982 on.

101. Carter Ratcliff, *Illustration and Allegory* (New York: Brooke Alexander, 1980). The exhibition consisted of paintings (not prints), selected by Ratcliff, by Richard Bosman, Ken Goodman, Wonsook Kim, Thomas Lawson, Robert Longo, David Salle, Philip Smith, and Michael Zwack. Most of these artists have gone on to serious printmaking.

102. See my "On Recent Woodcuts," *Print Collector's Newsletter* 13:1 (March–April 1982), 1–6.

103. One could trace the steps from 1960, as this essay does: lithography, screenprinting, etching, aquatint, renewal of the painterly screenprint, paperworks, hand-colored prints, monotype, and finally, the woodcut (with a nod to the pochoir by such artists as Katz, Freckelton, and Beal).

104. See Riva Castleman, *Prints from Blocks* (New York: Museum of Modern Art, 1983); and J. Nebraska Gifford, *Intuition and the Block Print: A New York Obsession, 1984* (New York: John Nichols Printmakers and Publishers, 1984); and for views of another revival, Jacquelynn Baas's and my *The Artistic Revival of the Woodcut in France, 1850–1900* (Ann Arbor: The University of Michigan Museum of Art, 1983).

105. Especially *The Raft of the Medusa*, *The Barque of Dante*, *The Castoffs of the Don Juan*, and *Christ on the Sea of Galilee*, all of which were charged with meaning for another proto-Expressionist, Paul Gauguin.

106. Especially the Hamburg harbor scenes by Emil Nolde, such as *The Fishing Trawler* of 1910.

107. See Elizabeth Armstrong et al., in *Images and Impressions: Painters Who Print* (Minneapolis: Walker Art Center, 1984), 10. This was one of the most interesting and original exhibitions of recent years. Included were prints and paintings by Richard Bosman, Louisa Chase, Francesco Clemente, Roger Herman, Jörg Immendorff, Mimmo Paladino, Susan Rothenberg, T. L. Solien, and Donald Sultan.

108. See Thomas Krens, *Helen Frankenthaler: Prints, 1961–1979* (New York: Harper & Row, 1979).

109. This is only apparent, of course. The black block, containing virtually all of the drawing in gouged lines, is printed over several layers of color. The white-line woodcut has always been a natural correlative for the night world of the imagination.

110. Quoted by Elizabeth Armstrong in *Images and Impressions: Painters Who Print*, 16.

111. It is astounding that controversy over "originality" could resurface in 1985; that it has must betray an impatience to return to the print that both evolves from the artist's total participation and is subject to the restraints of the trade (or materials) through publication in small editions. One would have thought that all the issues about collaboration, process, and photographic inclusions would have been aired and settled by now. See "Collaboration East and West: A Discussion," *Print Collector's Newsletter* 16:6 (January–February 1986), 196–205.

112. See Donald Kuspit's blistering attack on these tendencies: "The New (?) Expressionism: Art as Damaged Goods," *Artforum* 20:3 (November 1981), 47–55.

113. For notes on Rothenberg at work at ULAE, see Clifford S. Ackley, "'I Don't Really Think of Myself as a Printmaker,'" *Print Collector's Newsletter* 15:4 (September–October 1984), 128–29.

114. In her own comments on the new Expressionism, Rothenberg underscored the nonrational aspects of her creativity: "Most of my work is not run through a rational part of my brain. It comes from a place in me that I don't choose to examine." Quoted in "Expressionism Today: An Artists' Symposium," *Art in America* 70:11 (December 1982), 65.

115. As were the aquatints, Rothenberg's first woodcuts were executed at Aeropress in New York City. See Ceil Friedman, *Susan Rothenberg: Prints 1977–1984* (Boston: Barbara Krakow Gallery, 1984).

116. In other words, there are no tools, techniques, processes, colors, or conventions to which women appear partial. The one arguable exception, of course, is paper itself, as I have already noted. That women have not utilized photographic printing elements as frequently as have men is as much a function of chronology as of preference.

117. Lucy Lippard, in her short introduction to the exhibition catalogue *Women Choose Women* (New York: New York Cultural Center, 1973), 7, does talk about the biological metaphors, with their roots at least in the art of Georgia O'Keeffe: "a central focus (or void), spheres, domes, circles, boxes, ovals, overlapping flower forms and webs." She even mentions certain "pinks and pastels and the ephemeral cloud-colors that used to be taboo unless a woman wanted to be 'accused' of making 'feminine' art." At least as interesting are Murray's claims that her cup images are decidedly sexual, but in both directions (note the title for one is the feminine *Inside Story* and for another is the masculine *Snake Cup*). The only artist among those considered here who has been seriously described as the author of feminist imagery is Joan Snyder.

118. One thinks of some of the early, non-Formalist articles on Abstract Expressionism, especially those by Gyorgy Kepes and others in the short-run publication, *Transformations*.

119. See Barbara Rose's exhibition catalogue, *American Painting: The Eighties* (New York: Grey Art Gallery, New York University, 1979).

120. "Expressionism Today: An Artists' Symposium," 75.

A GRAPHIC MUSE

PRINTS BY CONTEMPORARY AMERICAN WOMEN

JENNIFER BARTLETT

Born Long Beach, California, 1941

■

Jennifer Bartlett, an artist of considerable diversity, knew as a child that she wanted to be an artist, and she has steadfastly adhered to her goal. She studied first at Mills College in Oakland, California, and then went to Yale University School of Art and Architecture, where she earned both her B.F.A. (1964) and M.F.A. (1965) degrees.[1] Bartlett is a prolific artist, working in painting, drawing, prints, and sculpture; and she has also undertaken complicated architectural installations, among them one for the General Services Administration in Atlanta, Georgia, and one for Volvo's international headquarters in Göteborg, Sweden.[2] Her now-legendary work *Rhapsody* was exhibited in 1976, bringing her extraordinary critical acclaim. The work, fifty-three feet long and seven-and-one-half feet high, consists of almost one thousand foot-square steel plates painted in enamel. The images that comprise it range from squares, circles, and triangles to houses and trees.[3] Bartlett had used less ambitious multiunit formats in her work before completing *Rhapsody*, and has continued to use them since, as may be seen in the prints included here. It is as if her thoughts in working are burgeoning so quickly that no one surface can contain them. In addition, a multiunit format has enabled her to explore broadly subtle variations in implied space, light, time, and mood as expressive visual components.

Imbued with elements of lyricism and directness, Bartlett's art is structured by an underlying formalism. *Day and Night*, 1978 (colorplate 4), is one of a group of five drypoints and one etching in her first series of prints, based on a painting of 1977, *Howard Street: Day and Night*.[4] The twelve-by-eight-unit grid structure was determined by the painting; and like the grid format, the simple, blocklike house image has become closely associated with the artist's work. In making the *Day and Night* prints, Bartlett was essentially learning the etching process. As she discovered the character of the incised line, the velvety surface of ink hugged by the rough, exposed drypoint burr, the dense quality of color printed discretely layer over layer, her visual challenges were enhanced. The new methods led to new ways of conceiving form and the indirectness

of the print media imposed a need for a slower kind of pacing in the work.

The *Day and Night* sequence was closely followed by the five-part print *Graceland Mansions*, 1978–79 (colorplate 5). The house image, again closely associated with a painting of the previous year, is dominant. Each of the five panels was executed in a different printmaking medium: drypoint, aquatint, screenprint, woodcut, and lithography—as if Bartlett were trying with this one print to increase her technical means and knowledge of process geometrically and to reinterpret one image through a range of media, reflecting her taste for repeated imagery in general. Each panel suggests changes in light—the passing of time—and changes in position. The size and role of the shadow changes from print to print, and there are also shifts in the insistence of the house shape. In their varying media, as Richard Field has pointed out, the individual prints directly address both a language of reproduction (at the left) and one of painterly approaches (at right). In doing this, Bartlett is shifting the dominance of the formal aspects of her image: she has given the mark prominence at the left and the right and the shapes prominence in the two panels that sandwich the central section, while at the center light and atmosphere are of pervasive importance.

Explaining her use of the landscape, or of such simple forms as the house in *Day and Night* and *Graceland Mansions*, Bartlett has said, "When I choose to use a figurative image, it's usually something natural and simple because I'm not really interested in figuration at all. . . . Landscape for me is just another tool."[5]

As Bartlett's work has progressed her imagery has become less schematic, and in her prints, a painterly approach has emerged. The use of numerous color overlays to develop her images has become exhaustively complex. For example, a six-panel woodcut and screenprint, executed in 1980 and titled *At Sea, Japan*, employed ninety-five screens and eighty-six wood blocks, all of them carved by Bartlett herself and printed in the traditional Japanese woodcut method, using water-based inks. Bartlett's response to

this, the oldest of the printmaking media, was clearly enthusiastic. One may see this in the work, and it is evident in Bartlett's many comments on the subject: "I like to chop and hack on wood. . . it gives me pleasure"; and elsewhere, "Woodcut is very direct. . . . It's quite close to drawing."[6]

Bartlett's renowned series of some two hundred drawings in a variety of media, In the Garden, completed at what she considered a dismal villa in Nice in 1979–80, became the basis for paintings and prints, also in many media.[7] Most of them use several panels in varying configurations. Among the most beautiful and ambitious is *Shadow*, 1984 (colorplate 6), which hardly resembles an "awful little garden with its leaky ornamental pool and five dying cypress trees," as Bartlett has described the scene.[8] Her use of the intaglio process to produce it was challenging in the extreme; hard- and soft-ground etching, aquatint, drypoint, spit bite, and burnishing are combined in so extraordinarily subtle a manner that the process is totally subsumed in the image. In four parts, each the same view of the garden from a slightly different vantage point, it is beautiful in its use of gesture and color.

In *Shadow*, as in *Graceland Mansions*, one's viewpoint varies from panel to panel. Distances shift, as does the focus on the central pool, guarded by a putto. Fuchsia blossoms of considerable brilliance in the first panel (reading from left to right) do not appear at all in the last. Strongly defined patches of russet leaves in the third panel are muted or more dispersed in the others. A commitment to delineation, the use of drawn marks to suggest form, is apparent in *Shadow*, and the richness of layered color enhances the incisiveness of Bartlett's drawing.

Light emanates throughout; we feel able to walk through this place as our eyes wander. And while this is an extraordinary *tour de force* of printmaking, the technique is submerged, embedded in the image. Marks dance on the sheet and every aspect of the landscape—the tree trunks, foliage, flowers, pool, walks, and sky—is composed of a multitude of hues and textures. Subtle color adjustments are apparent on every inch of the surface.

1. Biographical, analytical, and critical data on Jennifer Bartlett may be found in Marge Goldwater, Roberta Smith, and Calvin Tomkins, *Jennifer Bartlett* (Minneapolis: Walker Art Center, and New York: Abbeville Press, 1984). The book, published on the occasion of an exhibition, includes a bibliography.

2. Roberta Smith, "Site Sensitivity: Jennifer Bartlett at Volvo and at Home," *House and Garden* (May 1985), 156–57, 228–32.

3. See Roberta Smith, *Rhapsody* (New York: Harry N. Abrams, 1985).

4. Richard S. Field, "Jennifer Bartlett Prints, 1978–1983," *Print Collector's Newsletter* 15 (March–April 1984), 1–6. This article describes two suites of prints published from the *Graceland Mansions* woodblocks.

5. Quoted in Tsipi Ben-Haim, "Interview, Jennifer Bartlett: Works in Transition," *International Sculpture* (May–June 1986), 8.

6. Quoted in "Collaboration East and West: A Discussion," *Print Collector's Newsletter* 16 (January–February 1986), 200. Throughout the article Bartlett's views on printmaking are expressed; see also Deborah C. Phillips, "Looking for Relief? Woodcuts Are Back," *Art News* 81 (April 1982), 92.

7. See John Russell, *In the Garden* (New York: Harry N. Abrams, 1982).

8. Quoted in Calvin Tomkins, "Drawing and Painting," *Jennifer Bartlett*, 33.

CHECKLIST

Day and Night, 1978.
Etching and drypoint on Arches paper.
Edition: 35.
Sheet size: 31¼ × 21 in. (79.4 × 53.4 cm).
Printed by Michael Durand at Aeropress, New York; published by Multiples, Inc., New York.
Lent by the Mount Holyoke College Art Museum, The Adelaide Button Memorial Fund and The Henry Rox Purchase Fund

Graceland Mansions, 1978–79.
Drypoint, aquatint, lithograph, woodcut, and screenprint on J. Green Cold Press and Rives BFK papers (five sheets).
Edition: 40.
Sheet size: 24 × 24 in. (61 × 61 cm) each.
Printed by Prawat Laucheron, New York (drypoint and aquatint), Simca Print Artists, New York (silkscreen), Chip Elwell, New York (woodcut), and Maurice Sanchez, New York (lithograph); published by Brooke Alexander, Inc. and Paula Cooper Gallery, New York.
Lent by Paula Cooper Gallery, New York

Shadow, 1984.
Soft-ground etching and aquatint on Fabriano Tiepolo paper (four sheets).
Edition: 60.
Sheet size: 30 × 22¼ in. (76.2 × 56.5 cm) each.
Printed by Pat Branstead at Aeropress, New York; published by Paula Cooper Gallery and Multiples, Inc., New York.
Lent by the Walker Art Center, Minneapolis, Gift of the artist in honor of Marge Goldwater

Colorplate 4

JENNIFER BARTLETT

Day and Night

Colorplate 5

JENNIFER BARTLETT

Graceland Mansions

Colorplate 6

JENNIFER BARTLETT

Shadow

NANCY CAMPBELL

Born Syracuse, New York, 1952

■

*F*or the past five years, Nancy Campbell's art has taken form either as acrylic paintings on paper or as prints, usually a combination of lithography and screenprinting. Campbell has always concentrated on printmaking, exploring a variety of media and developing the skills that have enabled her to do her own printing.

Campbell's early work was representational, although never tightly rendered. Images were based on views from her studio of what appears to be a suburban neighborhood, offering images predominantly composed of houses, trees, and bushes. As Campbell's thinking developed, her lithographs and etchings based on scenes from nature were drawn with increasing freedom, with broad, gestural strokes that unify the various parts of the image. She gave considerable attention to effects of light, and although the elements of each place—tree trunks, porches, and so forth—remained clearly recognizable, descriptive details of them came to be of less and less concern. Space was flattened as the undulating edges of foliage moved gracefully into geometric planes of architectural definition.

Through the late 1970s Campbell's views of nature became increasingly abstracted, as the artist assessed the importance of representation and figuration in her work. The role of these fluctuated—some works clearly contained forms derived from the natural world, while others did not. As her work evolved, the size and color of a form came to convey, for example, qualities of weight, rather than a sense of identifiable place or object, and gestural strokes increasingly were used to activate space rather than to define edges. In exploring the painterly aspects of lithography, building rich surfaces of deeply bitten fields in aquatint and open-plate etching, and discovering the potential of the flat, applied colors associated with screenprinting, Campbell sought to locate the methods and forms best suited to her ideas. By the end of the decade, her concern to maintain a clear reference to sources in nature was overcome by a commitment to gestural abstraction, although loosely defined figurative elements continued to be visible in some images. Arriving at a combination of lithography and screenprinting, often with hand-drawn additions, she contrasted dense, screenprinted layers of flat color with a fluid, draftsmanlike approach to lithography.

Campbell's major sources of inspiration have been Japanese scroll paintings from the twelfth through the sixteenth centuries, which she first saw at the University of Michigan Museum of Art in Ann Arbor when she was a graduate student. She has responded to "their delicate yet intense color, the viewpoint from above, the fluidity of line and movement, their abstract qualities, as well as their intimate story-telling aspect. I love the sense of the 'continual' in these works where there is a constant desire to know what will follow."[1]

At times Campbell uses reproductions of specific scroll paintings as a source, maintaining in her own work shards of the forms she has observed, such as clear indications of figures in motion. At other times she calls to mind scrolls she has admired and visualizes a translation of these memories. She also makes working studies in pencil and paint from reproductions of scroll paintings: some remain studies alone while in other instances several studies are combined to form the basis for a print.[2] In visually interpreting her responses to these scrolls, Campbell has evolved an approach that pays homage to the harmonious color she admires in them, enhancing the subtlety in her own works with occasional bright hues that shatter their compositional unity. Multiple readings of space are possible as the closely toned hues reveal themselves in gradual stages and alter perceptions of the picture plane.

Campbell imbues her paintings on paper and her prints with a sense of structure held in tension with an erratic calligraphic movement. In many of her works, including *Cremorne Lights*, 1980, and *Fitting*, 1984 (colorplates 7 and 8), she establishes a central field of focus surrounded by a deep framing border that visually contains the field as it interacts with it. She has explored and expanded upon this format for several years, coordinating a stable, rectangular field of pulsating organic forms and linear elements with dark, calligraphic strokes that seem both to overlay the surface and to interact with it spatially. Both the central field and its frame tend to be neutral in color, and to function as a foil for the darting gestures

Colorplate 7

NANCY CAMPBELL

Cremorne Lights

Colorplate 8

NANCY CAMPBELL

Fitting

and amorphous areas of color that hover in juxtaposition to them. Campbell both reinforces and alters the plane of the sheet, as the activity of the forms forces us constantly to adjust our understanding of her spatial structure. We see a quest for unity between the logical and measured, and the intuitive and spontaneous.

Campbell studied painting and printmaking as an undergraduate at Syracuse University, where she earned her B.F.A. degree in 1974. She went on to make printmaking her major area of concentration as a graduate student at the University of Michigan at Ann Arbor, receiving her M.F.A. in 1976. Currently in charge of printmaking in the art department at Mount Holyoke College in South Hadley, Massachusetts, she has taught the basic printmaking processes—lithography, intaglio, screenprinting, and relief—at a number of places (among them the Swain School of Design in New Bedford, Massachusetts, Oberlin College, Oberlin, Ohio, and the Hartford Art School in Connecticut) since graduating from Michigan.

In 1983 Campbell established a visiting-artists program at Mount Holyoke, which to date has brought to the campus Elaine de Kooning, Joan Snyder, Vija Celmins, and Sondra Freckelton (see colorplates 1, 2, 31, 32, and 58) and master printers John A. Hutcheson, Doris Simmelink, and Norman Stewart. The purpose of the program has been to introduce the process of collaborative printmaking to her students, and to expose the students at this women's college to successful women artists whose work exemplifies a variety of directions.

Campbell and her husband, painter Carl Caivano, live and work in Hadley, Massachusetts. She has recently made her first trip to Japan to study at first hand the art that has been so influential on her work.

1. Letter to the author, 26 August 1986.

2. Telephone conversation with the author, 5 October 1986.

CHECKLIST

Cremorne Lights, 1980.
Lithograph and screenprint on Rives BFK paper.
Edition: 15.
Sheet size: 21½ × 29 in. (54.7 × 73.7 cm).
Printed and published by the artist, Oberlin, Ohio.
Lent by the Mount Holyoke College Art Museum, The Henry Rox Memorial Fund for the Acquisition of Works by Contemporary Women Artists

Fitting, 1984.
Screenprint and lithograph with hand coloring on Buffalo handmade paper.
Edition: 13.
Sheet size: 21 × 27 in. (53.3 × 68.5 cm).
Printed and published by the artist, Hadley, Massachusetts.
Lent by the Mount Holyoke College Art Museum, The Henry Rox Memorial Fund for the Acquisition of Works by Contemporary Women Artists

VIJA CELMINS

Born Riga, Latvia, 1939

■

*V*ija Celmins came to the United States at the age of ten, settling in Indianapolis, Indiana. She received a B.F.A. degree in 1962 from the Herron School of Art in Indianapolis, and an M.F.A. in 1965 from the University of California, Los Angeles. Celmins's base remained the West Coast until 1981, when she began living and working in New York. She makes paintings and sculptures, but her principal mode of expression for the past two decades has been drawing. She has also completed a small but significant body of prints, working first in lithography, and, for the past several years, in the etching processes, including not only etching but also aquatint, drypoint, and mezzotint.

Celmins's early figurations, large-scale, everyday objects such as a bowl of soup or a lamp, rendered carefully in grisaille, associated her with the West Coast branch of the Pop art movement. About 1967, however, her interests shifted, and she embarked on the metaphysical odyssey that has since focused her vision on the galaxies, deserts, and oceans that may be seen in her intaglio prints *Drypoint—Ocean Surface*, *Alliance*, and *Concentric Bearings B*, all 1983, and *Untitled Galaxy*, 1986 (colorplates 1, 9–11).

Celmins's art uses the nature of the world as her apparent subject, but in the stillness of her world she convinces us that her true subject is the nature of picture making.[1] Her prints, like her graphite drawings, address her intense concern with the surface on which she works, her testing of the picture plane and of pictorial depth. "I usually go across the surface, and I account for the surface in those little points, accounting for my being on the whole plane."[2]

An obsessive attention to detail leads her to pay homage not only to the natural universe, but to the act of working. The sources of her imagery may not be ignored, of course, and one senses her respect for those who explore the sky: she has worked from satellite photographs of the lunar surface, and some of her galaxies are based on NASA photographs. She has herself explored the desert, and has worked from her own photographs as well. Place becomes

a point of departure, however, rather than a point in itself. In spending long expanses of time working to create the stillness of her images, Celmins seems to negate the passing of time. Light, a signifier of time, is held captive in the work, subservient to her extraordinary skills in forming, ordering, and rendering.[3]

Celmins has worked on all of her etchings with Doris Simmelink—at Gemini G.E.L. in Los Angeles, as a visiting artist at Mount Holyoke College, and while executing four mezzotints to accompany Czeslaw Milosz's text, *The View*.[4] Throughout her exploration of the intaglio processes, she has examined and used many of its forms, each time finding the proper sense of touch to develop the sort of mark she sought.

Drypoint—Ocean Surface and *Alliance* are from Celmins's first group of five etchings. The ocean image and another print from this set, *Strata*, are reminiscent of her four lithographs, published by Cirrus Editions, Los Angeles, in 1975. In them, carefully modulated slices of the sea, the sky, and the desert were meticulously rendered in lithographic crayon onto stone. The drypoint ocean, seen here, was eventually developed further and published in a second state. This earlier version is less dense and stormy than the darker, later one.

Concentric Bearings B is one of a set of four prints titled *Concentric Bearings*, followed by the letter *A*, *B*, *C*, or *D*. All are composed of individual selections from four small plates of different sizes that were worked simultaneously. For each print, the plates were placed horizontally adjacent to one another; two plates were used for two of the prints, including *Concentric Bearings B*, and three plates each for the other two. The images not in *Concentric Bearings B* are a reworked photogravure made from Celmins's drawing after a photograph of Duchamp's optical disk rotorelief and a second galaxy. In developing these prints, as she has developed all of the etchings, Celmins worked through many proof stages to achieve the precise tonalities she desired. In the course of proofing she was able to test the various combinations of images.

Drypoint (in *Drypoint—Ocean Surface*) and mezzotint (in the galaxy plate of *Alliance* and the monoplane plate in *Concentric Bearings B*), are two processes in which the artist works directly on the plate, without the use of grounds and acids. They have proved to be particularly sympathetic methods for Celmins in her meditative process of building form. In juxtaposing disparate images of nature and of man-made objects to present a collage view of the world, she is responding to one of the dominant visual directions of our time. The airplane image in *Concentric Bearings B*, based on a found photograph, is reminiscent of her so-called Pop-oriented work of the 1960s. Many of her object references are derived from photographs, some of them of works of art, as, for example, the Duchamp rotorelief that appears elsewhere in the *Concentric Bearings* series, and, in *Alliance*, the sailing vessel, an image based on a reproduction in a compendium of engineering drawings. Celmins's art often confounds our notions of scale or perhaps suggests that it is immeasurable and incomprehensible. In either event, she presents us with the difficulty of understanding relationships, and the challenge of grasping reality. Her title *Alliance* suggests one aspect of this challenge: it is meant to connote a loose application of the sort one finds in many of her printed juxtapositions.

Celmins's most recent etching, *Untitled Galaxy*, was started on campus as part of Mount Holyoke College's printmaking workshop. However, several months of further work in the artist's studio were required before it was completed.

1. See Carter Ratcliff, "Vija Celmins: An Art of Reclamation," *Print Collector's Newsletter* 14 (January–February 1984), 193–96.

2. Quoted in Ruth E. Fine, *Gemini G.E.L: Art and Collaboration*, exhibition catalogue (Washington, D.C.: National Gallery of Art, and New York: Abbeville Press, 1984), 24.

3. See Max Kozloff, "Vija Celmins," *Artforum* 12 (March 1974), 52–53; and Kenneth Baker, "Vija Celmins: Drawings without Withdrawing," *Artforum* 22 (November 1983), 64–65.

4. In a volume published in 1985 by the Library Fellows of the Whitney Museum of American Art, New York.

CHECKLIST

Untitled Galaxy, 1986.
Etching on Somerset paper.
Edition: 10.
Sheet size: 12 × 15¼ in. (30.5 × 38.7 cm).
Printed by Doris Simmelink at Mount Holyoke College and Simmelink Sukimoto Editions, Los Angeles; published by Mount Holyoke College.
Lent by the Mount Holyoke College Art Museum, Gift of the Mount Holyoke College Printmaking Workshop

Drypoint—Ocean Surface, 1983.
Drypoint on Arches satine paper.
Edition: 75.
Sheet size: 26 × 20¼ in. (66 × 51.5 cm).
Printed by Doris Simmelink at Gemini G.E.L.; published by Gemini G.E.L., Los Angeles.
Lent by the Mount Holyoke College Art Museum, Museum purchase in honor of Professor Jean C. Harris

Concentric Bearings B, 1983.
Aquatint, drypoint, and mezzotint on Rives BFK paper.
Edition: 35.
Sheet size: 17½ × 14½ in. (44.5 × 36.8 cm).
Printed by Doris Simmelink at Gemini G.E.L.; published by Gemini G.E.L., Los Angeles.
Lent by the Mount Holyoke College Art Museum, Gift of Renee Conforte McKee

Alliance, 1983.
Aquatint, drypoint, and mezzotint on Fabriano Rosaspina paper.
Edition: 48.
Sheet size: 24 × 19½ in. (61 × 49.5 cm).
Printed by Doris Simmelink and Ken Farley at Gemini G.E.L.; published by Gemini G.E.L., Los Angeles.
Lent by the Mount Holyoke College Art Museum, Gift of Renee Conforte McKee

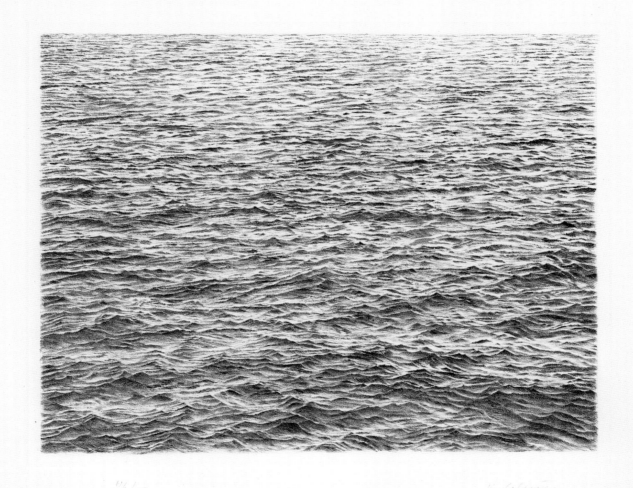

Colorplate 9

VIJA CELMINS

Drypoint—Ocean Surface

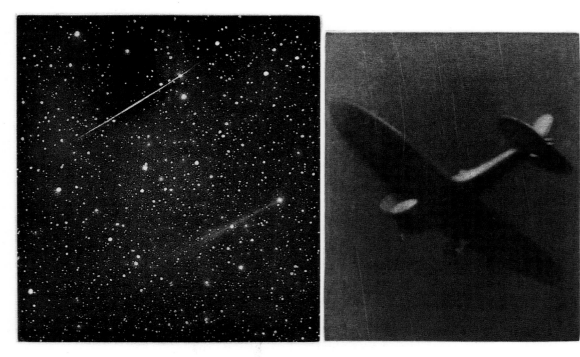

22/35 V. Celmins

Colorplate 10

VIJA CELMINS

Concentric Bearings B

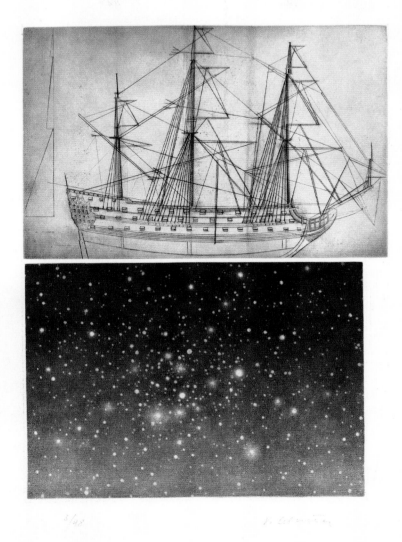

VIJA CELMINS

Alliance

LOUISA CHASE

Born Panama City, Panama, 1951

■

*L*ouisa Chase earned a B.F.A. degree from Syracuse University in 1973 and an M.F.A. degree from Yale University School of Art and Architecture in 1975. That same year her first solo exhibition in New York was held at Artists Space. Among the works on exhibition were three-dimensional pieces made of wood, a material she has since mined for form in printmaking.

Chase's first two prints, *Grotto* and *Squall*, made in 1981, were both black-and-white woodcuts. They were inspired by the prints she had seen in the 1980 Solomon R. Guggenheim Museum exhibition of German art from 1905 to 1920, *Expressionism: A German Intuition*; Chase had been particularly impressed with the powerful form of the woodcuts.[1] Her first woodcuts were not only important steps in her own art, but were also among those works that made apparent the renewed interest in the art of the woodcut in the early 1980s, especially among younger artists.[2] Chase has since made several more woodcuts, working in black and white and in color (at times employing hand-coloring), and has also worked in etching and monotype.

In both her paintings and her prints, Chase's symbolic landscapes tend toward the tumultuous. Her images of land and sea, storm-filled skies, jagged mountain cliffs, and rough, enveloping ocean waves, are all drawn with a fierce, rapid stroke that establishes a disjointed world. In it the elements seem always to be clashing. When peopled, her fragments of place are inhabited by partial figures: torsos, hands, feet. They are hovering or falling or drowning or being assumed into the sky. Events seem always to be cataclysmic. Never comforting, these pictures remind us of our fractured experience. Her schematic drawing style, however, invests her work with a lightness that confounds the violent powers of nature. Chase is insisting that the will of the artist will prevail, preventing her—and us—from going under, from falling off the cliff, into the abyss. The simplified, often bulbous forms display a

keen wit that characterizes much of her work, investing her allusions to the truly menacing with a large measure of irony.

In her woodcuts Chase explores the medium's potential for strongly defined marks, and for dramatic contrasts of black and white; or, as in *Thicket* and *Red Sea*, both 1983 (colorplates 12 and 13), juxtapositions of black and rich colors. Variant middle values are created as Chase's rigorous strokes are locked into the surrounding field. Sometimes the field overcomes the strokes, creating spatial tensions that further animate the images.

These two dynamic woodcuts are exemplary of Chase's work in the medium. Her use of insistent strokes and gouges of many lengths, depths, and widths, placed adjacent to each other in a variety of schemes, offers a sense of the rich network of surfaces possible in a woodcut. Strongly defined and imagistic, the prints are organized by means of a layering and fracturing of space. Inherent in the definition of her forms is an odd sense of relative scale among elements; the body parts are often quite large with respect to the fragmented natural elements. In speaking of her early prints the artist has said, "I loved carving the marks . . . and just as my paintings are about brushstrokes, in the woodcuts you can really feel the separate marks." Indeed, drawings having been transferred to the woodblocks, the process of the subsequent carving naturally mandates the final character of Chase's works.[3]

Chase's recent works on canvas, like her recent etchings, seem to rely more heavily on painterly means than on draftsmanship. In both media, surfaces emerge and individual marks lose their autonomy as part of the process.[4] Chase works the etchings, in contrast to the earlier woodcuts, with a lighter touch, in keeping with the possibilities of the various intaglio processes: a thinner line and subtle tonal values are evident in the images. Forms seem to emerge from the sheet, revealing that they were placed on the plate more gently, rather than being energetically carved and sliced into

it. There is a delicacy in Chase's etchings, and a greater sense of mystery, while space functions in a less defined manner. These etchings have a compelling surface character, dense and intense, despite the delicacy of the artist's etched mark. The natural elements—fire, air, water, earth—remain, as do the evocative body parts, hands and feet and torsos: the artist? Humankind? Both, one assumes.

1. Elizabeth Armstrong, "Louisa Chase," *Images and Impressions: Painters Who Print*, exhibition catalogue (Minneapolis: Walker Art Center, 1984), 16.

2. Richard S. Field, "On Recent Woodcuts," *Print Collector's Newsletter* 8 (March–April 1982), 1–6; and Deborah C. Phillips, "Looking for Relief? Woodcuts Are Back," *Art News* 81 (April 1982), 92–96.

3. Phillips, "Looking for Relief? Woodcuts Are Back," 94.

4. For Chase's account of working on paintings, see *Louisa Chase*, exhibition catalogue (New York: Robert Miller Gallery, 1984). The catalogue includes a bibliography.

CHECKLIST

Thicket, 1983.
Woodcut on DPAI Oriental paper.
Edition: 10.
Sheet size: 30 × 36 in. (76.2 × 91.3 cm).
Printed by Chip Elwell, New York; published by Diane Villani Editions, New York.
Lent by Diane Villani Editions, New York

Red Sea, 1983.
Woodcut with hand coloring on Sekishu paper.
Edition: 25.
Sheet size: 33 × 38½ in. (83.8 × 97.8 cm).
Printed by Chip Elwell, New York; published by Diane Villani Editions, New York.
Lent by the Mount Holyoke College Art Museum, The Henry Rox Memorial Fund for the Acquisition of Works by Contemporary Women Artists

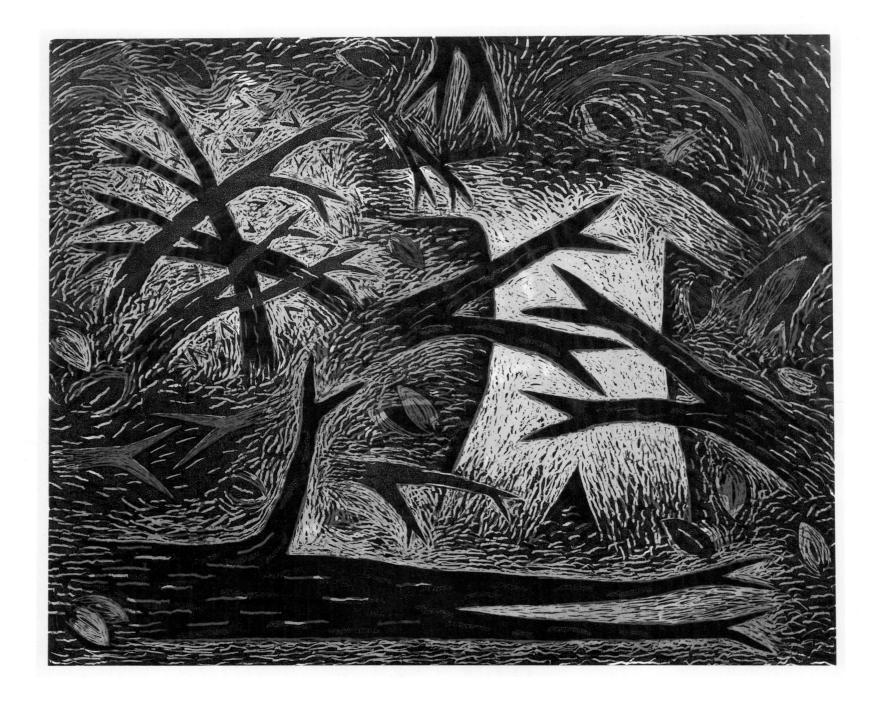

Colorplate 12

LOUISA CHASE

Thicket

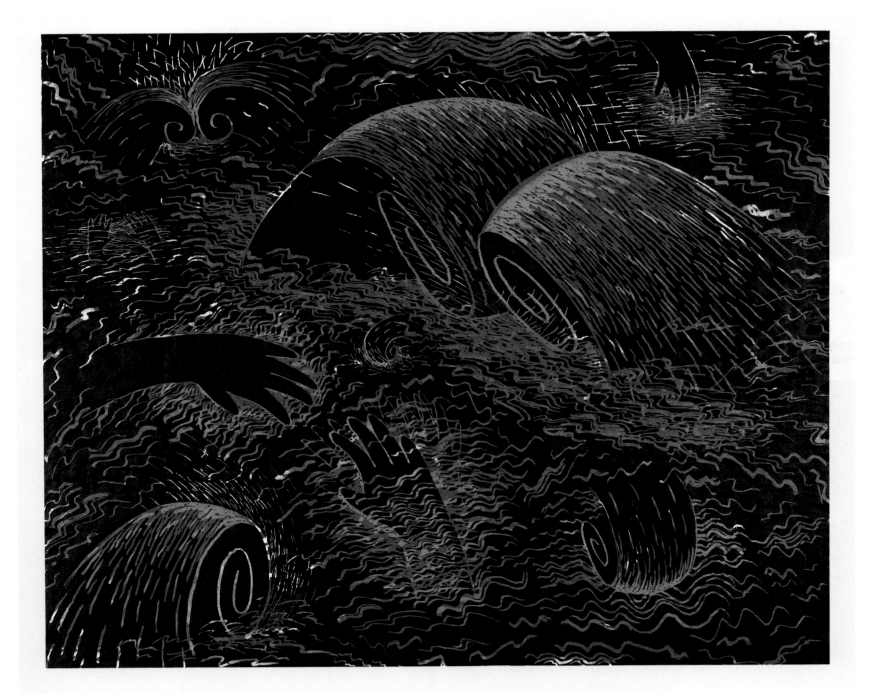

Colorplate *13*

LOUISA CHASE

Red Sea

SUSAN CRILE

Born Cleveland, Ohio, 1942

■

Susan Crile studied at Bennington College, receiving her B.F.A. there in 1965, as well as at New York University and Hunter College. Her art has explored the uses of pattern in defining space. Her early works focused on still life, but as her ideas evolved the objects were eliminated and the richly patterned surfaces of their environments remained. Works of the early 1970s depicted sections of complicated Oriental carpets, fluidly set out, with gentle folds and densely structured clusters of forms, their zones of vivid color acting to organize both the spatial structures and the plane of the picture surface. These pieces brought her considerable acclaim, but in mid-decade she shifted the source of her work outdoors, to the landscape.[1]

During this period Crile derived her images from both sites directly seen and sites remembered, working them with an increasing sense of abstraction, at times developed by allusion to aerial perspective. By the end of the 1970s her art had become virtually without specific figuration and had grown larger in size, often with an affinity to architectural scale. At times she has created works meant to be placed in corners or planned for other particular spaces.

Crile's work, then, has shifted from a representational to an abstract mode, and her drawing and color decisions increasingly have appeared to respond to a felt rightness rather than to cues based on specific observation. She has said that "drawing is thinking, particularly drawing in black and white. The materials are immediate. The decisions are structural. Thus one is pushed closer to the content of one's work."[2] This sense of the essence of drawing, however, seems to inform her other work as well, to be embedded in the way she organizes her paintings and prints. In Crile's work, shapes move dynamically in and out of space, creating a fluctuating visual tension. Their drawn presence is reinforced by color and surface modulation, which varies from the very subtle to the very insistent.

Crile's prints—she has worked in etching, lithography, and woodcut—clearly reflect the interests of her painting and drawing.

In them, the challenge is to create a convincing visual space through color, shape, and surface. Crile's structures are unpredictable. For example, in her color lithograph *Expansion*, 1981 (colorplate 16), she juxtaposes undulating, fluid forms, marked by modulated surface transparencies that pulsate in space, with more sharply defined and densely constructed geometric shapes that may refer to architectural perspective and structure—shapes that seem both locked into a location and to imply jarring spatial shifts. Thus the artist evokes the specter of duality.[3]

The quality of edges is crucial, their softness and sharpness playing an important role in the degree of liberation that is allowed to form. *Expansion* further offers an example of Crile's daring color, the sort of color that sets up her most extreme spatial tensions. In this respect, *Renvers on Two Tracks* and *Buskirk Junction* (colorplates 14 and 15), both completed a year later than *Expansion*, are more subtle.

Crile's paintings often comprise several panels of different sizes, so that the works function in actual space while dramatically insisting on the reality of the painted space as well. She uses this approach in *Renvers on Two Tracks*, which consists of two panels. To structure this work, the configuration of the composition on the left-hand sheet is turned 180 degrees and printed again on the right; thus, the light band at the top of the left-hand sheet is at the bottom of the right. Sweeping shifts in space are established by variation in the cutting of different zones and in the use of color. Different woods carved with a variety of strokes allow both natural grain and cut marks to create a sense of space. Colored inks are layered on the left panel and printed so as to soften the effects of the gouges. The wood grain is less forceful there as well, and the spatial definition of the panel is more gentle and mysterious than in the right panel, where the natural surface of the block is more insistent and the marks appear more sharply. Differences in color and surface are so significant that one is not readily aware of the repeated nature of the image; the title acts as a clue.

There is a clear sense of scale in the print, a feeling of grandeur;

Colorplate 14

SUSAN CRILE

Renvers on Two Tracks

Colorplate 15

SUSAN CRILE

Buskirk Junction

Colorplate 16

SUSAN CRILE

Expansion

the shapes press against the edges of the sheet as if too large to be contained. The use of the light bands at upper left and lower right imply an eccentric outer edge, though none has actually been created. Essentially geometric shapes are invested with great dynamism. The juxtaposition of muted, grayed colors with the strong contrasts of black and white in the cut marks creates an aura of peacefulness in sharp contrast to this activity.

In *Buskirk Junction*, printed from three blocks of wood in three colors of black, Crile seems to be challenging herself to create space without color. And she succeeds. The construction of the print makes some reference to Crile's aerial views and "map" paintings of the 1970s, although here a much tighter structure is employed. One senses here also Crile's notion of "drawing as thinking": each

carved groove is invested with a sense of the artist's careful consideration of thickness, sharpness, unmediated length, and suggestions of liveliness and speed. Gouged surfaces interact with enhanced wood grain and sensitive printing to establish the tensions usually associated with Crile's complex color structures.

1. See Kenneth Baker, "Susan Crile: Abstracting the Image," *Arts* 50 (December 1975), 54–55.

2. Elke Solomon, *Large Drawings*, exhibition catalogue (New York: circulated by Independent Curators Incorporated, 1984), n.p.

3. See Elizabeth Frank, *Susan Crile: Recent Paintings*, exhibition catalogue (Cleveland: Cleveland Center for Contemporary Art, 1984), 10. The catalogue includes a bibliography.

CHECKLIST

Renvers on Two Tracks, 1982.
Woodcut on Gampi Torinoko paper (2 sheets).
Edition: 35.
Sheet size: 24 × 18⅟₁₆ in. (61 × 46 cm) each.
Printed by Chip Elwell, New York; published by 724 Prints Inc., New York.
Lent by the Mount Holyoke College Art Museum, The Henry Rox Memorial Fund for the Acquisition of Works by Contemporary Women Artists

Buskirk Junction, 1982.
Woodcut on Suzuki paper.
Edition: 35.

Sheet size: 30½ × 36¼ in. (77.5 × 92.1 cm).
Printed by Chip Elwell, New York; published by 724 Prints Inc., New York.
Lent by the Yale University Art Gallery, Fleischer Fund and Anonymous Purchase Fund

Expansion, 1981.
Lithograph on Rives BFK paper.
Edition: 50.
Sheet size: 25 × 42 in. (63.5 × 106.7 cm).
Printed by Bud Shark, Boulder, Colorado; published by 724 Prints Inc., New York.
Lent by 724 Prints Inc., New York

JANE DICKSON

Born Chicago, Illinois, 1952

■

Much of Jane Dickson's imagery has been informed by life in New York, where she has lived and worked since 1978. In subject and mood, she is linked to artists who made paintings and prints depicting the less picturesque aspects of everyday life in the city during the early years of the century; and the taut structure of her work also seems to refer back to an earlier, less petulant time in American art. Dickson's quintessential views of the isolation of big-city life are firmly rooted in the tradition of Edward Hopper's scenes of quiet desperation in offices and all-night cafés and Armin Landeck's prints of the vacant night city. And, like Reginald Marsh's depictions of burlesque theater, Dickson's recent work features the game booths and daredevil rides at amusement parks and fairs, suggesting the intense loneliness one may feel even while participating in the entertainments of Anywhere, U.S.A. The irony and self-awareness in Dickson's art, however, place it firmly in our time. She has said of her art that she is "interested in the ominous underside of contemporary culture that lurks as an ever present possibility in our lives. . . . I aim to portray psychological states that everyone experiences, and I am interested in how situations dictate our emotional states."[1]

The subjects of Dickson's aquatint etchings, *White Haired Girl* and *Stairwell*, both 1984 (colorplates 17 and 18), are related to earlier canvases and drawings.[2] Working on the aquatint plates and developing rough, bumpy surfaces with an insistent presence, held in constant tension with zones of black and of acid color, Dickson has arrived at a facture that is close in quality to the scumbled richness of her oilstick images on dark, textured rubber or canvas that has been stained black.

Dickson's loft studio overlooking Times Square and its surrounding vicinity was the source for the images in *White Haired Girl* and *Stairwell*, two of her first three published editions. The third, *Mother and Child*, shows a woman pulling a child in a stroller up the steps from a subway concourse. In it, as with these prints, Dickson's dramatic color and vantage point turn an everyday occurrence into a dramatic event. Little known are two small plates from this same period, printed in black: two figures on the street, entitled *Kiss*, and a profile head, entitled *Smoker*. They were used by Dickson for the technical explorations that led to these larger, more complex color prints, and were issued quietly, in small editions. Less dramatically forceful than the three color images, they nevertheless exemplify all of Dickson's wit and powers of incisive observation.[3]

The *White Haired Girl*, a lone figure on an empty street, is highlighted by the garish brilliance and strong local color produced by the area's neon lights, a source of much of the distinctive luminosity in Dickson's art. She had worked as a programmer for the colorful computer billboard at Times Square when she first came to New York, putting to use the computer-animation courses she had taken during her student years at the School of the Museum of Fine Arts, Boston, and at Harvard University.[4]

A woman on a stairway has been the subject of a series of monoprints and a number of Dickson's drawings and works on canvas as well as the print seen here. In many of these she is looking down over the bannister. One wonders why; is she feeling fear or anticipation? Has she heard a strange noise? Has someone left, or is someone about to arrive? Is anyone else in the building? Dickson challenges us to name our own narrative. A sense of menace is pervasive, and the atmosphere is sinister—clearly defined compositions structured by otherworldly color locked in by black contribute to the tension of the scene. There is so strong a sense of drama as to suggest the theatrical, a quality enhanced by the nature of Dickson's light.

Both *White Haired Girl* and *Stairwell* involve only one figure, but even in works in which many figures people the scene, there is a sense of haunting isolation and rarely any formal or emotional interaction. Each figure is in his or her own airless space and, as here, the figures seem in arrested motion.

Verbal and visual language associations are often vital to Dickson's content. The painting entitled *Park* is not a park at all (and trees are nowhere in sight); the title, instead, refers to a neon

sign outside a parking garage. By contrast, another title, *Sizzlin' Chicken*, may refer to a neon sign identifying the fast-food place that is the backdrop for the scene, to the sexy central figure in the composition, or to both. Other sexual implications are also evident in Dickson's work, especially in her repeated use of phallic forms in the games and rides in the amusement-park scenes, the most obvious being her *Banana Girl* canvases, in which a lone figure stares into a booth filled with enormous stuffed, dangling bananas.

A subject of recent interest has been the demolition derby, an automotive event popular at such festivals as state fairs that channels aggression into what some see as a recreational activity. The dust and fumes engendered by the vehicles' fierce acceleration are apparent in a series of monotypes Dickson completed in 1986, based on drawings and photos from derbies in Florida and elsewhere. Their active compositions are very different in feeling from the static forms seen here. So too is her beautiful aquatint *Yo Yo*, depicting an aerial ride. It is as if spending more time out of the city and outdoors has provided Dickson with a sense of liberation, of freedom to explore gesture and a more open visual structuring.

1. Claudia Gould, "Jane Dickson: An Interview," *Print Collector's Newsletter* 17 (January–February 1987), 204.

2. The images are in reverse in the prints, indicating that in working the matrices the artist followed the format of the earlier compositions, which were then reversed in printing.

3. My thanks to Joe Fawbush of Joe Fawbush Editions for showing these and other Dickson prints to me.

4. Cynthia Nadelman, "Artists the Critics are Watching: Jane Dickson," *Art News* 83 (November 1984), 77.

CHECKLIST

White Haired Girl, 1984.
Aquatint on Rives BFK paper.
Edition: 45.
Sheet size: 35¾ × 22¾ in. (90.8 × 57.8 cm).
Printed and published by Maurice Payne, New York.
Lent by the Mount Holyoke College Art Museum, The Henry Rox Memorial Fund for the Acquisition of Works by Contemporary Women Artists

Stairwell, 1984.
Aquatint on Rives BFK paper.
Edition: 45.
Sheet size: 35¾ × 22¾ in. (90.8 × 57.8 cm).
Printed by Maurice Payne, New York; published by Maurice Payne and the artist.
Lent by the Mount Holyoke College Art Museum, The Henry Rox Memorial Fund for the Acquisition of Works by Contemporary Women Artists

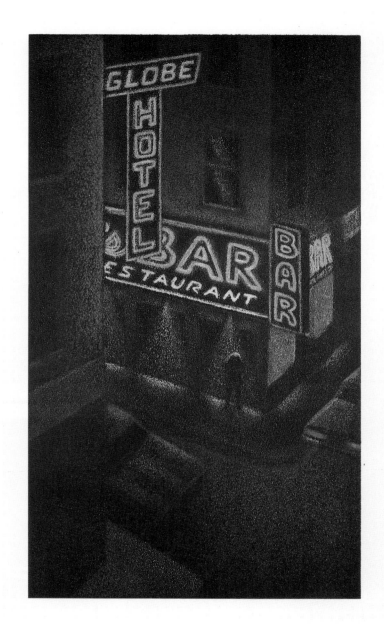

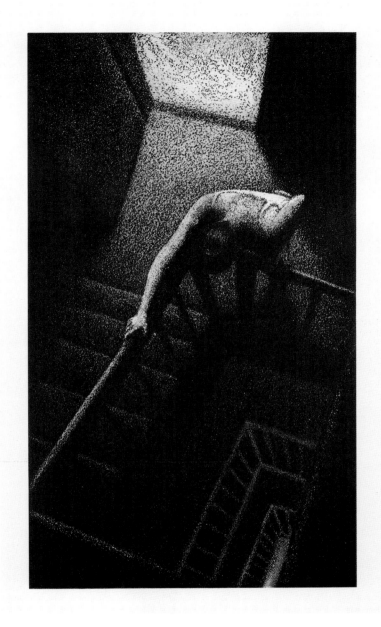

Colorplate 17

JANE DICKSON

White Haired Girl

Colorplate 18

JANE DICKSON

Stairwell

ALINE FELDMAN

Born Leavenworth, Kansas, 1928

■

*A*line Feldman studied at Washington University in Saint Louis, and then at Indiana University, Bloomington, where she received her B.A. degree in 1951. In addition to classes in etching and engraving with Fred Becker she worked in painting and design with Seong Moy and Werner Drewes respectively, both of whom were active printmakers. As Feldman's career has evolved, the print, and in particular the woodcut, has become increasingly important to her; this medium has been her principal mode of expression for more than two decades.[1]

Feldman's early paintings and prints were narrative figure compositions influenced by Max Beckmann, who was teaching at Washington University while Feldman was a student there. Gradually, however, she became interested in landscape. During the late 1970s she began making images of a bicyclist. As the series progressed, the landscape in which the cyclist was riding became increasingly important, until, as the artist amusingly put it, "he rode out of the picture." Since 1979 the landscape itself has dominated Feldman's work.

Concurrent with the exit of the bicyclist, Feldman began to depict aerial views, at first working from her imagination. She soon found it useful to make idea-gathering trips in small airplanes, drawing and taking photographs. In addition, some of her views are worked from tall buildings, such as the hotels in which she stays during her travels. The sites Feldman has depicted reflect her vacations and the various places she has lived (Hawaii, West Virginia, Utah, Alaska, Illinois, and Maryland among them); she rarely travels to a place specifically seeking out its visual data. For example, the journey to Hawaii that stimulated *Hawaiian Memory (Kauai)*, 1985 (colorplate 19), was planned around a visit to a college roommate. Once there, however, a flying session was an obvious necessity.

Feldman's early woodcuts employed methods and materials commonly used in the Western tradition: the use of several blocks for a multicolor piece, one block for each color printed; inking the blocks from a roller charged with oil-based printer's ink. Her work changed radically, however, in 1962, when she discovered some Japanese woodcuts in a Washington, D.C., gallery and became intrigued by their distinctively soft color quality and the nature of their surfaces. In the Japanese tradition, water-based, rather than oil-based inks are applied to blocks with a variety of brushes, not rollers.

Feldman learned the processes necessary to Japanese print-making from Unichi Hiratsuka, who had come to live in Washington at about the time her interest was stimulated. Having conquered the basic requirements of this approach, Feldman then explored further, becoming intrigued by another woodcut method, a linear approach that, combined with Oriental printing processes, has marked her prints for the past fifteen years. This "white-line" method of making woodcuts was especially popular with a group of artists working in Provincetown, Massachusetts, during the early years of this century.[2] The white-line approach calls for a spare, linear drawing of the entire image to be carved into a single block of wood, rather than making several color-separation blocks, each of which carries a portion of the image. The single carved block is then inked with as many colors as desired, each color locked into place by its surrounding carved furrow, which reads as a white line when the print is transferred to paper.

Although Feldman cuts the entire subject into a single block, she inks and prints the image section by section. Individual areas often are overprinted in several layers of a single hue to achieve the desired density and luminosity.[3] Feldman always prints on Japanese papers, the fibers of which are particularly sensitive to the water-based inks she prefers. The prints are usually preceded by drawings in pencil, charcoal, and sometimes pastel. In some drawings color decisions are fairly complete, while in others the composition alone is blocked in, leaving color to be worked out during the course of the printing.

While Feldman's broad, schematic shapes lack detail and careful refinement, the character of the drawing is marked by an exuberance and delight in the process of forming. Directly cut lines and textures set the stage for the dialogue of colors that follows. Her

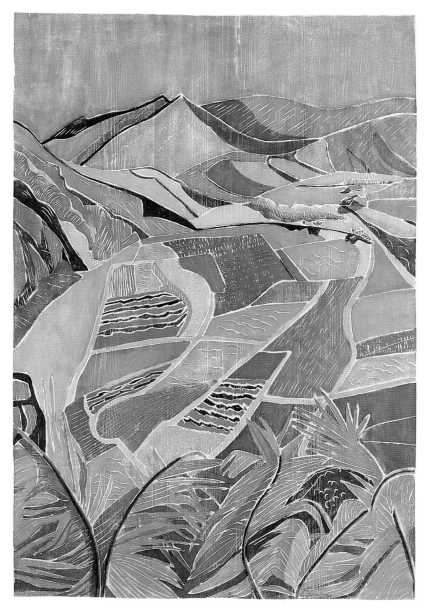
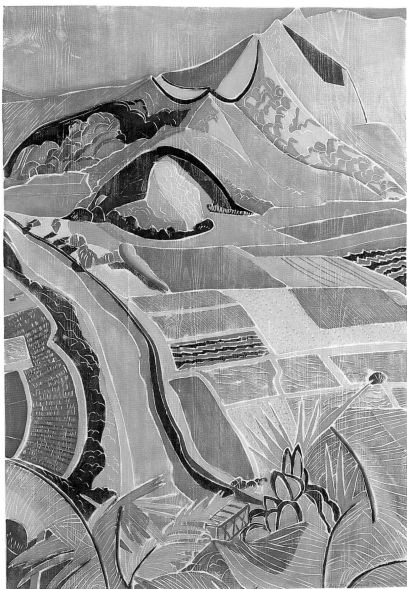

Colorplate 19

ALINE FELDMAN

Hawaiian Memory (Kauai)

broadly patterned images make no attempt to describe form specifically, but offer us a sense of the scheme of the land. In *Hawaiian Memory (Kauai)*, lush greens and quiet grays act as a foil for the hot reds and oranges, brilliant blues, and moody violets. Dark, thin shapes—almost lines—establish, for example, edges of slopes and heavy branches, and intensify the composition marked out by the white grooves. The overall distribution of shapes forms an irregular patchwork quilt, effectively establishing a flatness that is simultaneously denied by the movement back into depth set up by the color. In addition, the areas of color, separated by the white channels, are enriched with additional schematic cutting to offer variations in surface. The grain and other markings of the wood are enhanced by the differences in ink transparencies, functioning as an expressive element as well (pine, yellow poplar, and cherry are the woods Feldman most often uses). Scenes are drenched with the light created by a range of transparent hues. Like her shapes, her color is never literal, but she is usually influenced by the coloration of a particular locale: "You take what is there and make it more so." As in *Hawaiian Memory (Kauai)*, Feldman often works in multiple panels, increasing the impression of vastness. The subject, the nature of the landscape, with its attendant sense of movement and the growth of natural form, functions as a metaphor for life's changes. Landscape per se, however, is often subordinated to the interlocking jigsawlike planes that activate the surface.

In 1984 Feldman completed a three-panel woodcut mural for Mutual of New York's employee center in Purchase. The project introduced the cityscape into her art, and has been followed by a view of Baltimore's Inner Harbor area and studies of other cities, among them Philadelphia and Houston. More recently she has worked several prints of Maryland's eastern shore, seen from the land rather than from above. Her work is in a time of ferment, addressing new considerations both in subject and in vantage point.

1. Biographical information and all quotations come from a conversation with the author, 8 September 1986.

2. See Janet Flint, *Provincetown Printers: A Woodcut Tradition*, exhibition catalogue (Washington, D.C.: National Museum of American Art, 1983).

3. Until recently Feldman has done all of her printing alone, but she now works with an assistant several days a week.

CHECKLIST

Hawaiian Memory (Kauai), 1985.
Woodcut with hand coloring on Okawara paper (2 sheets).
Edition: 25.
Sheet size: 47¾ × 31¾ in. (126.2 × 80.7 cm) each.

Printed and published by the artist, Columbia, Maryland.
Lent by the Mount Holyoke College Art Museum, The Henry Rox Memorial Fund for the Acquisition of Works by Contemporary Women Artists.

HELEN FRANKENTHALER

Born New York, New York, 1928

■

*H*elen Frankenthaler earned her B.A. degree from Bennington College in 1949. While there she studied painting with Paul Feeley; she also studied with Vaclav Vytlacil at the Art Students League in New York, and with Rufino Tamayo and Hans Hofmann. Frankenthaler's first solo exhibition was at the André Emmerich Gallery, New York, in 1959, and since that time she has been one of the most highly respected and influential painters of the New York school.

Like many artists of her generation, Frankenthaler has a belief in the aesthetic importance of the risks of intuitive immediacy; she therefore set to making prints warily. The necessary technical demands of printmaking and the indirectness essential to the evolution of printed form undoubtedly seemed contrary to her style and methods. Yet Frankenthaler ruled the materials immediately and since 1961, when she made her first lithograph (discounting a few student exercises), she has completed a large body of work equal in beauty and significance to her canvases and unique works on paper. Her prints include works in lithography, screenprinting, etching, pochoir, woodcut, and monotype.

Fluid spontaneity, gestural immediacy, and sumptuous surfaces that seem magically to emerge from the support (whether canvas or paper) are all qualities associated with Frankenthaler's art, and she retains all in her prints.[1] It is remarkable that, in fact, she often works and reworks them, changing matrices and calling for extensive proofing sessions as she seeks the absolutely right shape or mark or color. Frankenthaler's exquisite sense of refinement has challenged the skills of several of the most talented master printers of our time (among them Robert Blackburn, Bill Goldston, and Kenneth Tyler); clear evidence of this may be seen in the numerous working proofs that exist for many of her printed images.[2] In working with these printers Frankenthaler has a very clear notion of the division of responsibility: "I want to draw my own images, mix my own colors, approve of registration marks, select paper— all the considerations and reconsiderations. Assuming that those who work in the workshop are artists at what *they* do, I can then entrust the actual duplicating process to other hands that pos-

sess—hopefully—*their* kind of magic. Sharing and participating to the end."[3]

East and Beyond, 1973 (colorplate 21), is Frankenthaler's first woodcut. Like her initial prints in lithography and etching, it was worked at Universal Limited Art Editions, West Islip, New York, and was developed in a similar spirit of exploration and invention. After experimenting with a variety of woodcutting tools, Frankenthaler grasped those properties of the wood that were sympathetic to her vision, and arrived at the use of a jigsaw for drawing. She found the jigsaw "the most freewheeling, fluid tool for getting into a woodcut, more than grooving with a knife into a wood surface or shading with splinter strokes."[4]

In all of Frankenthaler's prints, her choice of paper is of great importance. Color, surface, and weight all play a crucial role in the sheet's contribution to the quality of light emanating from the print. In *East and Beyond* a handmade Oriental sheet interacts with the grain of the inked wood surface. Sharp edges, modulated fields, and brilliant color come together to offer an experience as expansive (despite the relatively small size of the print) as that offered by Frankenthaler's monumental canvases.

Following *East and Beyond* by ten years, and after Frankenthaler had executed a number of beautiful woodcuts at both U.L.A.E. and Tyler Graphics, Ltd., in New York, the artist accepted Kathan Brown's invitation to make a print as part of the distinctive project initiated by Crown Point Press in which artists from the United States traveled to Kyoto, Japan, to work in the traditional Japanese manner, using water-based inks.[5] *Cedar Hill*, 1983 (colorplate 22), printed in ten colors from thirteen blocks of linden and mahogany (a coarse-grained wood that was an unusual choice for the Japanese method),[6] was the result of Frankenthaler's journey. In executing *Cedar Hill*, the artist bent the known methodology, transforming the Japanese processes to meet her own needs. In writing of Brown's staff from both California and Japan, Frankenthaler has told how they introduced her to new processes, such as the use of water-mixed raw pigment for printing. "They

also engaged me in various methods of woodcutting that before were unknown to me. By the same token, I opened them up to and insisted upon many of my Western techniques! It was a (often, anguishingly) beautiful experience."[7]

In *Cedar Hill* the wood is marked by striated carving that dances in an interplay with the wood's natural character. The transparent, water-based colors, layered onto a pale pink, handmade sheet, impart a luminosity that slowly reveals the forms floating in Frankenthaler's pulsating field.

Sure Violet, 1979 (colorplate 20), completed a few years earlier than *Cedar Hill*, beautifully exemplifies Frankenthaler's ability to transform a graphic medium with presumed limitations into a sympathetic painterly form. Working in sugar lift, aquatint, and drypoint, Frankenthaler created delicate modulations of surface juxtaposed with deeply etched areas that hold relatively thicker quantities of ink, and expanded on the aesthetic evident in her recent unique works on paper, which are marked by sumptuous bands of paint.[8]

Frankenthaler here makes the etching medium succumb to the sensations she wishes to convey. Her surfaces emerge slowly to form space as the print is studied: first an outer field of quiet blue-greens, then an inner field of tan moving into red-violet that increases in intensity as the color moves out at the top edge. Sweeps of bright, rich blue-greens and touches of deep ultramarine mark the horizontality of the field—the blue-green a similar hue to the outer field that almost frames, but without trapping, the central configuration. Thin red parallel lines flow across the center, liberated in some areas, kept in check elsewhere.

Lines cross, tones slowly become richer and denser, only to disappear. Shapes take form as the process evolves and the work conveys a sense of the passage of time, of the fluidity of experience. There is a feeling of controlled accident, of surface areas that were predictable only up to a point.

Here, as in all of her prints, Frankenthaler has invented the necessary approach: "Since I am essentially a painter, I never feel that work in another medium is a matter of reproducing what is on canvas. Rather it is my translation of my image in a new vocabulary."[9]

1. See Judith Goldman, "Painting in Another Language," *Art News* 74 (September 1975), 28–31.

2. Frankenthaler's prints to 1979 are recorded in *Helen Frankenthaler Prints, 1961–1979* (New York: Harper & Row, 1980). The catalogue documents the printers and publishers with whom Frankenthaler has worked and reproduces numerous trial and working proofs.

3. Helen Frankenthaler, "The Romance of Learning a New Medium for an Artist," *Print Collector's Newsletter* 8 (July–August 1977), 66.

4. Frankenthaler, "The Romance of Learning a New Medium," 67.

5. Another example is Judy Pfaff's *Yoyogi II*, colorplate 44.

6. Information from print documentation released by Crown Point Press for *Cedar Hill*.

7. Helen Frankenthaler, "News of the Print World: People & Places, To the Editors," *Print Collector's Newsletter* 16 (May–June 1985), 53.

8. See Karen Wilkin, *Frankenthaler: Works on Paper 1949–1984*, exhibition catalogue (New York: International Exhibitions Foundation and George Braziller, 1984).

9. Frankenthaler, "The Romance of Learning a New Medium," 66.

CHECKLIST

Sure Violet, 1979.
Sugar-lift, aquatint, and drypoint on TGL handmade paper.
Edition: 50.
Sheet size: 31¼ × 43⅜ in. (79.4 × 110.2 cm).
Printed by Rodney Konopaki, Lee Funderburg, Bob Cross, and Roger Campbell at Tyler Graphics Ltd.; published by Tyler Graphics Ltd., Bedford Village, New York.
Lent by the Walker Art Center, Minneapolis; Tyler Graphics Archive

East and Beyond, 1973.
Woodcut on Nepalese handmade paper.
Edition: 18.
Sheet size: 31⅛ × 22 in. (80.4 × 55.8 cm).
Printed by William Goldston, James V. Smith, and Judah Rosenberg at

Universal Limited Art Editions; published by Universal Limited Art Editions, West Islip, New York.
Lent by Morton and Carol Rapp

Cedar Hill, 1983.
Woodcut on tinted Mingei Momo paper.
Edition: 75.
Sheet size: 20¼ × 24½ in. (51.5 × 62.3 cm).
Printed by Tadashi Toda, Japan; published by Crown Point Press, Oakland, California.
Lent by the Mount Holyoke College Art Museum, The Henry Rox Memorial Fund for the Acquisition of Works by Contemporary Women Artists

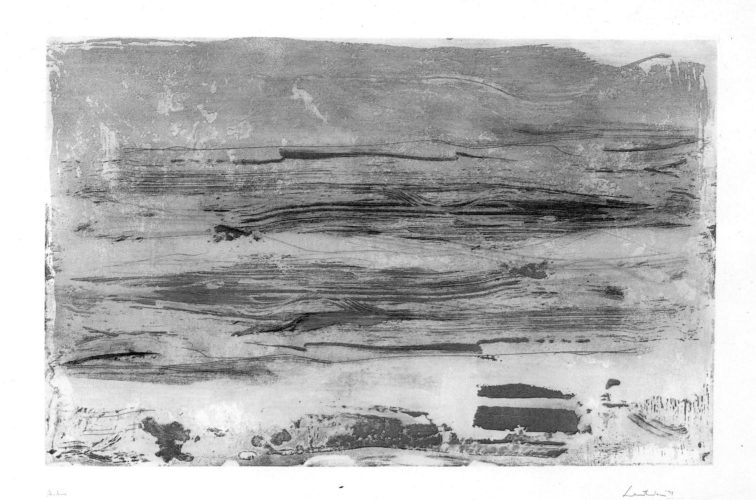

Colorplate 20

HELEN FRANKENTHALER

Sure Violet

Colorplate 21

HELEN FRANKENTHALER

East and Beyond

Colorplate 22

HELEN FRANKENTHALER

Cedar Hill

SONDRA FRECKELTON

Born Dearborn, Michigan, 1936

■

Sondra Freckelton paints watercolors and makes prints of still lifes, a subject of considerable interest to artists during the past several decades.[1] Freckelton's arrangements include fruits and vegetables, plants and flowers, quilts and country furniture, and colorful gardens at the height of their season. Her emphasis within this domestic genre is on kitchen objects—uncooked foodstuffs and bowls, for example; things that one thinks of as informal, cozy, rather than things one might find in the library or sitting room, or even food elegantly arrayed, as in the seventeenth-century Dutch still-life tradition.

The extraordinary finish with which Freckelton invests her watercolors, and their large size, are more readily associated with oil painting. In her choice of watercolor she has elected to paint in a medium that is associated with intimacy, rather than the more heroic painting tradition of oils.

Freckelton lives and works in Oneonta, New York, and New York City. She studied at the School of the Art Institute of Chicago from 1954 to 1956, and started her career as a sculptor, working in wood and plastics under the name of Sondra Beal (her husband is the painter Jack Beal). She shifted direction from abstraction to realism, and from sculpture to painting, in the early 1970s. Her experience in working in three dimensions has served her well, however, for the objects in her paintings are rendered with convincing volume. Indeed, this notion of working in an intimate medium, depicting humble objects, is ironic. Freckelton invests her objects with as grand and heroic an attitude as one might find in a nineteenth-century landscape depicting the vast American West. By making everyday objects larger than life, brilliantly colored, and sharply defined, Freckelton seems, in fact, to be challeng-

ing our notions of what heroic media and subjects really are, and to tell us that what she does is heroic too.

In prints, in addition to lithography (direct and offset) and screenprinting, both represented here, Freckelton has also worked in the stencil process of pochoir. She works from direct perception rather than from photographs.[2] Her carefully planned compositions deny the casualness implied by the subject. The use of shadows to enhance some forms but not others is a rejection of absolutely literal description. Freckelton's still lifes are immaculate. In her offset lithograph *Plums and Gloriosa Daisies*, 1980 (colorplate 23), the fruit and flowers are impeccably formed, the quilt stitched to perfection. Light floods the scene as if to confirm that all is right with the world.

In *Blue Chenille*, 1985 (colorplate 24), a screenprint printed from eighteen stencils, the forms are voluptuous, with an emphasis on shape and heightened color defined by a flood of light similar to that in *Plums and Gloriosa Daisies*. These qualities are extended in *Openwork*, 1986 (colorplate 1), a screenprint recently undertaken as part of the Mount Holyoke College printmaking workshop program.

There is a sense of joy and abundance and insistence in Freckelton's imagery, a fullness of form, implying a super-healthy harvest. Not only does she depict real vegetables, but often porcelain ones too: a tureen decorated with cabbages, for example, or a teapot in the form of a tomato, or flower vases decorated with flowers. Mirror images often play a role in her work as well, extending the pictorial space and adding a further level of reality to the scene.

Freckelton's art is exceedingly skillful and smooth, with the hand of the artist played down rather than displayed. Before begin-

ning a piece, either painting or print, she does considerable preliminary planning, involving a variety of media. Crucial to her art are the vibrancy of colors, the luminosity of each form, the accuracy of surface variations. To achieve and maintain these visual properties is technically challenging when working in the transparent media that Freckelton explores in both her paintings and her prints.[3]

1. See Linda L. Cathcart, *American Still Life, 1945–1983*, exhibition catalogue (Houston: Contemporary Arts Museum, and New York: Harper & Row, 1983). Interestingly, Freckelton is not included in this exhibition, but her husband, Jack Beal, is. His painting, entitled *Still Life Painter* (reproduced p. 44), shows Freckelton at work, peering out from behind one of her abundant still lifes composed of a begonia plant, fruit bowl, woven basket, and quilts.

2. Alvin Martin, "Facing Reality: Twentieth Century American Realist and Realistic Drawings in Perspective," *American Realism: Twentieth Century Drawings and Watercolors from the Glenn C. Janss Collection*, exhibition catalogue (San Francisco: San Francisco Museum of Modern Art, and New York: Harry N. Abrams, 1986), 153.

3. For an account of Freckelton's watercolor procedures, see Sondra Freckelton, "The Watercolor Page," *American Artist* 47 (July 1983), 42–47 and 97–98.

CHECKLIST

Openwork, 1986.
Screenprint on Rives BFK paper.
Edition: 67.
Sheet size: 21⅝ × 28 in. (54.9 × 71.1 cm).
Printed by Norman Stewart at Mount Holyoke College and Birmingham, Michigan; published by Mount Holyoke College, South Hadley, Massachusetts, Alice Simsar Gallery, Ann Arbor, Michigan, Gryphon Gallery, Grosse Pointe Farms, Michigan, the artist, and Stewart & Stewart, Printer/Publisher, Birmingham, Michigan.
Lent by the Mount Holyoke College Art Museum, Gift of the Mount Holyoke College Printmaking Workshop

Plums and Gloriosa Daisies, 1980.
Offset lithograph on Arches Cover paper.
Edition: 150.
Sheet size: 28¾ × 24¼ in. (73 × 61.6 cm).
Printed by Joe Petruzzelli at Siena Studios, New York; published by Brooke Alexander, Inc., for the benefit of the Grace Church School Scholarship Fund, New York.
Lent by the Mount Holyoke College Art Museum, Gift of Alice Simsar

Blue Chenille, 1985.
Screenprint on Rives BFK paper.
Edition: 56.
Sheet size: 29½ × 21½ in. (74.9 × 54.6 cm).
Printed and published by Stewart & Stewart, Printer/Publisher, Birmingham, Michigan.
Lent by Stewart & Stewart, Printer/Publisher, Birmingham, Michigan

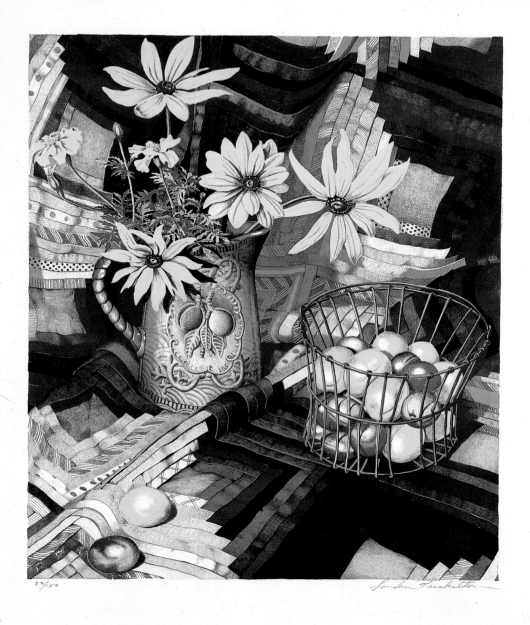

32/150 Sondra Freckelton

Colorplate 23

SONDRA FRECKELTON

Plums and Gloriosa Daisies

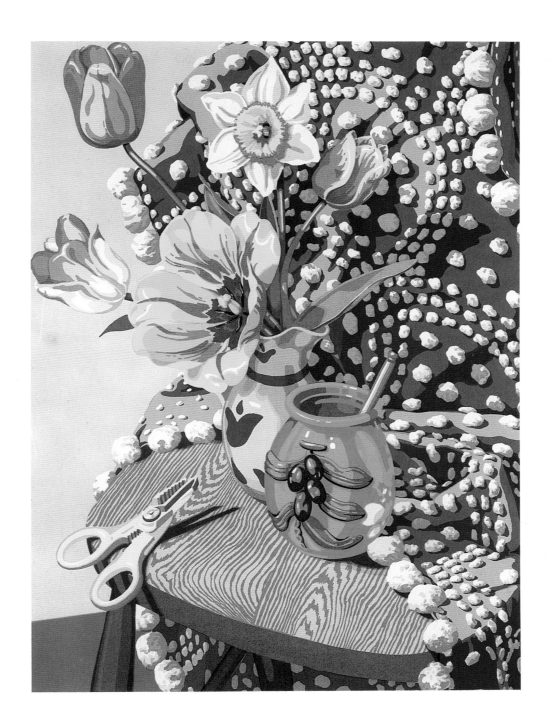

Colorplate 24

SONDRA FRECKELTON

Blue Chenille

JANE FREILICHER

Born Brooklyn, New York, 1924

■

*J*ane Freilicher studied at Brooklyn College, receiving her B.A. in 1947. She earned an M.A. from Columbia University the following year, during which she also studied with Hans Hofmann, both in New York and in Provincetown. She says of him, "What you really caught was the contagion of art—what it meant to be an artist—the seriousness of it and then also developing a sensitivity and responsiveness to measure, value, and proportion, and care for the vitality of the surface."[1]

Freilicher's career began at a point when abstraction dominated art in America; yet she has steadfastly remained a figurative artist, working directly from life in New York and, since the early 1960s, at her summer home in Water Mill, Long Island.

Apparent in Freilicher's art is her delight in looking at places and things. Light drenches her paintings and prints, pressing through windows or shining directly upon land and water. There is a deceptive casualness about her compositions: the still lifes seem to be almost offhandedly in front of windows, and the landscapes appear to be those she simply happens upon; but the repetition of her selections and her great familiarity with them make it obvious that they are indeed selected with great care—arranged, one might say, so that the position of the artist establishes the arrangement.

Facture further structures Freilicher's compositions. One is aware of air in her art, the soft application of color enhancing space in its most fluid aspect, the color itself alluding to a heightened experience of the natural world. "I am interested in feelings—in making something from my own experience have a universal appeal. The old eternity-in-a-grain-of-sand syndrome is a way of justifying my relatively small field of subject matter."[2]

There is often an awkwardness to Freilicher's forms, an awkwardness one sees as an intentional means of balancing and offsetting any prettiness. Her attention is equally on the site and on the painting, and her work informs us that mirrorlike representations tell less about seeing than does a felt repositioning of the observed world. In discussing Freilicher's art, the poet John Ashbery, a friend of the artist since 1949, has aptly suggested that "lesser

artists correct nature in a misguided attempt at heightened realism, forgetting that the real is not only what one sees but also a result of how one sees it—unattentively, inaccurately, perhaps, but nevertheless that is how it is coming through to us and to deny this is to kill the life of the picture." Ashbery goes on to suggest that Freilicher's career "has been one attempt . . . to let things, finally, be."[3]

Freilicher's paintings and prints are imbued with the cohesion of process and image. Although she has not made very many prints, she has nonetheless worked in a variety of processes—in lithography as well as etching and the stencil method of pochoir seen here.

Flowering Cherry, 1978 (colorplate 25), derived from the 1977 painting *Cherry Blossoms Painted Outdoors* (the tree is in the artist's backyard in Water Mill), is the artist's first print in pochoir. All essentials of the painted composition were retained as it was translated to print. Typical of Freilicher's landscapes, there is an element of architecture, a rigid geometric form setting off the gracefulness of nature and functioning as an allusion to two kinds of reality. At times this architectural form is a section of Freilicher's studio, so that the artist or viewer is looking out to the landscape rather than surrounded by it, as in *Flowering Cherry*. Freilicher has suggested that the coordination of architecture and landscape may be "a way of asserting control—may be also to indicate another subjective level, the simultaneous experience of an interior and outside world, closure and openness."[4]

The etching *Poppies and Peonies*, 1983 (colorplate 26), based on a 1981 oil of the same subject, sets up another sort of duality. Not only is an architectural element (or at least a geometric, man-made element)—the table—set against amorphous natural forms, but nature itself is depicted in two aspects. The flowers, tame, even captured, in a jar, are set off against dappled green grasses and bushes and the blues of the water and sky. As in her painting, Freilicher has grasped in aquatint the subtle distinctions of hue that offer a sense of the formal life of the scene.

Freilicher's layered spaces, her atmospheric skies, her respect for the beautiful aspects of her surroundings, awaken us to these qualities and invite us to participate in a serenity that we tend to forget exists. Despite clear input from American gestural abstraction, Freilicher's primary sources are in French painting, the Intimist works of Henri Matisse, Édouard Vuillard, and Pierre Bonnard, and her paintings and prints, like theirs, have the power to delight and sustain us if we submit to them.

1. Quoted in Robert Doty, "Interview with the Artist," *Jane Freilicher: Paintings*, exhibition catalogue (Manchester, New Hampshire: The Currier Gallery of Art, 1986), 47.

2. Margaret Mathews, "Jane Freilicher," *American Artist* 47 (March 1983), 78.

3. John Ashbery, "Jane Freilicher," *Jane Freilicher: Paintings*, 21.

4. Quoted in Doty, "Interview," 51–52.

CHECKLIST

Flowering Cherry, 1978.
Pochoir on Arches Cover paper.
Edition: 68.
Sheet size: 30 × 30¼ in. (76.2 × 76.8 cm).
Printed by Chip Elwell, New York; published by Orion Editions, New York.
Lent by the Mount Holyoke College Art Museum, The Henry Rox Memorial Fund for the Acquisition of Works by Contemporary Women Artists

Poppies and Peonies, 1983.
Etching and aquatint on Rives BFK paper.
Edition: 50.
Sheet size: 36¾ × 36⅞ in. (93.4 × 93.8 cm).
Printed by Condeso–Brokopp, New York; published by 724 Prints Inc., New York.
Lent by Jane Freilicher

Colorplate 25

JANE FREILICHER

Flowering Cherry

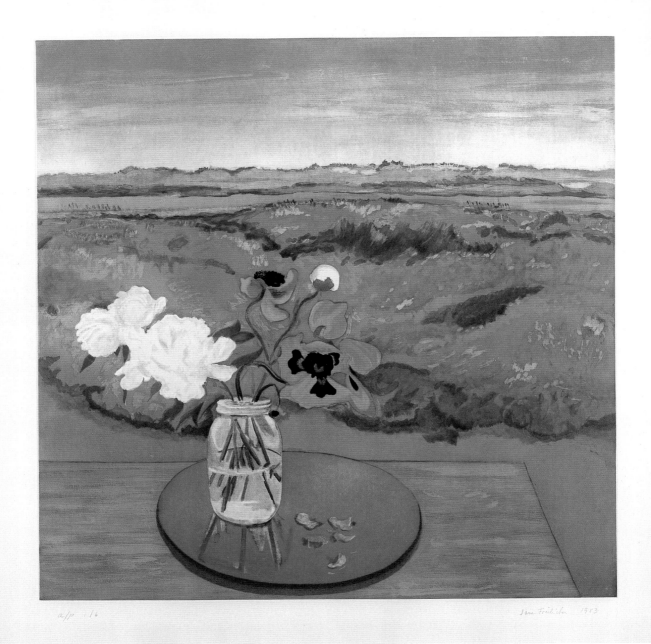

a/p 16 Jane Freilicher 1953

Colorplate 26

JANE FREILICHER

Poppies and Peonies

NANCY GRAVES

Born Pittsfield, Massachusetts, 1940

■

Nancy Graves has worked as a painter, sculptor, printmaker, filmmaker, and set designer. Each of these aspects of her work has been explored in a variety of materials, processes, and conceptual means. Graves draws her references not only from art, but also from anatomy, botany, geology, meteorology, anthropology, and ethnology. Her father was an administrator of the Berkshire Museum, which attended to science, history, and art, and the childhood hours she spent there, immersed in exhibits from all three fields, undoubtedly set the direction for her broad intellectual curiosity. Much has been made of her interest in fields other than art, but she is equally inquisitive about art history, traveling widely and studying closely. Her interests range from Chinese garden sculpture to the paintings of Titian, Francisco de Goya, and Peter Paul Rubens; asked the importance of other art to her own, Graves responds, "I don't think about it qualitatively. I think what I can do with it."[1]

Graves graduated from Vassar College with a degree in literature, and earned her B.F.A. and M.F.A. degrees in painting from the Yale University School of Art and Architecture. She lived in Europe for two years in the mid-1960s, starting in Paris in 1965 on a Fulbright-Hayes Fellowship. Although she spent the early part of this sojourn painting, in Florence she became intrigued by the work of an eighteenth-century anatomist, Clemente Susini. Susini made life-size wax models of human and animal bodies, and Graves's interest in his work had an immediate impact on her own, shifting its emphasis from painting to sculpture for the next several years.

After a number of preliminary efforts at building animal structures using a variety of materials, Graves began constructing life-size camels (some of them made of wood, steel, burlap, polyurethane, skin, wax, and oil) that functioned symbolically in her effort to make art out of anything, as well as being a metaphor for the clash she was feeling between the drama and mystery of the ancient past and a society dependent upon a plethora of immediate information from a plethora of sources.[2] Graves moved from whole camels to their bones as she began to focus on structure, "questioning a post-Brancusi, post-Andre, late '60s notion of armature,"[3] and later developing her ideas to form pieces that carried mythic, ritualistic overtones of shamanism. Although Graves was not concentrating on painting during the period between 1966 and 1971, she continued to draw, often using color and, in effect, making paintings on paper.

Although in the 1980s Graves has again given considerable attention to sculpture,[4] in the early 1970s her major emphasis had shifted back to painting. Her sources included amphibians, reptiles, and insects with camouflage surface markings, and she used geology as a point of departure, basing her work on maps and charts of Mars, the moon's surface, the ocean floor, on aerial photographs of Antarctica, and on images of microscopic organisms. She sought out the concrete things and places that are known to us through abstract representations. As always, the source images were transformed by Graves, and unexpected changes took place as she worked. "But," as she noted, "the content must adapt itself to my concerns which are primarily those of creating a new way of seeing."[5]

At first the paintings were composed of patterns of dots, building into densely packed surfaces.[6] As the work developed, however, Graves's images became increasingly abstract. By 1976 she had moved away from specific geologic references, and both image and color were seen to be independent of their sources. Color was serving expressive pictorial functions without descriptive references. It is in this context that the print *Ngetal* (colorplate 27) may be placed.

Ngetal is one of six etchings completed at Tyler Graphics between January and August 1977. They coordinate the processes of etching, aquatint, drypoint, engraving, and pochoir. All six have additions hand drawn by Graves after the completion of the edition printing. *Ngetal* is especially rich in this respect: of twenty colors, sixteen are printed, followed by four (a green, an orange, a blue, and a gray) directly drawn in pastel and paintstick.

In all of the prints a linear patterning is layered by means of the etching process itself. For example, the sixteen printed colors in *Ngetal* are printed several at a time from three successive copper plates, so that a physical layering structures the implied visual layering. The images are open, rather than dense (one entitled *Ruis* is an exception), and they reflect Graves's paintings and drawings at this time.[7] Each colored gesture has autonomy, does its own dance, is wholly of a piece, and yet each is also essential to the orchestration of the work in its entirety. The quality of each color is determined by the method used to make the mark.

During her second working session at Tyler Graphics, in 1981, Graves completed three prints in editions, *Calibrate* (colorplate 3) among them. She also produced a group of thirty-one monotypes worked from varying combinations of etched plates. One of these, *Alloca* (colorplate 28), with *Calibrate*, makes evident the greater density of Graves's works on paper during this later period. Rather than an open field with marks floating freely, these works are richly and densely overprinted. Strokes are no longer delicate, but explosive and forceful; and the colors, too, are intense and anxious, rather than pastel and ethereal in mood and effect.

The weight of the metal with which she was working in sculpture seems implied in the handling of her two-dimensional marks. And the flow of ribbonlike forms into space is essential as well. As in the earlier prints, abstract markings move across the sheet. In *Alloca*, however, one senses sources in nature—references, for example, to flowers and trees; and in *Calibrate* zones of brilliant pink, red, black, and white function as fields and refer back to some of Graves's earlier mapping strategies. In all of her prints the speed of Graves's assured strokes is a fast one, reflecting the same knowledgeable, confident searching that has distinguished her work in all other media.

1. Elizabeth Frank, "Her Own Way," *Connoisseur* 85 (February 1986), 60.

2. Avis Berman, "Nancy Graves' New Age of Bronze," *Art News* 85 (February 1986), 60.

3. Nancy Graves, quoted in Linda L. Cathcart, *Nancy Graves: A Survey 1969/1980*, exhibition catalogue (Buffalo: Albright-Knox Art Gallery, 1980), 14.

4. See Debra Bricker Balken, *Nancy Graves: Painting, Sculpture, Drawing, 1980–1985*, exhibition catalogue (Poughkeepsie, New York: Vassar College Art Gallery, 1986); and E. A. Carmean, Jr., et al., *The Sculpture of Nancy Graves: A Catalogue Raisonné* (New York: Hudson Hills Press in association with the Fort Worth Art Museum, 1987).

5. Joan Seeman, unpublished interview with Nancy Graves, New York, 6 June 1979; quoted in Cathcart, *Nancy Graves*, 22.

6. See Jay Belloli, *Nancy Graves*, exhibition catalogue (La Jolla, California: La Jolla Museum of Contemporary Art, 1973).

7. For a discussion of Graves's paintings at this time see Susan Heinemann, "Nancy Graves: The Paintings Seen," *Arts* 51 (March 1977), 139–41.

CHECKLIST

Calibrate, 1981.
Etching, aquatint, soft-ground etching, engraving, and lithograph on Lana mouldmade paper.
Edition: 30.
Sheet size: 29¼ × 32¾ in. (74.3 × 83.2 cm).
Printed by Rodney Konopaki and Kenneth Tyler at Tyler Graphics Ltd.; published by Tyler Graphics Ltd., Bedford Village, New York.
Lent by Helen and Paul Anbinder

Ngetal, 1977.
Etching, aquatint, engraving, pastel, and solidified oil-paint stick on Arches Cover 300 paper.
Edition: 33.
Sheet size: 32 × 35½ in. (81.3 × 90.2 cm).
Printed by Rodney Konopaki at Tyler Graphics Ltd.; published by Tyler Graphics Ltd., Bedford Village, New York.
Lent by the Mount Holyoke College Art Museum, The Henry Rox Memorial Fund for the Acquisition of Works by Contemporary Women Artists

Alloca, 1981.
Monotype on colored TGL handmade paper.
From a group of 31 monotypes.
Sheet size: 32 × 44½ in. (91.3 × 113 cm).
Printed by Kenneth Tyler, Lee Funderburg, and Roger Campbell at Tyler Graphics Ltd.; published by Tyler Graphics Ltd., Bedford Village, New York.
Collection Walker Art Center, Minneapolis; Gift of Dr. Maclyn E. Wade, 1984

Colorplate 27

NANCY GRAVES

Ngetal

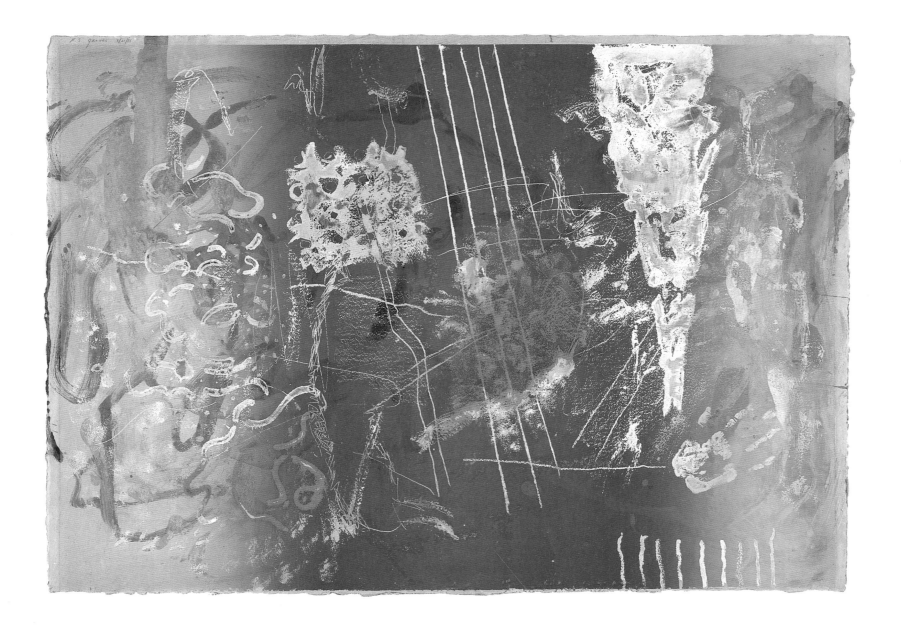

Colorplate 28

NANCY GRAVES

Alloca

YVONNE JACQUETTE

Born Pittsburgh, Pennsylvania, 1934

■

Yvonne Jacquette's views of dense, urban geometry, cavernous spaces such as those in *Aerial View of 33rd Street*, 1981, and *Northwest View from the Empire State Building*, 1982 (colorplates 29 and 30), based on one panel of a painted triptych, spring from an amalgam of sources, both abstract and representational: carefully controlled Bauhaus design introduced to her while she was a student at the Rhode Island School of Design in Providence (1952–56); the luminosity and sensuous brushwork of Impressionism, examples of which she studied firsthand at the museum adjacent to the school; the raw energy and broad gestural approach of Abstract Expressionist painting that she later sought in New York; and the Minimalist concerns of many of her contemporaries.

Working in New York in the late 1950s, Jacquette was eager that her work reflect her responsiveness to the city: "I remember Joan Mitchell at that time seemed to me to be a model for an artist who was working with that. Not so much specifically New York, but an attempt to interpret landscape in a form so that there was still a trace of the visual aspect of nature. The scene was not just an idea about structure but could incorporate the outward appearance too."[1]

For a brief period Jacquette, like Mitchell, painted in an Abstract Expressionist mode, but by the early 1960s her interest had shifted to making meticulous drawings and paintings of stark interiors with clearly defined forms: ceilings, corners, and so forth. The technical drafting skills that she was using to support herself fitted well with this shift in direction. Formal ideas of delineation took shape in her painting, and the code of Jacquette and many of her associates at the time was to "see what you can do with as little as possible—and see if it gets stronger that way."[2] Everything was very smoothly rendered, with surfaces that were flat and underplayed.

In 1965 Jacquette and her husband, the photographer and filmmaker Rudolph Burckhardt, along with the poet and critic Edwin Denby, bought a farm in Searsmont, Maine, where Jacquette has since spent part of each year, away from the spare, industrial components of the city that until then had dominated her visual consciousness. The fluidity of natural forms and the brilliance of color heightened by outdoor light, unmediated by skyscrapers, had a powerful impact on her vision. She turned to the landscape for subject; her interest in urban landscape followed on that of the country. She began to work outdoors in the city during the winter, as well as in the country during the summer: "When it got really cold, I would just run home and warm up."[3]

Many of Jacquette's early landscapes focused on clouds, and she often worked in series devoted to a single scene on several days. Her interest in time sequences and light changes may have some roots in Burckhardt's involvement with film narrative, and Jacquette has connected some of her paintings and prints of New York with his still photographs of the city dating from the 1930s and 1940s.[4]

Jacquette started making flights in airplanes in 1973, in order to look out, rather than up, at the clouds. Looking out at clouds soon led to looking down at the land. Aerial views, either from planes or from tall buildings, have occupied the artist's attention for the past several years; and some works from the early 1980s, views of patchwork Midwestern farms, show renewed interest in clouds, hovering low, casting their shadows on the land below.

Jacquette has trained her eye and mind to remember keenly what she has seen, and her work is based on a combination of drawings, photographs, memory, and invention. She does many small studies, using these preliminary works to refine her thoughts about such things as the structure of her densely worked strokes. As in the final paintings and prints, the staccato hatch-marks composing the drawings and studies are rendered in layers, giving a pulsating spatial density to the images. This is particularly effective in the graphics. Projected slides of the drawings are often the starting point for more finished works.[5]

Jacquette's transcriptions of the site seen are never realistic or literal, regardless of how detailed they may be, but are selectively

rendered and synoptic. When she uses color, it too is derived from the site, and is used locally in zones, adding to the atmospheric qualities of the drawing and enhancing the structural divisions of space as well as the patterning across the surface, a patterning that has aptly been associated with the art of Maurice Prendergast.[6]

Although Jacquette has worked in many cities—among them Tokyo, Minneapolis, and Washington, D.C.—New York, the city that intrigued her in the mid-1950s, continues to be important in her art. That she lives there and can return to a scene repeatedly enables her to continue to mine the city for new ideas and sites. Night scenes such as *Aerial View of 33rd Street* and *Northwest View from the Empire State Building* have dominated Jacquette's work since 1978, when she made frequent evening visits to her friend Denby, who was hospitalized at the time. His concern that she was losing too much time from her work by keeping him company led her to work in his hospital room, depicting the view from the window.[7]

In working her images of night, Jacquette often works in semidarkness so as to maintain the consistency of her vision. Indeed, she has found it helpful to know a place both by day and by night—by night to capture effects of light and color accurately, by day to get a clear sense of a place's structure. A sense of the city's movement, its activity, its drama is developed from the quality of flickering luminosity. While figures are at times visible in Jacquette's work, they are subdued and small scale; more often, their presence in large numbers is implied by the dialogue of myriad lights.

In an unpublished statement of 1979 for a proposed dictionary of women artists, Jacquette wrote to explain some of her thoughts on painting that may be held true for her work in printmaking as well: "I'm interested in paint suggesting atmosphere and movement and a moment when the dizzying perspective makes the landscape most intense. Seeing is played off against memory and unconscious understandings."[8]

1. Quoted in Kate Horsfield (interviewer), "On Art and Artists: Yvonne Jacquette," *Profile* 2 (November 1982), 6.

2. Horsfield, "Jacquette," 10.

3. Horsfield, "Jacquette," 16.

4. Horsfield, "Jacquette," 12.

5. Carter Ratcliff, "Yvonne Jacquette: American Visionary," *Print Collector's Newsletter* 12 (July–August 1981), 66.

6. Ratcliff, "Yvonne Jacquette: American Visionary," 68.

7. Edgar Allen Beem, "A View from Above," *Maine Times* (25 July 1986), 26. See note 3 in Mangold essay, p. 111, for further comments on night imagery. For recent night views by Jacquette see *Yvonne Jacquette: Tokyo Night Views*, exhibition catalogue (New York: Brooke Alexander, and Brunswick, Maine: Bowdoin College Museum of Art, 1986).

8. The statement, in a letter to Lamia Doumato dated 20 August 1979, is on file at the National Museum of Women in the Arts, Washington, D.C.

CHECKLIST

Aerial View of 33rd Street, 1981.
Lithograph on Transpagra vellum.
Edition: 60.
Sheet size: 47½ × 31 in. (120.7 × 78.8 cm).
Printed by John C. Erikson at Siena Studio, New York; published by Brooke Alexander, Inc., New York.
Lent by the Mount Holyoke College Art Museum, The Henry Rox Memorial Fund for the Acquisition of Works by Contemporary Women Artists

Northwest View from the Empire State Building, 1982.
Lithograph on Transpagra vellum.
Edition: 62.
Sheet size: 51 × 35 in. (129.5 × 88.9 cm).
Printed by John C. Erikson and Joe Petruzzelli at Siena Studio, New York; published by Brooke Alexander, Inc., New York.
Lent by Brooke Alexander, New York

Colorplate 29

YVONNE JACQUETTE

Aerial View of 33rd Street

Colorplate 30

YVONNE JACQUETTE

Northwest View from the Empire State Building

ELAINE DE KOONING

Born New York, New York, 1920

■

*E*laine de Kooning, a key participant in the New York School since the 1940s, is widely known not only for her paintings and prints but also for her writings on art, especially her articles in *Art News* during the late 1940s and 1950s. As an artist herself, de Kooning brought special insight to her articles about painters at work (among them Karl Knaths, Hyman Bloom, and Hans Hofmann) and her reviews of exhibitions and books. That the art world at that time was essentially a male world was indicated, if only casually, in the opening of her *Art News* review of books on the female nude, where she noted that "the two books were delivered one sunny afternoon in a house full of painters (mostly male)."[1] De Kooning is a highly respected teacher as well as a painter, printmaker, and writer, and she has had numerous art-school and university appointments.

In 1936 and 1937, in New York City, de Kooning attended Hunter College briefly, the Leonardo da Vinci Art School, and the American Artist's School, where Social Realism was the dominant style. She soon moved in another direction, however. After she came to know Arshile Gorky and Willem de Kooning (to whom she was married in 1943), she immersed herself in the salient painterly issues of the period, her interest in figuration taking life within formal and gestural concerns. De Kooning accompanied her husband to Black Mountain College, in North Carolina, where he taught during the summer of 1948; she took classes with Josef Albers and Buckminster Fuller and studied dance with Merce Cunningham.[2] Thus, as a young painter, she was in close touch with some of the most imaginative and influential cultural ideas of the time.

De Kooning's first New York exhibition took place at the Stable Gallery in 1952, the year after she participated in the now legendary Ninth Street exhibition of Abstract Expressionist art, as did Helen Frankenthaler and Joan Mitchell. Her work at that time displayed her attraction to the turbulent, emotion-filled images of the Spanish painter El Greco, particularly his vigorous brush-work.[3] Indeed, throughout her career de Kooning's work has always had strong elements of action and drama.

Although de Kooning came to maturity during a period in which abstraction was considered the primary direction of artistic importance, figuration remained central to her work. Many of her early paintings were portraits of men in which a likeness was achieved as part of the dominant activity and gestures of the figures. Environments, too, were loosely and atmospherically defined. "For me, doing portraits is an addiction. I don't choose to do portraits—I just do them."[4] While portraiture has been an enduring interest of the artist (she was working on a painting of John F. Kennedy at the time of his assassination), several other subjects have been important to her as well. De Kooning tends to devote considerable periods of time to specific themes. One of these has been groups of figures in action: basketball and baseball encounters date from the 1950s, and during the 1970s and early 1980s she worked a series of paintings, drawings, watercolors, and prints based on a statue of Bacchus in the Luxembourg Gardens in Paris.[5]

De Kooning's work since 1983 has been inspired by prehistoric animal images painted on the walls of caves in southern France, images that are embedded in our imagination as the foundation of human image making. When de Kooning first visited the caves she was struck by the extraordinarily lifelike quality with which the animals were imbued, and she was inspired by the atmosphere of mystery and magic that she sensed in the subterranean caverns.[6] Slicing through millennia, de Kooning has reminded us of these extraordinary pictographs while producing her own images of bison and horses, pictures firmly enmeshed in the art of our own time. Her gestural brushwork evokes the speed of striding beasts, while the drips and drops of facture remind us of her ever-present painterly concerns.

In 1983, the year she began working with the cave imagery, de

Kooning was invited to be the first artist to participate in the Mount Holyoke College artist-in-residence print-publishing program. She completed five lithographs (four printed in black and one in three colors) entitled the Lascaux series, exemplary of her cave images.[7]

As evident in *Lascaux #3* and *Lascaux #4*, both 1984 (colorplates 31 and 32), the prints are composed of broad, sweeping strokes that activate surfaces and enclose forms. The immediacy of de Kooning's gesture exudes the artist's assured approach to both subject and material. Lithography has been thought of as the most painterly and direct of the printmaking processes, and de Kooning's direct drawings with tusche wash and lithographic crayon onto stone explicate this view with virtuosity. Velvety darks result from her layering of strokes, and the tone of the sheet plays an active role in her compositions. Space is compressed as animals and elements of implied landscape (or implied rock surface) are layered in bands, one above another. The weight and solidity of the animals in motion are conveyed by the character and placement of her incisive marks: their precise length and thickness, the nature of their flow—the stops and starts that build form as well as structuring space. De Kooning seems also to be trying to re-create the textured surface qualities of the cave walls.[8]

De Kooning has made prints at several workshops, including Tamarind Institute in New Mexico and Crown Point Press in California. At the latter she completed several prints on the cave theme, among them a series of eight etchings entitled Torchlight Cave Drawings. In them, as in the Mount Holyoke lithographs, the speed of animals in motion is conveyed by long, sweeping strokes. Expansive drawn gestures are crucial to the development of these challenging images. The action of the artist's arm is ever present, even in this relatively small scale.

1. Elaine de Kooning, "Venus, Eve, Leda, Diana, et al.," *Art News* 52 (September 1953), 20.

2. For de Kooning's account of this period see Elaine de Kooning, "De Kooning Memories," *Vogue* (December 1983), 352–53, 393–94.

3. See the transcript of a taped conversation with Elaine de Kooning edited by Bruce Duff Hooton, "'My first Exhibit. . . . To now'—Elaine de Kooning," *Art World* (October 1982); the article is on file at the library of the National Museum of Women in the Arts, Washington, D.C.

4. Gerrit Henry, "The Artist and the Face: A Modern American Sampling, Ten Portraitists: Interviews/Statements," *Art in America* 63 (January–February 1975), 35.

5. See Rose Slivka, "Elaine de Kooning: The Bacchus Paintings," *Arts* 57 (October 1982), 66–69.

6. See Crown Point press release [1985, Oakland, California], announcing the new etchings by Elaine de Kooning. One may track de Kooning's interest in this animal subject to a much earlier time, however. A painting entitled *Bullfight*, similar in spirit to the works inspired by the cave paintings, is reproduced in the catalogue for the 1972 exhibition of de Kooning's work at the Tyler Museum of Art in Tyler, Texas.

7. For paintings related to the present prints see *The Time of the Bison*, exhibition catalogue (New York: Gruenebaum Gallery, 1986).

8. This observation was suggested by Wendy M. Watson.

CHECKLIST

Lascaux #3, 1984.
Lithograph on Arches paper.
Edition: 16.
Sheet size: 15 × 21 in. (38.1 × 53.4 cm).
Printed by John Hutcheson at Mount Holyoke College; published by Mount Holyoke College, South Hadley, Massachusetts.
Lent by the Mount Holyoke College Art Museum, Gift of the Mount Holyoke College Printmaking Workshop

Lascaux #4, 1984.
Lithograph on Arches paper.
Edition: 16.
Sheet size: 15 × 21 in. (38.1 × 53.4 cm).
Printed by John Hutcheson at Mount Holyoke College; published by Mount Holyoke College, South Hadley, Massachusetts.
Lent by the Mount Holyoke College Art Museum, Gift of the Mount Holyoke College Printmaking Workshop

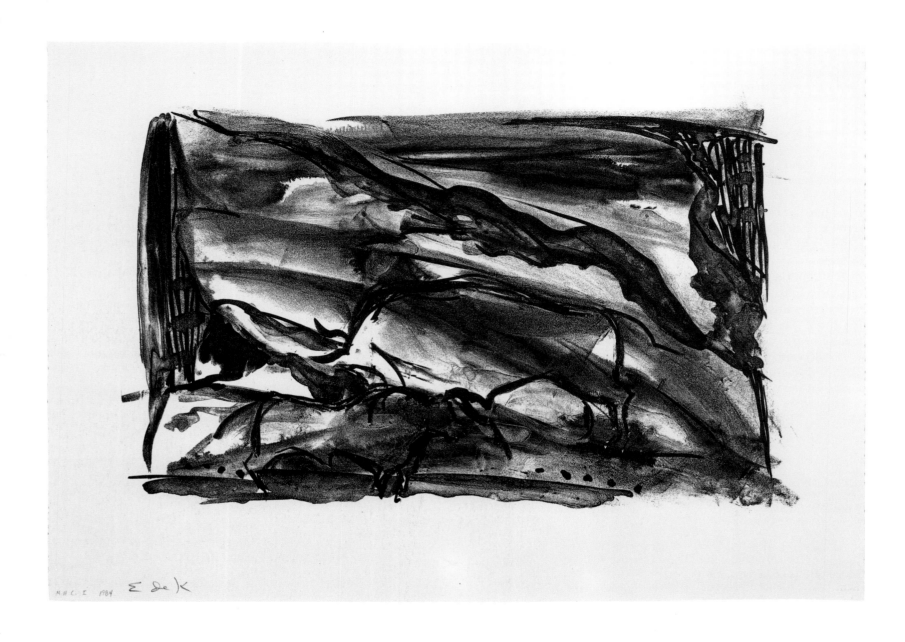

Colorplate 31

ELAINE DE KOONING

Lascaux #3

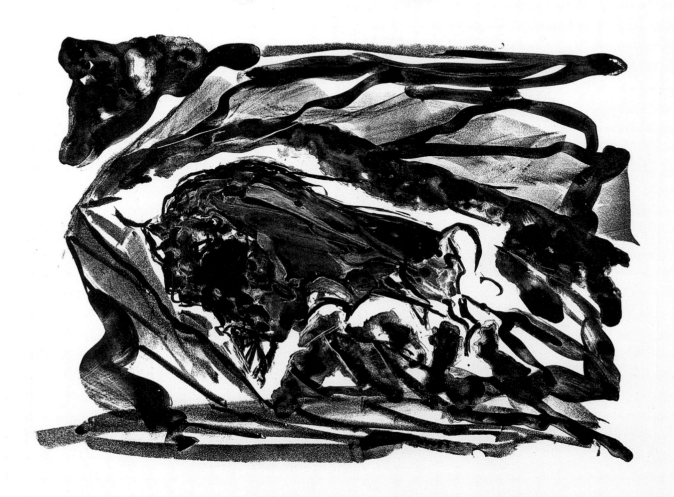

M.H.C. I 1964 E de K

Colorplate 32

ELAINE DE KOONING

Lascaux #4

JOYCE KOZLOFF

Born Somerville, New Jersey, 1942

■

*J*oyce Kozloff received a B.F.A. degree from Carnegie Institute of Technology in Pittsburgh in 1964 and an M.F.A. from Columbia University in New York in 1967. She has been a key figure among artists who have spearheaded interest in the impulse toward decorative, ornamental pattern in art.[1] She has also been active in the feminist movement. Kozloff's involvement with feminism, however, has not led her to explore specifically feminist, political imagery. Rather, as she explains it, "the way in which my work is political has more to do with the ideas that motivated me in the first place than with any message that the viewer might readily receive."[2] Kozloff's feminist concerns have led her to examine objects that are part of women's cultural heritage (pottery, costume, textiles, and so forth) and to question the hierarchies that have been imposed on art by a mostly male power structure. She asks some of the questions centrally associated with feminist criticism, such as What is "high" art? What is "decoration"? Can "decoration" be "high" art? What, ultimately, is art's contribution to our lives? In her most recent public commissions she has made a clear effort to reach a broad public, attempting to enhance our lives in the most basic sense, by making our surroundings more beautiful.[3]

The sources for Kozloff's dense, colorful patterns have been diverse: Greek, Mexican, and Islamic civilizations have been among her interests. Most recently, in her architectural commissions, she has referred to cultural artifacts from specific regions of the United States. The lithograph *Cochiti*, 1972 (colorplate 33), is one of a group of six prints whose spare compositions comprise broad bands of subtle color inspired by the rows of pattern in the pottery and textiles native to the Southwest. Kozloff encountered Native American design at first hand in the early 1970s, just as her interest in ornament was developing. The delicate, refined touch with which *Cochiti* was drawn onto stone has characterized much of Kozloff's subsequent work. Close examination reveals intricacies that would otherwise escape notice. This approach to lithography was developed considerably in three Pictures and Borders prints, printed with Judith Solodkin at Solo Press in New York in 1977.

In the summer of 1973 Kozloff traveled to Mexico specifically to study ornament, and she discovered no lack of material in the exotic conflation of Spanish and Indian mark making she found. The artist kept a notebook recording in detail the abundance of patterning she observed in the architecture, weavings, and ceramics that surrounded her there. This period in Mexico also strengthened Kozloff's growing feminist awareness of works made by anonymous women, the artists and artisans who were responsible for the invention of many of the patterns she was using as sources for her own art.

The thinking about pattern and ornament and their sources spurred Kozloff to consider the barrier her education had enforced, separating "high" art from crafts. *Is It Still High Art? State III*, 1979 (colorplate 34), was issued in four versions, marked by differences in ink colors and variations in paper. Seen here is one of the three states that employ a Chinese sheet with a laminated layer of silk. An elegant pattern repeat, the print is mounted in the manner of Oriental scrolls, enforcing its "high-art" tone. In its blatant uniformity and seductive color, however, it reflects the tensions and challenges in Kozloff's thinking as it taunts us to consider whether and how it differs from a fabric design. One can certainly argue that it does. The coloration of the pattern itself is not, for example, an actual repeat.

Kozloff first encountered the complexities of Islamic pattern configurations in 1967, during a trip to the Alhambra in Granada, Spain, with her husband, the photographer and critic Max Kozloff. In the mid-1970s she began seriously to study these extraordinary schemes and to use them in her art. She was dazzled by the rich colors and dense geometry that enhanced every surface of many Islamic buildings, and became acutely aware of the important relationships established within the architectural arena. *An Interior Decorated*, 1979–81, a work conceived for the Tibor de Nagy Gallery in New York, and later installed in three museum sites, incorporated a ceramic-tile floor, numerous tile pilasters, screenprinted silk hangings, and a variable number of lithographs printed on

Chinese silk and mounted on rice paper.[4] Kozloff's intentions for *An Interior Decorated* reflect her work in its entirety: "My aim is to create an environment that is sumptuous but not suffocating, refined but not aesthetic, meditative but not spiritual, demanding but not pompous, repetitive but not boring," she wrote at the time.[5] This piece marks a watershed for Kozloff, who has since become increasingly involved with architectural commissions.

Kozloff's work in printmaking, while not extensive, has spanned her career and played an important role. She has worked in lithography, screenprinting, etching, and pochoir and employed a variety of special papers and fabrics, since the time of her project at the Fabric Workshop in Philadelphia in 1978. She has used rejected proofs as collage materials to create new pattern juxtapositions in unique pieces, and has featured used prints as elements of her architectural installations, as in *An Interior Decorated*.

Kozloff's involvement with architecture has had other kinds of impact on her prints as well. *Homage to Robert Adam*, 1982 (colorplates 35 and 36), was inspired by ornamental plaster moldings designed by the eighteenth-century Scottish architect whose sumptuous interiors Kozloff much admires, and was conceived to function as a decorative facing for either a ceiling or a wall.[6] It consists of a cast-paper module, made by Donald Farnsworth, that houses nineteen individual color etchings derived from Egyptian and Islamic patterns. Kozloff thinks of the prints as "ornamental architectural moldings with colored, patterned inserts. The piece is a module and it's meant to be shown in groups."[7]

In 1986, working again with Judith Solodkin at Solo Press, Kozloff completed an extremely complicated pochoir/lithograph, *Harvard Litho*, based on her eight-by-thirty-two-foot tile mural at the Harvard Square subway station in Cambridge, Massachusetts (in the print an inch is equal to a foot). Composed of flat shapes,

intricate designs, and superimposed figurative elements, many derived from local architectural details, the piece is a riot of color and presented extraordinary printing challenges. As in all of Kozloff's prints, the overall patterning is evident from across a room. The luxurious intricacy and richness of her surfaces, however, are apparent only upon close, careful examination. This sensuous complexity has characterized all of her prints, and the density of implied meaning is enriched as the sources of her forms are expanded to include less overtly exotic milieux.

1. In 1975 Kozloff and several other artists, among them Robert Kushner, Miriam Schapiro, and Robert Zakanitch, met to share their mutual interest in pattern. They have referred to these meetings, which were few in number, as "pattern painting meetings." See Kozloff's account in Robin White (interviewer), "Joyce Kozloff," *View* (Oakland, California: Crown Point Press, 1981), 20–21. See also Amy Goldin, "Pattern and Print," *Print Collector's Newsletter* 9 (March–April 1978), 10–13.

2. Quoted in White, "Joyce Kozloff," 3.

3. On the architectural projects, see Thalia Gouma-Peterson, "Decorated Walls for Public Spaces: Joyce Kozloff's Architectural Installations," in Patricia Johnston, *Joyce Kozloff: Visionary Ornament*, exhibition catalogue (Boston: Boston University Art Gallery, 1986), 45–57. This catalogue includes Hayden Herrera's "A Conversation with the Artist" and a bibliography.

4. On *An Interior Decorated*, see Carrie Rickey, *Joyce Kozloff: An Interior Decorated*, exhibition catalogue (New York: Tibor de Nagy Gallery, 1979); Patricia Johnson, "An Overview," in *Joyce Kozloff: Visionary Ornament*, 8–9; and Gouma-Peterson, "Decorated Walls for Public Spaces," 47.

5. Joyce Kozloff in *Joyce Kozloff: An Interior Decorated*.

6. Gouma-Peterson, "Decorated Walls for Public Spaces," 48.

7. Quoted in White, "Joyce Kozloff," 6.

CHECKLIST

Cochiti, 1972.
Lithograph on Rives BFK paper.
Edition: 20.
Sheet size: 18 × 24 in. (45.7 × 61 cm).
Printed and published by Tamarind Institute, Albuquerque.
Lent by the University Art Museum, University of New Mexico, Albuquerque

Is It Still High Art? State III, 1979.
Lithograph on embossed Chinese silk laminated paper.
Edition: 45.
Mount: 17 × 31 in. (43.2 × 78.8 cm); sheet: 13 × 23 in. (33 × 58.5 cm).
Printed by Judith Solodkin at Solo Press, New York; published by

Barbara Gladstone Gallery, New York.
Lent by the Mount Holyoke College Art Museum, The Henry Rox Memorial Fund for the Acquisition of Works by Contemporary Women Artists

Homage to Robert Adam, 1982.
Cast-paper module and 19 inset plates (4 images) in soft-ground etching, aquatint, and open-bite etching on Rives BFK paper.
Edition: 25.
Composition size: 32 × 32 in. (81.3 × 81.3 cm).
Printed by Lilah Toland at Crown Point Press; published by Crown Point Press, Oakland, California.
Lent by Crown Point Press, Oakland, California

Colorplate 33

JOYCE KOZLOFF

Cochiti

Colorplate 34

JOYCE KOZLOFF

Is It Still High Art? State III

Colorplates 35 and 36

JOYCE KOZLOFF

Homage to Robert Adam

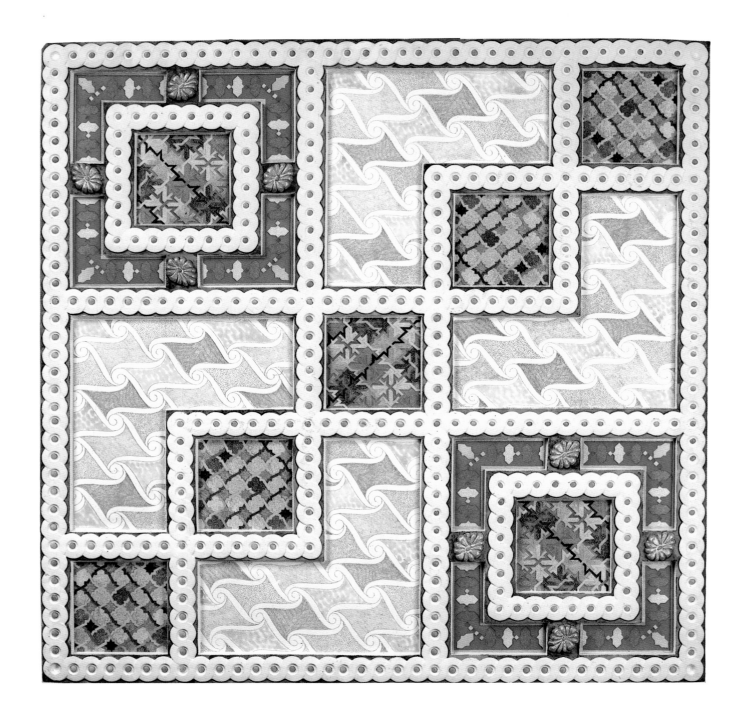

SYLVIA PLIMACK MANGOLD

Born Bronx, New York, 1938

■

Sylvia Plimack Mangold grew up amid the stimulation of New York City. She took classes at the Museum of Modern Art as a child, attended the High School of Music and Art, and then the highly competitive Cooper Union School of Art. Mangold earned her B.F.A. degree in 1961 from the Yale University School of Art and Architecture, where she met her husband, the painter Robert Mangold. The two painters moved to New York City and, after living there for a decade, moved to the New York State countryside; she currently lives in Washingtonville, New York, on the west bank of the Hudson River, a place that has played an increasing role in her art.[1]

Sylvia Mangold's work coordinates issues of concept, perception, and process, although her emphasis on each of these aspects has fluctuated. That a work of art *is* a work of art, that it occupies a specific space, although it may allude to another space or place, and that it is made over time by means of a variety of operations—these are the basic tenets of Mangold's content.

Her early concerns focused on the conceptual: a place might be a source, but its "placeness" was less important than the nature of its transformation onto the page or canvas. In these works atmosphere is not a serious issue, and color is synthetic; art-color first and place-color second. The works of the early 1970s are at root intellectual constructs, rather than mimetic explorations, despite Mangold's meticulous rendering and allusions to time and light in her titles (for example, *Light at 10:30 A.M.*, of 1972). Her spare, reductive interiors explicated Minimalist concerns of the period without eliminating aspects of the observable world. A frequent use of mirrors supported the metaphor. Real space—implied depth—realistically rendered and reflected space—implied flatness—were depicted with great similarity.

Measurement and closure or framing are recurrent visual issues in Mangold's art. Rulers and masking tape have appeared among her pictorial elements, and she is constantly reminding us, perhaps reassuring us, that part of the subject of a work of art is the notion of making it. *Paper under Tape, Paint over Paper*, 1977 (colorplate

37), marked by an austere beauty, is a splendid example of Mangold's *trompe l'oeil* illusionism and her insistence that the print is meant to be seen as an idea of a thing, despite the risk that it may be mistaken for the thing itself.

Mangold's most recent work has incorporated romantic landscape images of the Hudson River area where she lives. Her continued insistence on framing these places with tape and on allowing all manner of processes to be reflected in the facture places them absolutely in the twentieth-century tradition of modernism. However, one can hardly ignore an association with the Hudson River School and the great landscape heritage of American painting. Mangold's sights are no less grand, her atmospheric effects no less seductive.

The lithograph *View of Schumnemunk Mt.*, 1980 (colorplate 38), closely related to a painting of the same subject dating from 1979, offers a view that may be seen from the Mangolds' land. The purple-gray fields, trees, and mountain range, moody and dense, imply the elusive weight of falling dusk. The work reveals Mangold's admiration for James McNeill Whistler and the layered bands of subtle tonalities he achieved in his paintings, watercolors, and prints, including many of his *Nocturnes*. Mangold says that Whistler's "shorthand technique—the application of paint as gesture, quick brushstrokes, and his light touch in forming landscape—has always appealed to me."[2]

Mangold has described her method of working on the night landscapes, a subject in her work since 1978. She moves from site to studio to site and back again to ensure accuracy in her translation into paint or print of the subtle color sensations that evoke the powerful mystery of this beautiful time of the day's cycle. By daylight she has confirmed her decisions, adjusting them to her memory of night light.[3]

Trees on Mangold's Washingtonville land have been the source for many recent paintings, watercolors, drawings, and prints. She continues to expand her repertoire of graphic techniques and has completed a woodcut entitled *Nut Trees*, made in the traditional

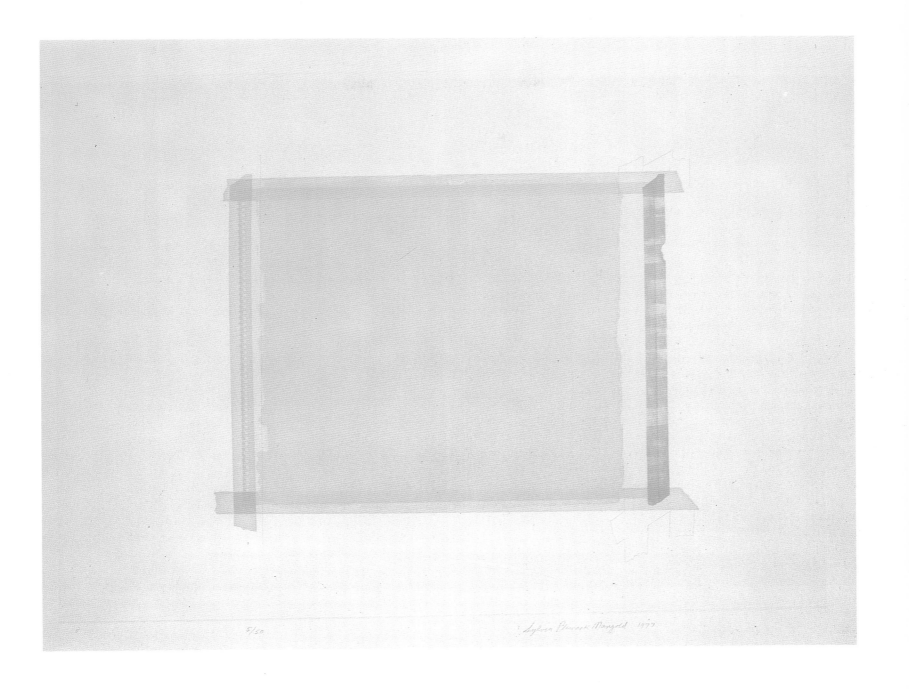

Colorplate *37*

SYLVIA PLIMACK MANGOLD

Paper under Tape, Paint over Paper

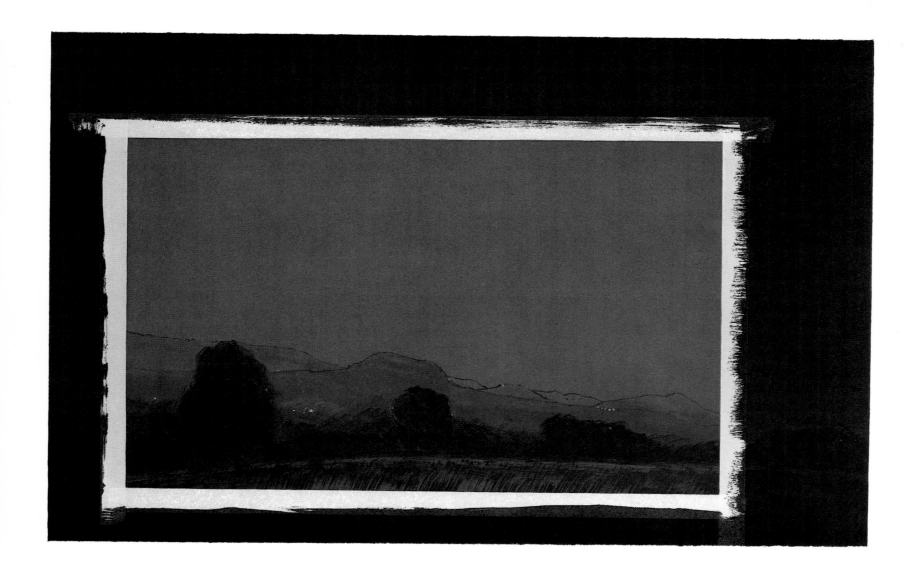

Colorplate 38

SYLVIA PLIMACK MANGOLD

View of Schumnemunk Mt.

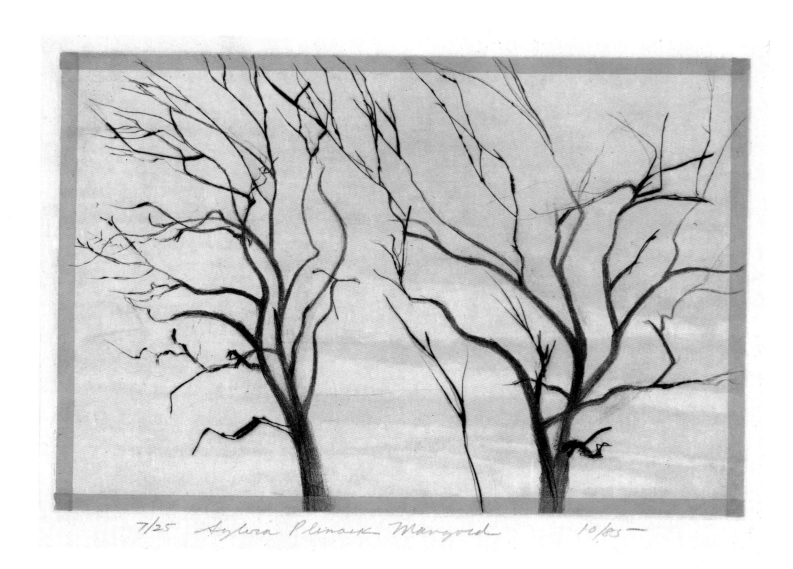

7/25 Sylvia Plimack Mangold 10/85

Colorplate 39

SYLVIA PLIMACK MANGOLD

Nut Trees (Red)

Japanese style for the Crown Point Press woodcut project in Japan.[4] *Nut Trees (Red)*, 1985 (colorplate 39), is one of three small etchings executed simultaneously; the other two are titled *Nut Trees (Blue)* and *Nut Trees (Yellow)*. As in *View of Schumnemunk Mt.*, in *Nut Trees (Red)* we see Mangold's use of landscape to examine ideas of re-presentation, as distinct from representation. She is committed to the translation of landscape into something else: a picture of a landscape wherein picture and landscape receive equal attention. The printed-tape frame reinforces the point.

The *Nut Trees* prints refer to the passing of time and to the seasons. In *The Pin Oak at the Pond*, 1986, a drypoint and spit-bite aquatint that followed them, she made the sky a strong orange-pink, its powerful color and luminosity indicative of a familiarity with the scene. To the uninitiated or unsure, such a sky may seem impossibly beautiful—too seductive to dare to depict. The direct lyricism of Mangold's landscapes, the intermingling in them of branches and air, the rich variety of markings, and the delicacy of the drawing and coloring all attest to Mangold's knowledge and love of a place that is hers. In these recent works, this aspect of the art is as palpable as Mangold's pleasure in making things and in recording the processes involved.

Mangold has long maintained a written dialogue with herself, recording her thoughts about her work and her ideas for lectures and for her teaching. Much of this material remains unpublished, but insight to the clarity of her thought may be seen in a book of her drawings and ideas, entitled *Inches and Fields*, a telling synopsis of her concerns.[5]

1. The most complete resource for biographical and other data has been Thomas H. Garver, *Sylvia Plimack Mangold: Paintings, 1965–1982*, exhibition catalogue (Madison, Wisconsin: Madison Art Center, 1982).

2. Quoted in Margaret Mathews, "Sylvia Plimack Mangold," *American Artist* 58 (March 1984), 85.

3. Mathews, "Sylvia Plimack Mangold," 85–86. See also Linda L. Cathcart, *Sylvia Plimack Mangold: Nocturnal Paintings*, exhibition catalogue (Houston: Contemporary Arts Museum, 1981). Depicting night has been a challenge to artists throughout history. Whistler's *Nocturnes* are one example. On prints in particular, see *Night Prints from the Fifteenth to the Twentieth Century*, exhibition catalogue (Washington, D.C.: National Gallery of Art [1983]). On current interest in the subject, see Margaret Mathews, "Landscape Painting at Night: Contemporary Artists Look at the Evening Skies," *American Artist* 48 (February 1984), 66–71.

4. Other examples from this project are Helen Frankenthaler's *Cedar Hill* and Judy Pfaff's *Yoyogi II* (colorplates 22 and 44).

5. *Inches and Fields* was published in 1978 by the Lapp Princess Press, New York.

CHECKLIST

Paper under Tape, Paint over Paper, 1977.
Etching and aquatint on Rives BFK paper.
Edition: 50.
Sheet size: 22 × 30½ in. (55.9 × 77.5 cm).
Printed by Patrick Foy and Doris Simmelink at Crown Point Press, Oakland, California; published at Parasol Press, Inc., New York.
Lent by the Mount Holyoke College Art Museum, The Henry Rox Memorial Fund for the Acquisition of Works by Contemporary Women Artists

View of Schumnemunk Mt., 1980.
Screenprint and lithograph on Arches Cover paper.
Edition: 50.
Sheet size: 21 × 32¼ in. (53.4 × 82 cm).

Printed by Craig O'Brien, Robbie Evans, Peter Catanzaro, and Steve Sangenario at Styria Studio, New York; published by 724 Prints Inc., New York.
Lent by the Mount Holyoke College Art Museum, The Henry Rox Memorial Fund for the Acquisition of Works by Contemporary Women Artists

Nut Trees (Red), 1985.
Drypoint and aquatint on Japan paper.
Edition: 25.
Sheet size: 25¾ × 20⅛ in. (65.4 × 51.1 cm).
Printed by Doris Simmelink and Sarah Todd, Los Angeles; published by Brooke Alexander, Inc., New York.
Lent by the Yale University Art Gallery, Katharine Ordway Fund

JOAN MITCHELL

Born Chicago, Illinois, 1926

■

Joan Mitchell has lived in France since 1955. She visits the United States on occasion, and while in New York in 1981 completed eleven lithographs. The Bedford Series, as the group is called, was created at the Bedford Village, New York, workshop of the master printer Kenneth Tyler. The prints, among them *Bedford II* and *Flower I* (colorplates 40 and 41), are exquisite evocations of landscape in their approach to light, space, and a mingling of rhythms. In these lithographic drawings and paintings, close in composition to her direct paintings and pastel drawings, Mitchell has translated to print language the physicality of her large-scale lyrical paintings, with loss of neither energy nor assurance, despite her relative unfamiliarity with the process.

After studying at Smith College and the School of the Art Institute of Chicago, Mitchell received a Fulbright grant to go to Europe in 1948 and 1949. She then returned to New York, where she lived until leaving for France in 1955. She became closely associated with the younger generation of Abstract Expressionist painters and, like Helen Frankenthaler and Elaine de Kooning, exhibited in the now-famous 1951 Ninth Street exhibition organized by members of The Club, a loosely associated group of artists in New York. Her connections to certain roots in American Abstract Expressionism remain strong.

Mitchell's work, though landscape in essence, is not derived from direct observation, but from a felt remembrance that takes form as she works. "My paintings aren't about art issues. They're about a feeling that comes to me from the outside, from landscape."[1] In her paintings the manipulation of materials that develops from this feeling is clearly evident, whereas in the prints, less involved with measurable layerings of pigment, this sense of working and reworking is implied rather than visible. Mitchell's work, despite a certain sensuousness, is neither ingratiating nor immediately seductive. There is an uncompromising boldness about her stroke and a toughness in her surprising juxtapositions of color.

To judge from the prints, Mitchell took to the lithographic process immediately. The series completed with Tyler explore four ideas or themes: Bedford (three prints), Flower (three prints), Brush (two prints), and Sides of a River (three prints).[2] These are all subjects that have an ongoing history in Mitchell's art. The Sides of a River prints, for example, convey her fascination with water—with storms, with reflections, and so forth—a fascination connected to several early homes near rivers and lakes, starting with a childhood in Chicago on the shores of Lake Michigan.[3]

Mitchell's remarks about her work often contain the word "feeling," and in this body of lithographs one is struck by the range of types of landscape conveyed, as well as a sense of the artist's deeply understood responses to these kinds of places. What she creates is not imitative of landscape, but is another reality that establishes its own sense of space and of scale, "acknowledging the impossibility of a picture's *replacing* the space of nature."[4]

Flower I—as do the other two lithographs in this group—juxtaposes a hovering shape and an activated field. One's sense of both space and the scale of forms is defined by the title: otherwise this weighty form might be a distant mountain. The three Bedford pieces are reminiscent of the rolling fields in the area of New York State where Tyler's workshop is located, but the title may simply refer to the fact that the prints were made in Bedford, the land that inspired them being more universally construed.

Colors imply temperature, season, time of day, materiality (sensations of fields read differently from sensations of water or sky). The nature of the strokes (short, long, thin, thick, sleek and continuous, textured and broken) alludes to atmosphere, the quality of light, the weather: stormy, calm, humid, dry. In reading translations of feelings into signs, one seeks equivalents. Mitchell encourages us to read and to understand her responses to nature, to sense the feelings she is imaging, and to share her responses to nature if our own experiences so enable us.

Mitchell's vocabulary of vigorous strokes that build form is distinctly hers, developed over time, but here translated into a new medium. In making the prints she has enlisted the participation of the white paper, and the flickering, shimmering light she creates depends on how much of the sheet she leaves untouched by ink.

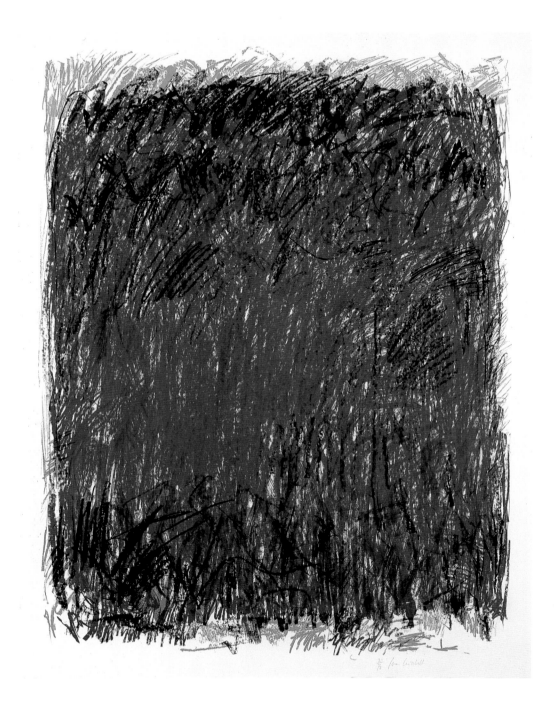

Colorplate 40

JOAN MITCHELL

Bedford II

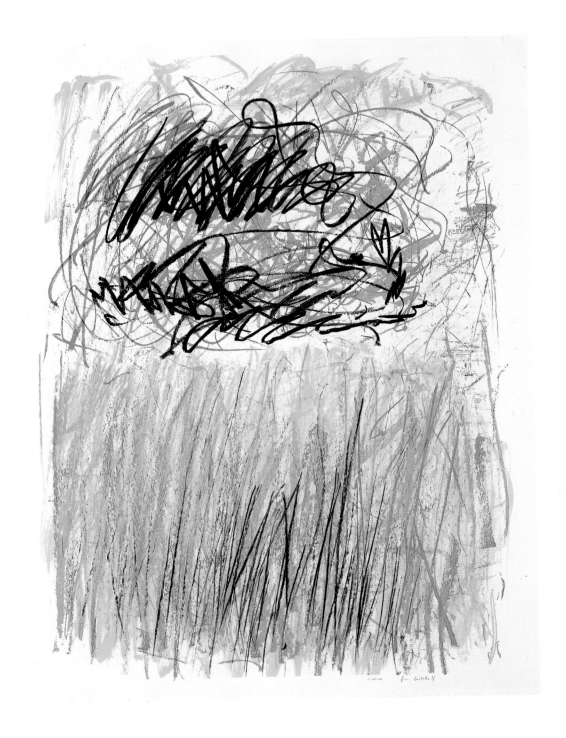

Colorplate 41

JOAN MITCHELL

Flower I

One gets some sense of her range in the differences in density between *Flower I* and *Bedford II*. These prints are remarkable for their physicality, their ability to portray space and weight. The quality of ink varies considerably from color to color, enhancing the liveliness of the marks. Sometimes it is chalky, at other times exceedingly greasy, reflecting the artist's search within the materials themselves, her exploration of the greasiness of crayon as distinct from the slick sheen possible with lithographic tusche. A characteristic distinctiveness of each material is apparent in the prints.

In rendering her landscape on stone Mitchell has maintained the concerns she expresses in her paintings: "I want to paint the feeling of a space. . . . Painting is a means of feeling 'living.'"[5]

1. Quoted in Marcia Tucker, *Joan Mitchell*, exhibition catalogue (New York: Whitney Museum of American Art, 1975), 6.

2. The prints are documented in Barbara Rose, *Joan Mitchell: Bedford Series* (Bedford Village, New York: Tyler Graphics, 1981).

3. Tucker, *Joan Mitchell*, 15.

4. See Rosalind Krauss, "Painting Becomes Cyclorama," *Artforum* 12 (June 1974), 52.

5. Joan Mitchell quoted in Yves Michaud, "Conversation with Joan Mitchell," *Joan Mitchell*, exhibition catalogue (New York: Xavier Fourcade, Inc., 1986), n.p.

CHECKLIST

Bedford II, 1981.
Lithograph on Arches 88 paper.
Edition: 70.
Sheet size: 42½ × 32½ in. (108 × 82.6 cm).
Printed by Lee Funderburg and Roger Campbell at Tyler Graphics Ltd.; published by Tyler Graphics Ltd., Bedford Village, New York.
Lent by the Mount Holyoke College Art Museum, The Henry Rox Memorial Fund for the Acquisition of Works by Contemporary Women Artists

Flower I, 1981.
Lithograph on Arches 88 paper.
Edition: 70.
Sheet size: 42⅞ × 32½ in. (107.9 × 82.6 cm).
Printed by Lee Funderburg and Roger Campbell at Tyler Graphics Ltd.; published by Tyler Graphics Ltd., Bedford Village, New York.
Lent by the Walker Art Center, Minneapolis; Gift of the Professional Art Group I and II

ELIZABETH MURRAY

Born Chicago, Illinois, 1940

■

*D*uring her childhood, Elizabeth Murray's family moved around a good bit in the Midwest, eventually settling in Bloomington, Illinois. There she was encouraged in her interest in art by her parents and by her high-school art teacher, and the excitement she experienced in viewing a still life by Paul Cézanne was so profound that she determined to become an artist.[1] She attended the School of the Art Institute of Chicago and the University of Chicago before doing graduate studies at Mills College in Oakland, California (M.F.A., 1964). Murray taught for a few years in Buffalo, New York, and then settled in New York City in 1967. She has been exhibiting steadily there since 1972.

As a graduate student at Mills, Murray was a teaching assistant in printmaking, and she later used this experience in setting up a printmaking workshop, one of the responsibilities of her first teaching job. She was not again involved with printmaking, however, until 1980, when she completed *Untitled, States I–V* (colorplate 43). This five-part work was inspired in part by Pablo Picasso's series of eleven Bulls, in which an image of the animal was taken through a variety of alterations, becoming increasingly simplified with each step. Since then Murray has worked in screenprinting as well as lithography. She apparently felt especially invigorated by her first serious work in the latter: "What I liked about working on the stone and doing this process work was that it stayed alive for me all along. I felt like the stone was connected to the drawing."[2] Printmaking also provided her with the possibility of maintaining a record of her thinking. At various points in the image-making process, proofs may be made, marking, in states, the development of her idea. This kind of sequential imaging is unique to making prints, and Murray was profoundly affected by its implications.

Murray's work is also characterized by an exuberant fracturing and synthesizing. The pieces are explosive in gesture, often in color, and in shape. Layered, both visually and literally, the works seem to be making themselves as we watch them, and the pos-

sibilities for visual expansion seem limitless. There is often a puzzlelike quality to the work, especially after 1980, but one senses that the parts will never quite fit. Murray's combinations of color, line, shape, and surface seem unwilling to cohere.

One senses that Murray draws, consciously or unconsciously, from both art and her surroundings: architectural expanses, Miróesque figural elements, distorted household forms—all enter into these oddly personal and unquantifiable compositions. *Inside Story* (colorplate 42) is one of a group of "cup" lithographs she completed in 1984. Others, such as *Snake Cup* and *Untitled (Black Cup)*, are similar in composition and rhythmic form, and in the painterly gusto with which they were worked. The stretched cup form that dominates *Inside Story* has its counterparts in a number of Murray's paintings, although the character of Murray's work in painting and printmaking differs significantly; most of the prints—and the lithographs especially—are closely aligned with the nature of the drawing processes involved.

Murray has offered a complex of associations for her cup image: "The cup is an extremely female symbol. It can be seen as an encasement for the female genitals. It is a male symbol too: the winner of an athletic event gets a cup—as an object—a beautiful image in itself. Handle, saucer, cup—three circular shapes. . . . Viewers can look for a long time and not see any image at all, which is fine. Or a cup can be a head, a head can be a cup."[3]

In *Inside Story* the base, or saucer, and handle echo one another's form, while the brushy, rhythmic splash from the inside bowl of the vessel breaks up any overall sense of iconic shape. Color seems meant to establish a space and then deny it, rather than to contribute to any literal reading of the piece. Sparse hand coloring is used to strengthen two dark loop forms at the top. In all the print surfaces seen here, the white sheet of paper plays a strongly interactive role with the drawn marks. They work together to establish the grand scale and dynamic spatial structure.

Murray starts her work "haphazardly," without preliminary

studies or maquettes, the interplay of shape and color developing as she works.[4] Her work of the early 1970s was relatively spare, but worked with a richness of surface.[5] Since the end of the decade, however, she has worked in an eccentrically shaped configuration, building paintings dimensionally in several parts, activating surfaces, and organizing dynamic gestures into tense, cohesive forms. Her work has been associated with "Expressionisms," the work of artists who may "be said to be investigating the emotive, evocative, or expressive power of certain symbols or visual signifiers."[6] Her approach has a forcefulness that is conveyed to the viewer in the confrontational insistence of her colors and forms. For herself, working is "like a mystery. Once the shapes and colors are established to my satisfaction, the mystery is solved."[7]

1. Paul Gardner, "Elizabeth Murray Shapes Up," *Art News* 83 (September 1984), 50–51; and Ronny H. Cohen, "Elizabeth Murray's Colored Space," *Artforum* 21 (December 1982), 54.

2. Jacqueline Brody (interviewer), "Elizabeth Murray, Thinking in Print: An Interview," *Print Collector's Newsletter* 13 (July–August 1982), 74.

3. Gardner, "Elizabeth Murray Shapes Up," 55.

4. Paul Gardner, "When Is a Painting Finished?" *Art News* 84 (November 1985), 97.

5. Richard Armstrong and Richard Marshall, *Five Painters in New York*, exhibition catalogue (New York: Whitney Museum of American Art, 1984), 46–60.

6. Phyllis D. Rosenzweig, "Expressionisms," *Directions 1983*, exhibition catalogue. (Washington, D.C.: Hirshhorn Museum and Sculpture Garden, Smithsonian Institution Press, 1983), 33.

7. See note 4.

CHECKLIST

Inside Story, 1984.
Lithograph with hand coloring on Arches paper.
Edition: 14.
Sheet size: 58½ × 36¼ in. (148.6 × 92.1 cm).
Printed by Maurice Sanchez and James Miller at Derrière l'Etoile Studios, New York; published by Paula Cooper Gallery, New York.
Lent by the Paula Cooper Gallery, New York

Untitled, States I–V, 1980.
Lithograph on Arches paper (five sheets).
Edition: 35.
Sheet size: 22¾ × 17¹³⁄₁₆ in. (57.8 × 45.2 cm).
Printed by Maurice Sanchez and James Miller at Derrière l'Etoile Studios, New York; published by Brooke Alexander and Paula Cooper Gallery, New York.
Lent by the Yale University Art Gallery, purchased with the aid of funds from the National Endowment for the Arts and the Susan Morse Hilles Matching Fund

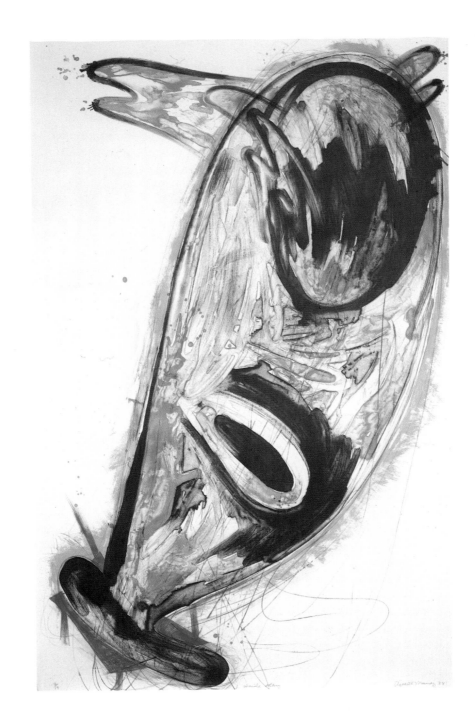

Colorplate 42

ELIZABETH MURRAY

Inside Story

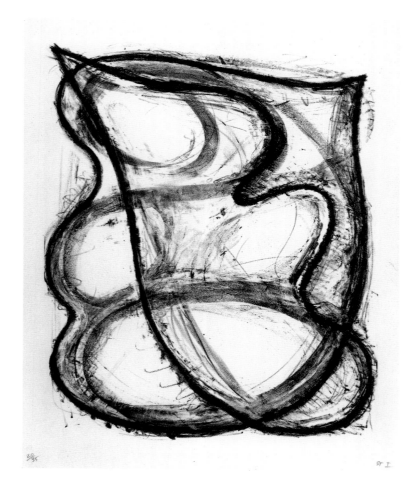

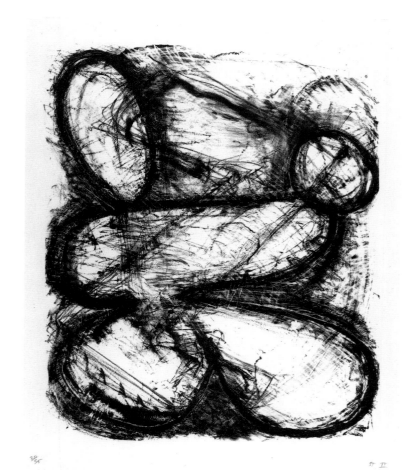

ST I

ST V

Colorplate 43

ELIZABETH MURRAY

Untitled, States I–V

JUDY PFAFF

Born London, England, 1936

■

*J*udy Pfaff moved from London to Detroit, Michigan, in 1959. She attended Wayne State University there, then Southern Illinois University, Edwardsville, before completing work for a B.F.A. at Washington University, Saint Louis, in 1971. Pfaff went on to earn her M.F.A. from the Yale University School of Art and Architecture in 1973.

At Yale Pfaff studied painting, and Al Held has frequently been referred to as her most important mentor there. Evidence of this may be seen in the insistent exploration in her work of space as projection. Her early paintings were as large as fifteen feet long,[1] and she maintains this sense of scale in her more recent three-dimensional work. These three-dimensional structures also continue to demonstrate Pfaff's strong painterly impulse.

Pfaff is best known for her complicated environments and installations, aspects of which served as the impetus for her colorful woodcut *Yoyogi II*, 1985 (colorplate 44). In her three-dimensional constructions she transforms spaces into dizzying landscape events that are both inviting and threatening. Brilliantly colorful, composed of all sorts of materials, Pfaff's environments seem to be intuitively organized at the start and then revised and expanded upon, the additions and changes made in response to what is already in place. There is a sense of dislocation and flamboyance about the work. Materials and shapes are unpredictable—rods, spirals, planes, soft and hard, movable elements and static ones, manufactured elements and such natural ones as tree branches.

Some of Pfaff's installations carry associations with places she has been, such as, for example, the Yucatán coast of Mexico in 1980.[2] The works have a generalized sense of place rather than descriptive referents, and the place is not always a remembered place, but may be an imagined one. We enter one of Pfaff's transformed arenas to experience the world of her particular imagina-

tion, and within we almost sense sounds and feel motion, as forms catapult at various speeds into our space, enforcing our awareness of ourselves as well as of the spaces we inhabit. Her color is at once aggressive and welcoming, lavish in its intensity and comprising a bonanza of hues.

In the catalogue to the exhibition "Directions 1981" at the Hirshhorn Museum and Sculpture Garden in Washington, D.C., for which she had planned an installation, Pfaff stated, "I want to exhaust the possibilities and push the parameters of dislocation and immersion as far as I can. . . . I want there to be a kind of synchromesh between my thinking and the making of the work, to free the gesture with the thought."[3] Since this piece (entitled *Formula Atlantic*), Pfaff's works have been composed of larger, even more densely organized forms, many of them hugging the wall more than did her earlier installations.

Less known are Judy Pfaff's works on paper, drawings, and collages. These too are colorful works that, like her installations, incorporate a variety of materials, among them numerous plastics and papers, and are also worked on a range of different surfaces—tracing paper, graph paper, Mylar, and so forth.[4] Somewhat simpler in means is Pfaff's woodcut *Yoyogi II*, the second state of two issued versions.

The two versions of the print are differentiated by dense color overlays. *Yoyogi I* has a cross-section of a tree trunk at the lower right that flattens the landscape arena somewhat. In *Yoyogi II*, by contrast, rich black and red spiral projections press forward and add to the pictorial space. In both prints the particular visual strength of these vivid overlays stems from the fact that they are printed in oil-based inks, rather than water-based ones, which are traditional for Japanese-style woodcuts, and are used for the other colors. Both prints offer suggestions of jagged rocks and deep

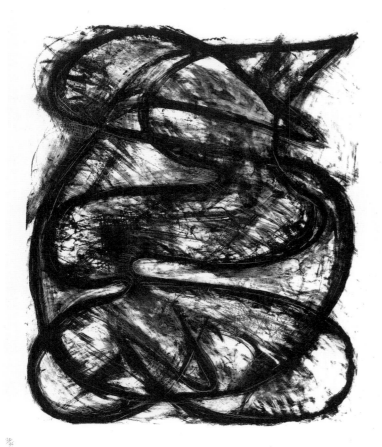 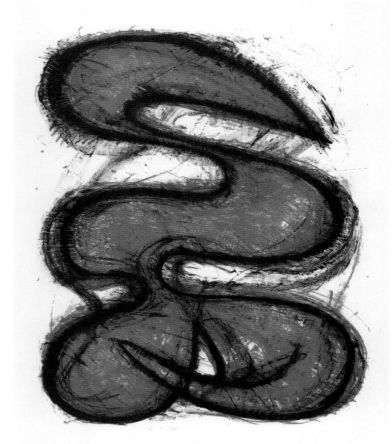

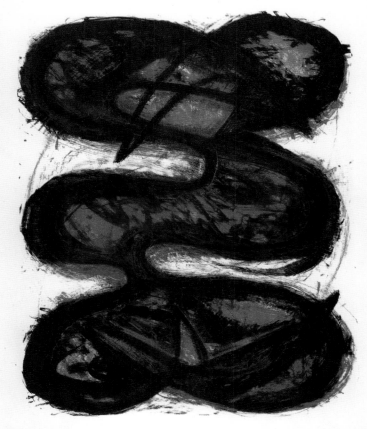

Elizabeth Murray

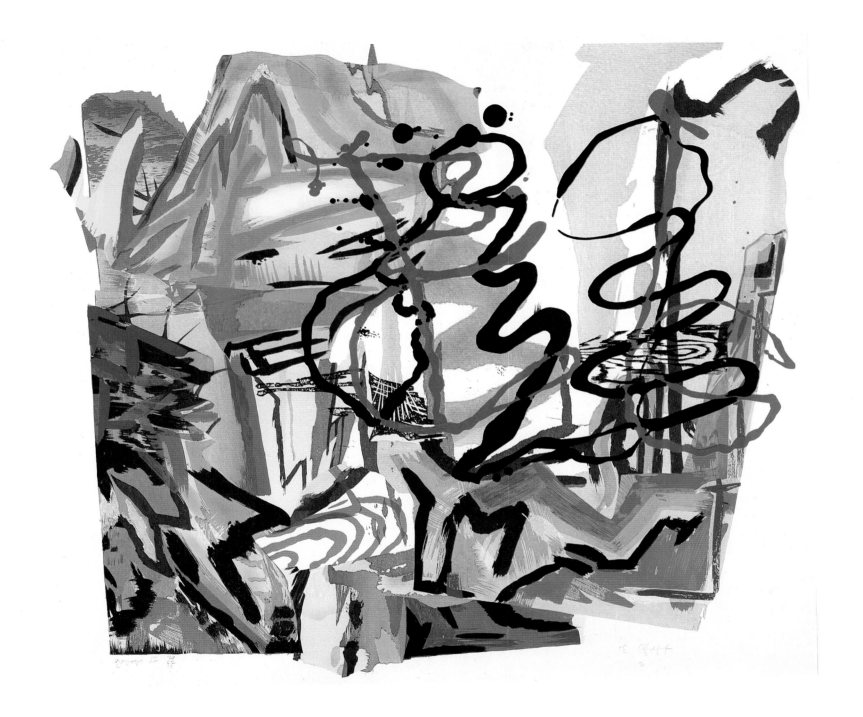

Colorplate 44

JUDY PFAFF

————————————————

Yoyogi II

ravines, trees and bushes, elements of Pfaff's fantastic landscape world, a world that is "about how the mind sees landscape . . . like peering through the woods and having no feeling of noticing the trees; it's just like you're in a very wet, dark place—more the memory of that sensation."[5] The title, *Yoyogi*, refers to a park in Tokyo.[6]

1. Susan Krane, "Pfaff's Installations: Abstraction on the Rebound," *Judy Pfaff*, exhibition catalogue (Buffalo: Albright-Knox Art Gallery and HALLWALLS, 1982), 8. The catalogue has a bibliography.

2. Michael Auping, introduction to *Judy Pfaff: Installations, Collages and Drawings*, exhibition catalogue (Sarasota: John and Mable Ringling Museum of Art, 1981), 9.

3. Miranda McClintock, *Directions 1981*, exhibition catalogue (Washington, D.C.: Hirshhorn Museum and Sculpture Garden, 1981), 24.

4. See Auping, *Judy Pfaff*, 13.

5. Quoted in Krane, "Pfaff's Installations," 10.

6. Crown Point press release, "Announcing a Woodblock Print by Judy Pfaff" [Oakland, California, 1985].

CHECKLIST

Yoyogi II, 1985.
Woodcut on Echizen Kozo paper.
Edition: 75.
Sheet size: 31⅞ × 36 in. (81 × 91.5 cm).

Printed by Tadashi Toda, Japan; published by Crown Point Press, Oakland, California.
Lent by the Yale University Art Gallery, Katharine Ordway Fund

HOWARDENA PINDELL

Born Philadelphia, Pennsylvania, 1943

■

*H*owardena Pindell has been closely associated with the feminist movement, and is also a strong voice on behalf of the cause of black artists.[1] There are, however, no overt political overtones readily apparent in her work as exemplified by such spirited pieces as her prints, *Untitled*, 1976, and *Kyoto: Positive/Negative*, 1980 (colorplates 45 and 46).

Pindell's work has involved coordination of a clear structure (in the early work this was often an underlying grid) and random markings. Hers is an art of surfaces, signs, and symbols, developed in layers and often using a collage approach—either literally or visually. The pieces have incorporated a multitude of materials, a variety of paints, dyes, papers, fabrics, sequins, glitter, and threads, and they are in consequence richly tactile and seductive. A variety of operations is also essential to her repertoire—die-cutting, tearing, pasting, painting, drawing, printing, sewing, layering, laminating, all in unpredictable combinations. Her manner of making her art leads us through our process of looking. Although she has completed a considerable body of works on paper, and has made paper by hand, Pindell has made few prints during her career. Nevertheless, her carefully controlled explorations of the graphic media are both beautiful and distinctive.

The lithograph/chine collé *Untitled* is from a portfolio of twenty prints, entitled *A.I.R. Portfolio*, published in 1976 by members of the New York women's cooperative gallery A.I.R., of which Pindell was an early member. The guidelines governing the production of prints for the portfolio mandated a twenty-two-by-thirty-inch sheet, two printed colors, and one plate.[2] Thus, while the number of ink colors and printing matrices was fixed, the number of sheets of paper was not, and Pindell's contribution to the undertaking incorporates a layering process that allows her to develop the surface character not only by ink layers, but also by paper layers, taking advantage of the distinctive properties of the two papers she chose.

In *Untitled* she printed the single plate twice, from two directional orientations, thus reversing the image, and on two sheets of paper. The first printing is on an Arches buff the size of the portfolio; the second printing, on a smaller sheet of Japanese paper with imposing brownish flecks embedded in it, was completed after the two sheets were adhered. The result is two distinct layers of ink over paper, with the translucent quality of the Japanese sheet enhancing our awareness of these varying densities. The insistent shape of the work is reinforced by the border, formed when the smaller Oriental sheet was adhered to the base sheet. Continuity of surface is affirmed by the ink color of the second printing across the entire work, while simultaneously interrupted by the pulsating nature of the same printed marks as they interact with the first printing, the two layers of paper, and the flecks of the Oriental sheet. Elements of chance—the locations of the flecks in the Japanese paper and the relationships of the ink markings when the plate is printed from two orientations—interact with other elements that were predetermined—the color of both paper and ink, the markings of the original drawing on the plate, and so forth.

Kyoto: Positive/Negative, a two-sided lithograph with collage and etching printed on laminated red and tan Oriental sheets, is considerably more complex, both technically and visually. Again a sense of the total structure, suggesting both flatness and objectness, is established and then challenged by multilayered colored markings that visually pierce the surface and by die-cut circles that literally do so. In this work, parallel bands of tan, separated by the red that also functions as a defining border, provide the sense of regimentation and flatness. Within and upon these two field colors are a variety of markings, among them: Pindell's distinctive, tiny, linear marks, numbers, shooting arrows, circles that dart every which way and are printed on both sides of the laminated surface; collaged dots of paper cut from the tan sheets with a circular punch, as well as red dots that are actually the holes in those sheets from which dots were punched, allowing the lower layer of paper to show through (surfaces composed of dots have long been associated with Pindell's art); and the irregular threads and lumps that give character to the beautifully colored, handmade Oriental

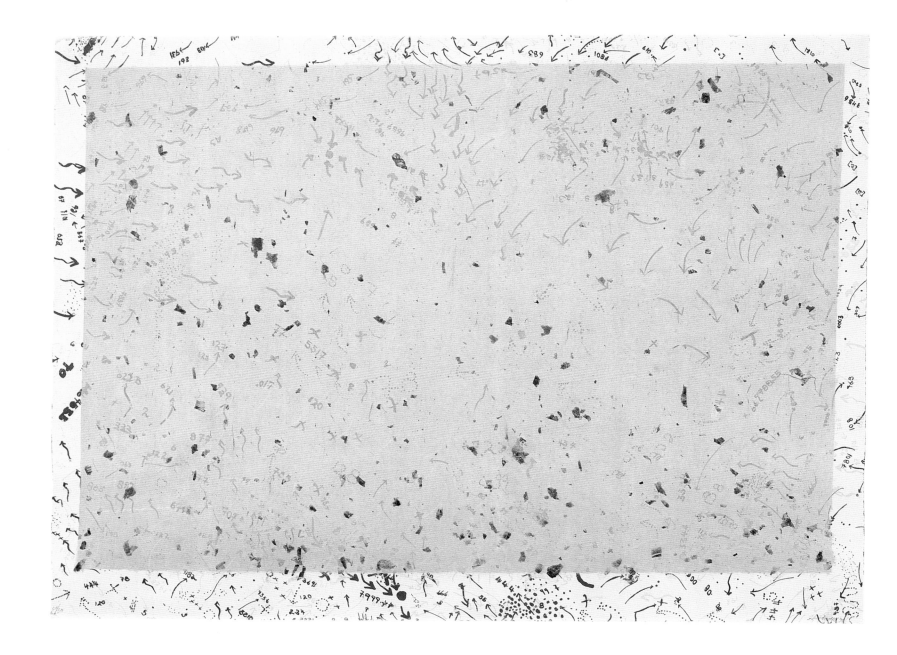

Colorplate 45

HOWARDENA PINDELL

Untitled

Colorplate 46

HOWARDENA PINDELL

Kyoto: Positive/Negative

sheets. All of these elements interlock, interweave, and overlap to determine composition and build space. The pulsating nature of the colors, implying deep, fluid space, is countered by the insistence of surface and by our sense of the physical reality of the collage.

Pindell's mysterious, atmospheric prints present elusive spatial effects. They seem to be in constant flux and yet to exude a sense of serene calm. This quality may have some source in another aspect of her art: the photographs that she makes from drawings on acetate overlaid onto an active television screen.[3] In these, and in much of her work, the static and the dynamic, the controlled and the uncontrollable conjoin and interact.

Both *Untitled* and *Kyoto: Positive/Negative* were printed by Judith Solodkin at Solo Press, New York (the etching in *Kyoto: Positive/Negative* was printed by Pat Branstead). Solodkin, in 1974, was the first woman to complete the famous Tamarind Institute printing course and become a Tamarind Master Printer. According to Pindell, "there isn't anything she cannot do."[4]

In recent years figuration has come to play a role in Pindell's work—collages of imagery derived from souvenirs and memories of places she has visited, among them Japan and India.[5]

Pindell earned degrees from Boston University and the Yale University School of Art and Architecture (M.F.A., 1967). For several years she was an associate curator in the Department of Prints and Illustrated Books at the Museum of Modern Art, New York, and among the writing she did while there is the groundbreaking article, "Alternative Space: Artists' Periodicals."[6] She is currently on the fine-arts faculty at the State University of New York at Stony Brook.

1. See Adriene Cruz and Gwendolyn Laughinghouse (interviewers), "Howardena Pindell," *Interviews with Women in the Arts, Part 2*, organized by Joyce Kozloff (New York: The School of Visual Arts, 1976), 21–23; and Richard Lorber, "Women Artists on Women in Art," *Portfolio* 2 (February–March 1980), 71.

2. "Prints and Photographs Published," *Print Collector's Newsletter* 8 (July–August 1977), 79-80.

3. For example, see "Prints and Photographs Published: Howardena Pindell, *Baseball Series*," *Print Collector's Newsletter* 7 (July–August 1976), 88.

4. Letter from the artist to Richard S. Field, 23 December 1985.

5. These recent works were exhibited 12 February–12 June 1986 in *Howardena Pindell: Odyssey*, organized by Terry S. Rouse for the Studio Museum in Harlem, New York. The catalogue for this exhibition includes several reproductions of the works, as well as a useful chronology.

6. See *Print Collector's Newsletter* 8 (September–October 1977), 96–109, 120–21.

CHECKLIST

Untitled, 1976.
Lithograph and chine collé on Arches buff paper.
Edition: 30.
Sheet size: 22½ × 30 in. (57.2 × 76.2 cm).
Printed by Judith Solodkin at Solo Press, New York; published by A.I.R., New York.
Lent by the Mount Holyoke College Art Museum, The Henry Rox Memorial Fund for the Acquisition of Works by Contemporary Women Artists

Kyoto: Positive/Negative, 1980.
Etching and lithograph on dyed Japan paper with five additional sheets of laminated Japan paper.
Edition: 30.
Sheet size: 26⅜ × 20½ in. (67 × 52.1 cm).
Printed by Pat Branstead at Aeropress, New York (etching), and Judith Solodkin at Solo Press, New York (lithography); published by Bristol Art Editions, New York.
Lent by the Yale University Art Gallery, purchased with the aid of funds from the National Endowment for the Arts and the Susan Morse Hilles Matching Fund

DOROTHEA ROCKBURNE

Born Verdun, Quebec, Canada, 1934

■

*D*orothea Rockburne was raised in Montreal and studied art at the Montreal Museum School and the École des Beaux-Arts before switching to Black Mountain College in North Carolina. At Black Mountain she met many stimulating people, among them the mathematician Max Dehn, whose theories had an important impact on her thinking.

Rockburne's art is engaged with a dialectic of ideas, materials, and actions. She has set up logical limitations or guidelines in each of these arenas and investigated the permutations possible within the constraints of her defined materials and proposed operations. Although involved with mathematical theory, Rockburne has explained that she does not "totally rely on theory because the act of forming a statement visually has always been paramount for me. . . . When I do a work I want to be surprised by it in such a way that I will be changed by having done it."[1]

The work involves an organic development, with cause and effect an aspect of its evolution. She is aware of an art-historical past, and of the visual data available from other times and cultures, and she draws energy from this knowledge without allowing the sources to be in any way apparent. In particular she has been interested in the early Renaissance, especially in Italy.[2]

Using her set variety of surfaces, papers, boards, linen, plastics, and so forth, Rockburne draws, laminates, colors, varnishes, layers, and folds, establishing works that range from the very austere to an almost baroque flamboyance. One gets a sense of her range in the prints seen here.

Rockburne has completed two important sets of prints, the six *Locus* etchings, 1972 (colorplates 47 and 48), and four lithographs worked as a group, two of which are *Radiance* and *Melencolia*, both 1983 (colorplates 49 and 50). Both bodies of work involve the processes of printing and folding, with forms preliminarily established by sharp lines and modulated fields. The first prints are quietly subtle in their overall grayish whiteness, whereas the later group is distinguished by brilliant and radical translucent color. Each set reflects the ideas and forms Rockburne was exploring in her drawings and paintings at the time they were undertaken. Rockburne's art as a unit explores meaning in verbal and visual language, and in the operations of making objects. In printmaking the processes are complex and often indirect, thus complicating the logic of structuring.

The *Locus* etchings were begun in 1972 and completed three years later. Each of the six is meant to be coherent within its own terms and complete as a separate piece, but the six together also form a unified structure with additional, relational meanings. In writing about the prints, Rockburne has explained that the etchings, developed over time, "contain the assimilation and integration of experience."[3]

The elements essential to etching, and the coordination of their functions, defined Rockburne's investigations. The elements themselves include those that are part of the print—the ink and sheet of paper—as well as those by which it is formed—the etched plate and printing press. The process was that of coordinating printing and folding, with clues to the next step developing from the last.

Rockburne considers the plane of the paper in all its aspects: its dimensions, its two-sidedness, and its edges, which may function graphically as lines, along with those that are printed, and she has indicated that "by staring intensely at the paper and thinking hard, I just for a certain time, in a certain sense, become the paper. The possibilities of decision are then understood. . . . Refinement lies in steps that are retained and those which are dropped in order to allow the paper to retain immediacy."[4]

In an unusual method, she applies white ink to an aquatinted plate, which is then impressed onto the sheet, after which she further enhances variations in density by wiping the surface of the sheet; the ink interacts with the paper to create a range of whites. The etching plate, which is the same size as the paper in all the *Locus* prints, under pressure from the press "makes the sheet of copper and the sheet of ink impart their properties to the paper."

Rockburne further explains that "the sum of these parts is not the totality of the work. . . . The last year of work was spent

Colorplate 47

DOROTHEA ROCKBURNE

Locus No. 1

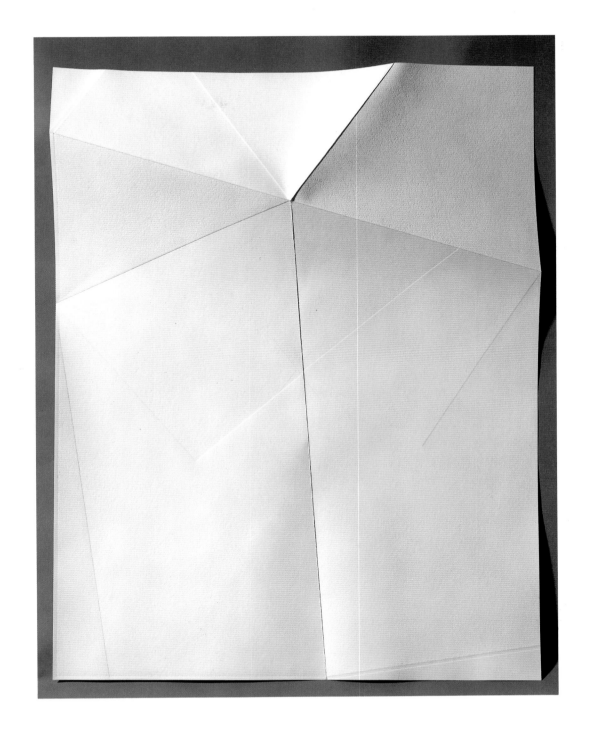

Colorplate 48

DOROTHEA ROCKBURNE

Locus No. 4

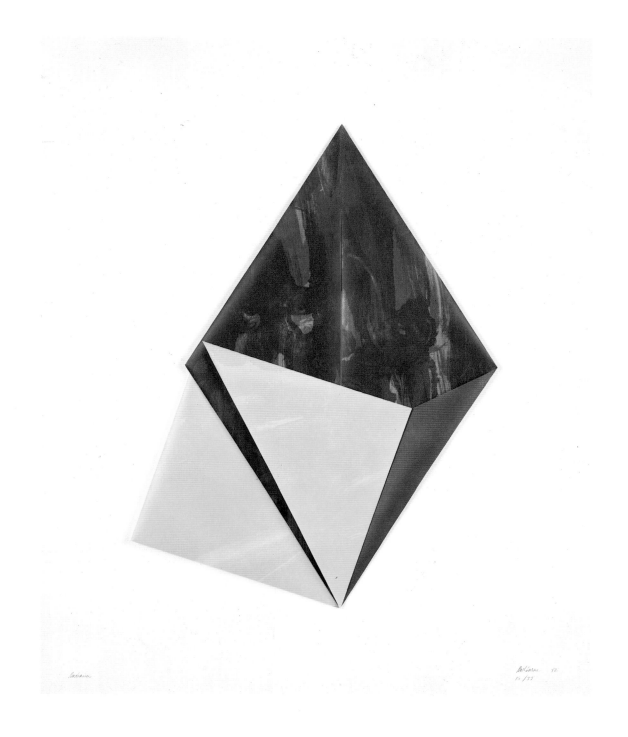

DOROTHEA ROCKBURNE

Radiance

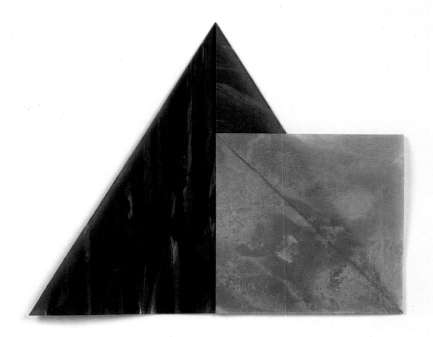

Colorplate 50

DOROTHEA ROCKBURNE

Melencolia

coordinating the ink, lines and folds, so that no part has more pronouncement than the other. *Locus*, in Latin, means location."

All four prints in Rockburne's Gemini lithography project, *Radiance* and *Melencolia* as well as *Uriel* and *Devine Ray*, employ the square and the rectangle that form the Golden Section, a proportion the artist has mined in her work in all media for more than a decade. The prints further reflect Rockburne's interest in the early Renaissance, and particularly the paintings of Giotto and Duccio, in which the figures are defined by colorful, voluptuous drapery that is folded and overlapped to establish form.

The prints are on Transpagra vellum, a three-ply paper composed of a sheet of Mylar sandwiched between two sheets of imitation vellum. Rockburne has been working with this material since the early 1970s. It is without tooth and therefore somewhat slick, so that the surface qualities are imparted to the ink color as it is layered onto the sheet. Both *Radiance* and *Melencolia* are printed in six colors, four on the front surface and two on the back of the sheet. In each print four colors are printed in areas of modulated washes and one color in a broad, flat area. In addition, a thin blue line defines the color fields and functions as a guide for the artist to the cutting and folding necessary to establish the piece's final configuration. In their complexity these colorful prints mask the stages of the process by which they were made. In the *Locus* etchings, by contrast, process is ever visible and its stages apparent, although not, perhaps, readily reconstructed in the mind of the viewer.[5]

While Rockburne's art is involved with proportion and process, its metaphysical content is central to her purpose. This purpose is "to form the 'emotional object,' to transfer the inside poignancy of feeling to an outside visual form."[6]

1. Quoted in Roberta Olson, "An Interview with Dorothea Rockburne," *Art in America* 66 (November–December 1978), 142–43.

2. See Michael Marlais, *Dorothea Rockburne, Drawing: Structure and Curve*, exhibition catalogue (New York: John Weber Gallery, 1978).

3. Quoted in "Dorothea Rockburne," *Prints: Bochner, LeWitt, Mangold, Marden, Martin, Renouf, Rockburne, Ryman*, exhibition catalogue (Toronto: Art Gallery of Ontario, 1976), 45. See also "Carter Ratcliff, Dorothea Rockburne: New Prints," *Print Collector's Newsletter* 5 (May–June 1974), 30–32.

4. This and the following two quoted passages appear in "Dorothea Rockburne," 45–46.

5. For a discussion of Rockburne's approach to process throughout her career, see Brian O'Doherty, *Dorothea Rockburne: A Personal Selection, Paintings, 1968–1986*, exhibition catalogue (New York: Xavier Fourcade, Inc., 1986).

6. Quoted in Ruth E. Fine, *Gemini G.E.L.: Art and Collaboration*, exhibition catalogue (Washington, D.C.: National Gallery of Art, and New York: Abbeville Press, 1984), 228.

CHECKLIST

Locus No. 1, 1972.
Soft-ground etching and aquatint on folded Strathmore Bristol paper.
Edition: 50.
Sheet size: 40 × 30 in. (101.6 × 76.2 cm).
Printed by Jeryl Parker at Crown Point Press, Oakland, California; published by Parasol Press, Inc., New York.
Lent by the Yale University Art Gallery, Fleischer Fund and Anonymous Purchase Funds

Locus No. 4, 1972.
Soft-ground etching and aquatint on folded Strathmore Bristol paper.
Edition: 50.
Sheet size: 40 × 30 in. (101.6 × 76.2 cm).
Printed by Jeryl Parker at Crown Point Press, Oakland, California; published by Parasol Press, Inc., New York.
Lent by the Yale University Art Gallery, Fleischer Fund and Anonymous Purchase Funds

Radiance, 1983.
Lithograph, printed on both sides of Transpagra vellum.
Edition: 37.
Sheet size: 40 × 32 in. (101.6 × 81.3 cm).
Printed by Serge Lozingot, James Reid, and Sarah Todd at Gemini G.E.L.; published by Gemini G.E.L., Los Angeles.
Lent by the Mount Holyoke College Art Museum, The Henry Rox Memorial Fund for the Acquisition of Works by Contemporary Women Artists

Melencolia, 1983.
Lithograph, printed on both sides of Transpagra vellum.
Edition: 40.
Sheet size: 31¾ × 39 in. (80.7 × 99.1 cm).
Printed by Serge Lozingot, James Reid, and Sarah Todd at Gemini G.E.L.; published by Gemini G.E.L., Los Angeles.
Lent by the Mount Holyoke College Art Museum, The Henry Rox Memorial Fund for the Acquisition of Works by Contemporary Women Artists

SUSAN ROTHENBERG

Born Buffalo, New York, 1945

■

Susan Rothenberg was introduced to great works of modern art at the Albright-Knox Art Gallery in Buffalo, New York, where she grew up. She started out studying sculpture and received her B.F.A. degree from Cornell University in 1967, settling in New York City two years later. Rothenberg's paintings were first exhibited in the city in 1974, and they have increasingly received international acclaim.[1] Her enigmatic images have called to mind dreamlike memories, seeming to seek essences and to approach the center of emotional experience. Her work is austere, yet often playful, its dense, somber core challenged by a lyrical immediacy of expression.

When Rothenberg arrived in New York, abstraction and Minimalism were of prime interest. However, she spent a brief period of time apprenticing in Nancy Graves's studio in 1970 (Graves was working with freestanding, life-size camels at that time), and was encouraged by the experience to tackle working with an image. Jasper Johns's work became a conscious precedent in her coordination of representational imagery with painterly brushwork.[2] The mark, the gesture, the stroke, are of distinctive importance in Rothenberg's paintings, in which a rich impasto forms, grasps, and reveals mysterious images. So, too, with her prints. In printmaking, however, the mark functions in very different ways, depending upon the particular printmaking process she is using, and her body of prints includes works in a wide range of graphic media.

Rothenberg's horse images, principal to her work through the 1970s, established her as an artist to be carefully considered. But why the horse? The image may stir memories of the cowhand's best friend, or we may think of it as a means of romantic escape, allowing us to ride swiftly off into the sunset; these are ideas central to the Western movies of the 1940s and 1950s, the time when Rothenberg was growing up. During that same period one learned that the horse might also be seen as symbolic of sexual desire in young women, or as distinguishing nature from the machine. (Certainly the automobile was a more popular subject for artists during the 1970s.)

Rothenberg has said that she came to realize that the horses were self-portraits;[3] but they may also be read more broadly, as suggesting the possibility of the horse as a surrogate human—a more detached and distancing subject, rather than one laden with the implied subjective weight the human figure carries. Rothenberg's work in recent years, however, has attacked the problem of humanness directly, and one is less involved with wondering about her selection of a subject per se than with relating to the work in a deeper, more direct and instinctual manner.

Several of the figurative paintings have made reference in their titles to Piet Mondrian, for whose work Rothenberg has great respect. Her admiration for Mondrian's "rigor and control" has been addressed, with mention of the stylistic differences between the two artists.[4] One wonders if Rothenberg might, in fact, be affected by Mondrian's work of 1908–14, when he was shifting toward abstraction and working with a rigorous gestural mark—a manner of working for which Rothenberg might feel a direct affinity. In this respect, Alberto Giacometti is another artist with whom one sees associations.[5]

Rothenberg's prints are not directly derived from painting images. Her approach in each case is a spontaneous response to the specific materials—for example, the shape of a block of wood—as much as a development of her own visual themes. Her direct approach is uncommon to this degree among painters working in prints.[6] The content of the prints, however, does relate closely to her work as a painter. The challenge of the horse as subject matter is evident in *Two Small Aquatints*, 1979 (colorplates 51 and 52), much as it is in the paintings. For example, in *Untitled (May #1)*, a full frontal image, clearly of a horse galloping forward, is simultaneously thrust into a deep pictorial space and flattened by the upside-down horse's legs that function as a frame. Rothenberg's touch, her apparent ease and exploratory approach in working with new materials may be seen in the richly sensuous surfaces the artist achieved by coordinating several etching processes, and by further developing the metal matrix with the scraper and burnisher.

In her prints, as in her paintings, Rothenberg insists that we

attend to how the works were made—how the hand responds to the mind and eye. *Pinks*, a 1980 woodcut, directly addresses the coordination of head and hand in its imagery; and *Head and Hand*, another woodcut of the same year, does this too, although somewhat less directly, except with respect to title. In *Head and Bones*, 1980 (colorplate 53), the grain of the wood reinforces the warm, natural surface and a rich variety of gouge marks places the image slightly off balance, emphasizing its lack of serenity. There is a nervous energy created by this pulsating surface, and a sense of brilliant light in the midst of darkness. The marks are cut with such vigor that one senses almost a dance, a ritual motion: head and bones, the mind and the body, the spiritual and the physical.

Rothenberg's experimental approach to the print matrix (which is as changeable as a canvas if one wants to work with a similar sense of freedom) has led her to do several unique printed images—images with additions by hand, each of which may be seen as a distinct work. Having moved from the idealized horse image, her subjects now include landscape, her family and friends, and her dog, all worked from memory. This autobiographical impulse, a looking inward, has been accompanied by an outward looking at form.

Her 1986 project at Gemini G.E.L. included five works in a variety of media—mezzotint, etching, woodcut, and lithography—printed on various papers. As in *Breath-man*, 1986 (colorplate 54), she readily combines processes in a single work. Rothenberg works as if to reinvent the inherent characteristics of each technique—the potential for layered surfaces in an intaglio plate;

the direct, draftsmanlike possibilities of lithography; the charged, sliced strokes of the woodcut—and to make them function to dramatize her vision. For the most part, her prints have retained an emblematic quality. The strength of this iconic graphic approach in no way diminishes the mysterious, charged, very personal expressiveness of Rothenberg's poetic vision. Indeed, the graphic work offers distinctive challenges to our understanding of its meaning.

1. Rothenberg was the one woman included in the "Zeitgeist" international exhibition in Berlin in 1982. See also Grace Glueck, "Susan Rothenberg, New Outlook for a Visionary Artist," *New York Times Magazine* (22 July 1984), cover and pp. 16–22 ff.

2. Eliza Rathbone, *Susan Rothenberg*, exhibition catalogue (Washington, D.C.: Phillips Collection, 1985), 10. The catalogue includes a bibliography.

3. Rathbone, *Susan Rothenberg*, 9.

4. Rathbone, *Susan Rothenberg*, 21 and catalogue numbers 6 and 7.

5. See Robert Storr, "Spooks and Floats," *Art in America* 71 (May 1983), 153–59.

6. A listing of Rothenberg's prints to 1984 is included in *Susan Rothenberg Prints, 1977–1984* (Boston: Barbara Krakow Gallery, 1984). The spontaneity of her approach is discussed in Clifford S. Ackley, "I Don't Really Think of Myself as a Printmaker: Susan Rothenberg," *Print Collector's Newsletter* 15 (September–October 1984), 128–29. See also Marge Goldwater, "Susan Rothenberg," *Images and Impressions: Painters Who Print*, exhibition catalogue (Minneapolis: Walker Art Center, 1984), 46–51.

CHECKLIST

Untitled (May #1), 1979.
Open-bite, spit-bite, hard-ground etching, and burnishing on Fabriano etching paper.
Sheet size: 29½ × 22 in. (74.9 × 55.9 cm).
Edition: 45.
Printed by Gretchen Gelb and Peter Drake at Aeropress, New York; published by Parasol Press, Inc., New York.
Lent by the Mount Holyoke College Art Museum, The Henry Rox Memorial Fund for the Acquisition of Works by Contemporary Women Artists

Untitled (May #2), 1979.
Soft-ground etching, sugar-lift, aquatint, spit bite, scraping, and burnishing on Fabriano etching paper.
Sheet size: 29½ × 22 in. (74.9 × 55.9 cm).
Printed by Gretchen Gelb and Sally Sturman at Aeropress, New York; published by Parasol Press, Inc., New York.
Lent by the Mount Holyoke College Art Museum, The Henry Rox

Memorial Fund for the Acquisition of Works by Contemporary Women Artists

Head and Bones, 1980.
Woodcut on Hosho paper.
Edition: 45.
Sheet size: 26 × 19 in. (66 × 48.3 cm).
Printed by Gretchen Gelb at Arrow Press, New York; published by Multiples, Inc., New York.
Lent by Multiples, Inc./Marian Goodman Gallery, New York

Breath-man, 1986.
Relief and intaglio on John Koller HMP pale-gray paper.
Edition: 37.
Sheet size: 20¾ × 20¾ in. (52.8 × 52.8 cm).
Printed by Ken Farley and Diana Kingsly at Gemini G.E.L.; published by Gemini G.E.L., Los Angeles.
Lent by Gemini G.E.L., Los Angeles, California

Colorplate 51

SUSAN ROTHENBERG

Untitled (May #1)

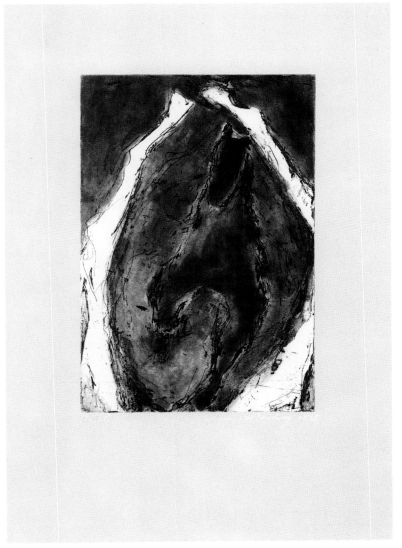

Colorplate 52

SUSAN ROTHENBERG

Untitled (May #2)

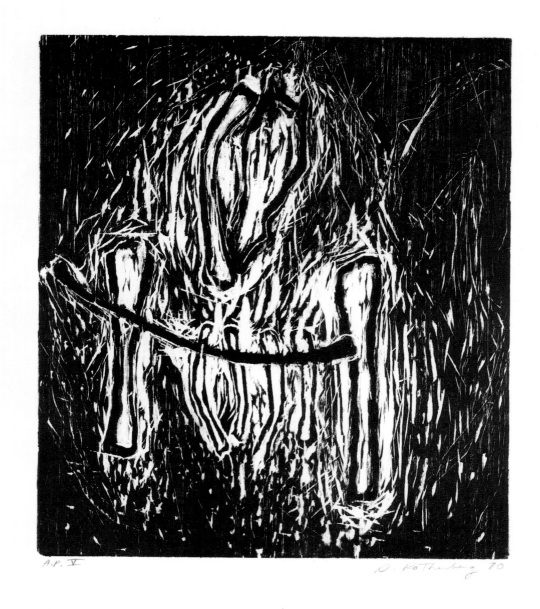

A.P. V S. Rothenberg 80

Colorplate 53

SUSAN ROTHENBERG

———————————————————

Head and Bones

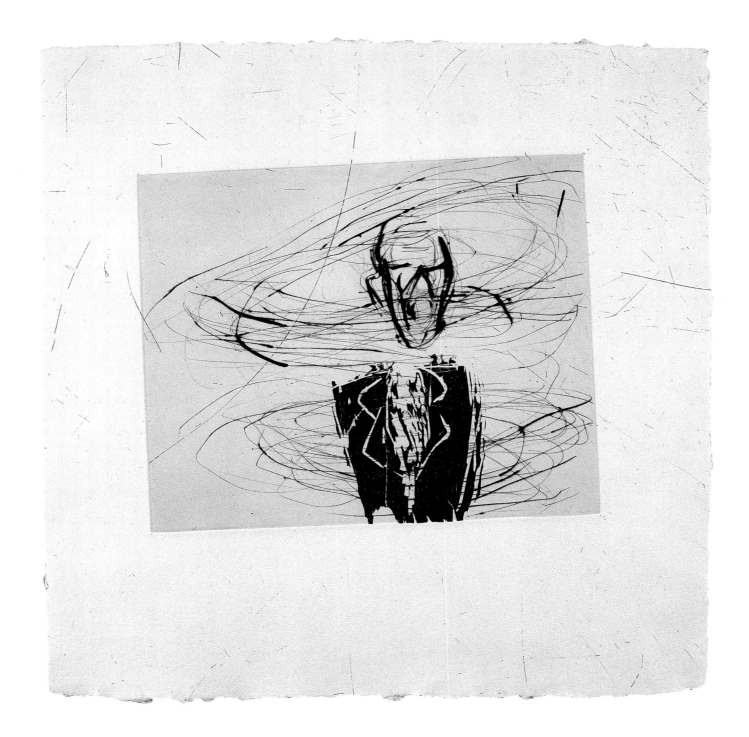

Colorplate 54

SUSAN ROTHENBERG

Breath-man

SUSAN SHATTER

Born New York, New York, 1943

■

Susan Shatter studied at the University of Wisconsin in Madison before shifting to the Pratt Institute in Brooklyn, New York, where she earned her B.F.A. degree in 1965. She earned an M.F.A. from Boston University in 1972. Shatter lived and worked in the Boston area for some years, painting scenes of Cambridge rooftops and along the Charles River. Currently she is based in New York City. Her images, as seen in the prints reproduced here, do not reflect her immediate surroundings as the Boston pictures did. Rather, Shatter is engaged in picturing the romantic expanses of an untamed natural world, panoramic views that earlier inspired such painters as Albert Bierstadt and Thomas Moran.

Many of Shatter's major works are large-scale watercolors. Her vast landscape subjects call into question the traditional notions of immediacy and intimacy associated with watercolor and demonstrate the artist's considerable ability to meet the difficulties of the medium. Especially challenging is the necessity to control transparent washes across extensive expanses of surface.

Shatter started working outdoors on watercolors as a student at the Skowhegan School of Painting and Sculpture in Maine in 1964. There, Fairfield Porter and John Button were especially supportive of the direction her work was taking.[1] She worked almost exclusively in the watercolor medium for several years, receiving considerable notice, but recently she has returned to working in oils and has, on occasion, been making prints.

Shatter has traveled extensively seeking subjects to picture—to the shores of the Mediterranean, the New England coast, the deserts, mountains, and canyons of the western United States, and, recently, Hawaii. She is attracted by rugged, rather than serene terrain, and her scenes of rocky vistas convey a sense of their formative evolution over millennia. Often she paints a scene from several different vantage points, a way of working that amplifies her own understanding of each place.

The jagged rocks along the Maine coast and the deep ravines of the Grand Canyon are heroic places that may be terrifying in their beauty. They challenge an artist to be more than merely picturesque, something that Shatter has accomplished by her use of strong compositional structures and by the all-encompassing approach that she takes to form. Although her work is rooted in careful observation, she cares more for grasping the overall sensation of a place than for meticulous depiction of its details.

The broad fluidity of her watercolor washes develops discrete areas of color and, though worked carefully over time, they maintain a sense of directness and immediacy. In such prints as *Rock Face/Zion Canyon*, 1981, and *Vertigo*, 1983 (colorplates 55 and 56), she maintains these qualities of directness and spontaneity in the zones of printed color despite the even more prolonged and fragmented nature of the processes essential to developing printed images. Printmaking, in fact, seems to function technically as a logical extension of her watercolors; in both she achieves luminosity by building up layers of color. In discussing her watercolor process, Shatter has explained, "I work with a limited palette and develop a range of colors, layering on the paint in transparent washes. To make a gray, for instance, I may first lay down a green and then apply a red wash."[2] She applies similar conceptual methods in making prints.

In both lithography (*Rock Face/Zion Canyon*) and aquatint etching (*Vertigo*) Shatter has organized her dense compositions by constructing patterns of chiaroscuro that set off her rich color effects. *Vertigo*, especially, insists on the presence of the picture's surface. A landscape without sky, it is composed of two jagged color arenas, a muted gray, brown, and blue section at left in deep shadow and, at right, a concentration of softened, undulating surfaces drenched in bright yellow and lime-green sunlight.

Shatter's art sets up a dialogue between the character of place (a

144

"revelation of the continuing unorthodoxy of nature's forms")[3] and the character of materials. She works with a powerful painterly approach that dispels any pretense to illusionism. Color is applied sensuously, the hand of the artist ever present, making it clear that her commitment to a painterly reality parallels the reality of the land.

1. M. Stephen Doherty, "Watercolor Today: Ten Contemporary Artists," *American Artist* 47 (February 1983), 84.

2. Doherty, "Watercolor Today," 84.

3. Donald B. Kuspit, "Susan Shatter at Fischbach," *Art In America* 70 (October 1982), 135.

CHECKLIST

Rock Face/Zion Canyon, 1981.
Lithograph on Arches Gamari paper.
Edition: 80.
Sheet size: 31½ × 44 in. (80 × 111.7 cm).
Printed by Judith Solodkin at Solo Press, New York; published by Judith Solodkin and Diane Villani Editions, New York.
Lent by Diane Villani Editions, New York

Vertigo, 1983.
Aquatint, etching, and roulette on Rives BFK paper.
Edition: 40.
Sheet size: 41⅜ × 18⅝ in. (105.1 × 47.4 cm).
Printed by Nancy Brokopp, New York; published by 724 Prints Inc., New York.
Lent by the Mount Holyoke College Art Museum, The Henry Rox Memorial Fund for the Acquisition of Works by Contemporary Women Artists

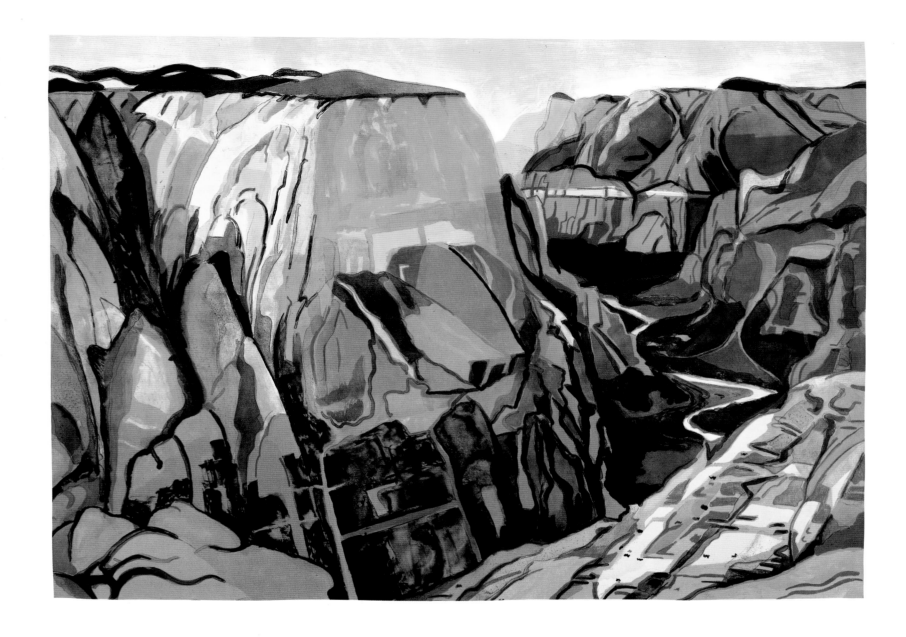

Colorplate 55

SUSAN SHATTER

Rock Face/Zion Canyon

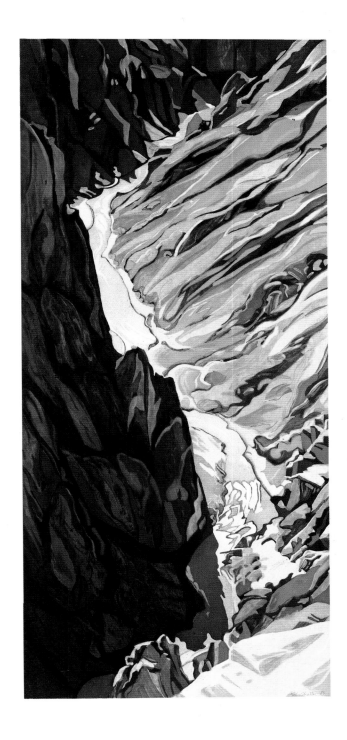

Colorplate 56

SUSAN SHATTER

Vertigo

JOAN SNYDER

Born Highland Park, New Jersey, 1940

■

Joan Snyder earned her B.A. degree in sociology from Douglass College, Rutgers University, New Brunswick, New Jersey, in 1962 and an M.F.A. degree also from Rutgers University four years later. Snyder has been an important figure in the feminist art movement, focusing her attention on feminist issues in her art, her teaching, and many other public forums.

Intensity of both image and process is essential to Joan Snyder's art, which explores anxiety as a fact of life. She plumbs the depths of her experiences as a woman and attempts to understand and to share them, battling with both ideas and sensibility. "Everybody was asking, is there a female esthetic or isn't there? And I was certainly out to prove that there is, that our work comes out of our lives, and that women's experiences are different from men's experiences, so our work is different too."[1]

While anguish is a paramount emotion in the work, it would be an oversimplification to see her paintings and prints as expressions of raw pain alone. Snyder's art demonstrates a heightened belief in visualizing psychological experiences and an extraordinary ability to tap the most personal thoughts, yet speak in a voice that yearns to make meaningful human connections.

As a painter and printmaker, Snyder often incorporates both material and conceptual uses of collage. Her juxtapositions of multimedia elements address questions asked by much of the art of recent decades: What is real? What makes art? Snyder's work has also explored other aspects of the formal language that have marked the art of the 1970s and 1980s—for example, her early use of a grid structure, her emblematic portrayal of human figures, and her incorporation of a word language as part of her picture language. Snyder's powerful pieces are expressive of such intense emotional content, however, that formal structures by their very use pose questions of how and why a work of art should be structured, when life is so uncontrollably unstructured. Her art, in fact, has moved back and forth, emphasizing formalist and expressive stances in turn, examining the dilemma presented by the potential of choosing one mode to the detriment of the other.[2]

Snyder's strong feminist leanings have determined the primary content of her work, much of it alluding to violence, violation, sadness, change, love, pain, joy. She is concerned with the possibility of an expressive exploration of the universality of our private experiences. Her source is her own psyche, as she seeks to present an underlying mythology to sustain humanity through turmoil; and she has been drawn to primitive art, using images based on African and pre-Columbian idols as part of her compositions because their feeling and content are primary.[3] In her own work she employs a language of signs, used metaphorically and expressed with a passion that grows as she immerses herself in the process. The surfaces, developed layer upon layer, carry an intensity and implications of depth that function to remind us of life's densely layered experiences.

With vitality and urgency, often employing childlike, schematic, primitive figural drawings, Snyder addresses the question of a female sensibility. Searching for it, locating it, registering it, ultimately defining it—for herself and for like-minded others—throughout her career she has very directly brought attention to this question, one of the most potent addressed by the art of our time.

The sensuousness that results from combining diverse materials and exploring the material qualities of processes is evident in Snyder's prints. She has worked in a variety of print techniques, etching as well as woodcut and lithography. In many instances, as part of her approach she either varies the quality of the printing or makes additions by hand to her printed impressions. For example, in the woodcut *Things Have Tears and We Know Suffering*, 1984 (colorplate 57), hand coloring added to the two printed colors reinforces the notion that even in prints—works made by what for the most part are indirect processes—an intimacy of touch and dense, tactile surfaces are essential to her meaning. She seeks in her prints equivalents for the rich impastos, textured scumblings, and washy drips in her paintings. The merging of idea and process is especially important in this emotionally charged, wrenching image of a mother nursing a child. The rough gouge marks and coarse

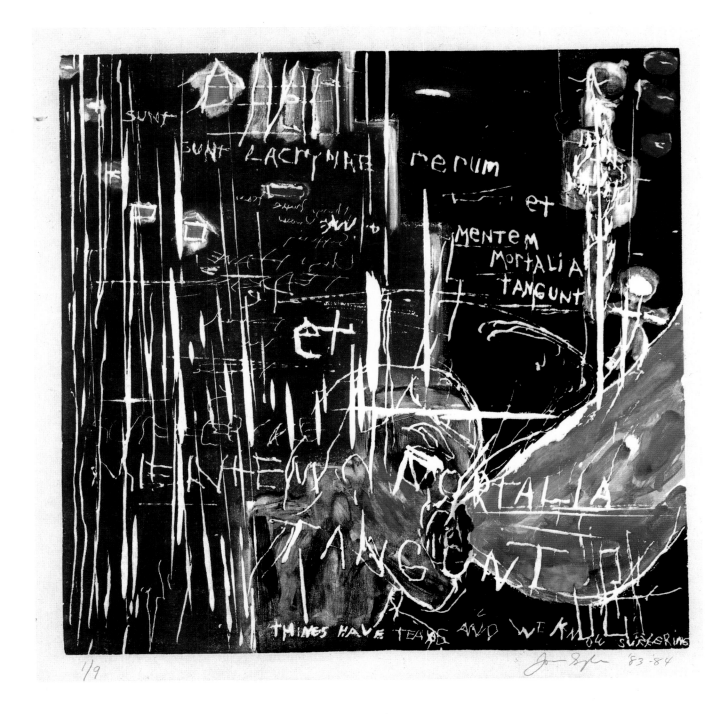

1/9

JOAN SNYDER

Things Have Tears and We Know Suffering

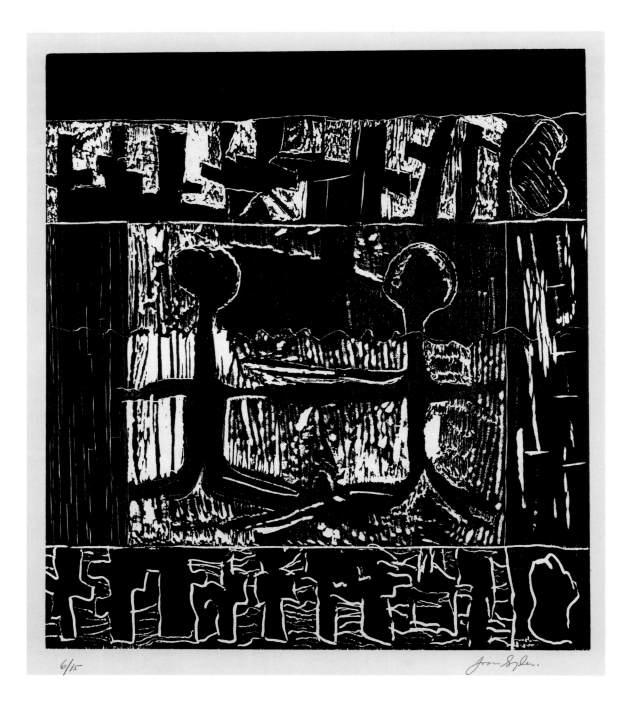

6/15

Joan Snyder

Colorplate 58

JOAN SNYDER

Dancing in the Dark

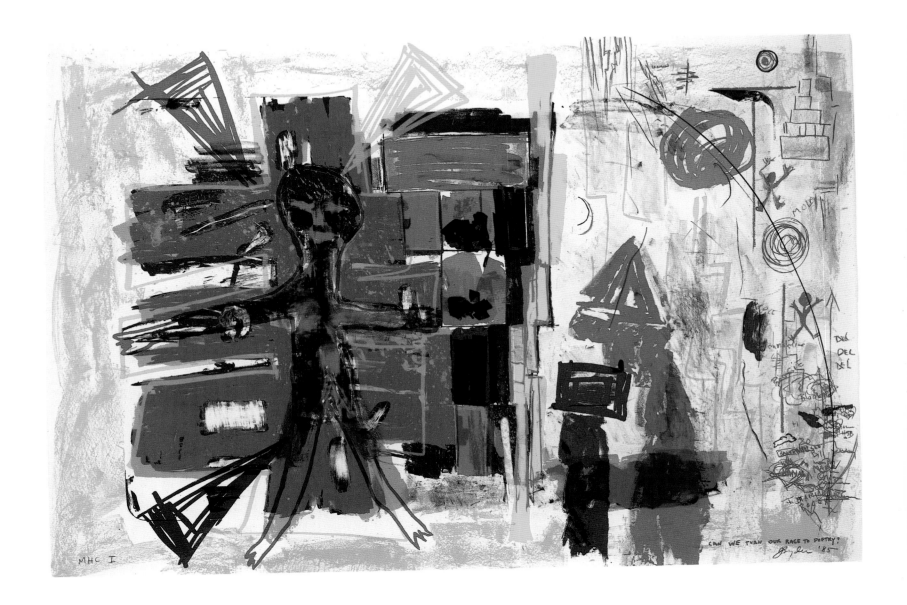

Colorplate 59

JOAN SNYDER

Can We Turn Our Rage to Poetry?

forms that break into the area surrounding the figures add to an atmosphere of tension that is contrary to the peace one associates with the subject.

Dancing in the Dark, 1982–84 (colorplate 58), composed essentially of horizontal bands, shows the central figure band sandwiched between two vertical columns; figures are thus confined and contained, their facial expressions implied rather than explicit. And while they are dark, they do not seem to be in darkness and perhaps are not even dancing. Again, the wood is coarsely and roughly gouged, with shapes in the bands above and below the figures that might be read as architecture (above) or, at a different scale, gravestones, and perhaps animals (below).

In the lithograph *Can We Turn Our Rage to Poetry?*, 1985 (colorplate 59), produced at Mount Holyoke College, in South Hadley, Massachusetts, the figures are embedded in the exuberance of the abstracted composition. Raw reds, blues, yellows, and blacks create a tension between the world and its occupants, between light and dark, between line and shape. The graffitilike inscription "Molly," Snyder's daughter's name, reminds us of the auto-biographical quality of her work. The tensions of existence explode as shapes press out from the center, a dark field at left, white at right, and a yellow light dividing them. The dark is the larger and the forms in the dark are locked in, rigid, whereas there is a floating openness at the right. The title of the print, also the title of a 1985 painting, functions as the leitmotif of Snyder's art. The urgency of the work carries a statement of optimism, a sense of belief that working leads to understanding, and that the work itself has the potential to alter experience.

1. Joan Snyder, quoted in "Expressionism Today: An Artists' Symposium," *Art in America* 70 (December 1982), 63–64. See also "The Women's Movement in Art, 1986," *Arts* 61 (September 1986), 54–57; and Hayden Herrera, *Joan Snyder: Seven Years of Work*, exhibition catalogue (Purchase, New York: Neuberger Museum, 1978). The catalogue has a bibliography.

2. See Gerrit Henry, "Joan Snyder: True Grit," *Art in America* 74 (February 1986), 96–101.

3. Joan Snyder, "Expressionism Today," 63.

CHECKLIST

Things Have Tears and We Know Suffering, 1984.
Woodcut on Yamoto paper.
Edition: 9.
Sheet size: 26 × 25 in. (66 × 63.5 cm).
Printed by Chip Elwell, New York; published by Diane Villani Editions, New York.
Lent by Diane Villani Editions, New York

Dancing in the Dark, 1982–84.
Woodcut on Shoin paper.
Edition: 15.
Sheet size: 29 × 25¼ in. (73.7 × 64.1 cm).
Printed by Chip Elwell, New York; published by Diane Villani Editions, New York.
Lent by Diane Villani Editions, New York

Can We Turn Our Rage to Poetry?, 1985.
Lithograph on Rives BFK paper.
Edition: 20.
Sheet size: 30¼ × 44½ in. (76.9 × 113 cm).
Printed by John Hutcheson at Mount Holyoke College, South Hadley, Massachusetts, and Riverview Fine Arts Press, Jersey City, New Jersey; published by Mount Holyoke College and Diane Villani Editions, New York.
Lent by the Mount Holyoke College Art Museum, Gift of the Mount Holyoke College Printmaking Workshop

PAT STEIR

Born Newark, New Jersey, 1938

■

*P*rints are an important aspect of Pat Steir's art, the printed mark conveying meaning of specific importance to her concern with the way visual language functions. She has worked in a variety of printmaking processes and has investigated the particular kinds of marks distinctive to each. She seems particularly comfortable with etching: "I feel that etching is the most basic and the most intimate way for me to work. . . . Litho and silkscreen don't offer me a new way of working and seeing like etching does."[1]

Steir first made prints as a student at the Pratt Institute in Brooklyn, New York, where she earned a B.F.A. degree in 1962, following a 1960 B.A. from Boston University. At the start of her professional career, she supported herself by working as an art director and book designer at Harper & Row, the book publishers, an experience that undoubtedly heightened her awareness of the ways in which the coordination of visual and verbal language supports meaning—an issue she has examined in much of her art.[2]

Steir's prints explore the vocabulary and syntax of the printed mark: What is available? What might it mean? For example, the prints in the two series Drawing Lesson, Part I and Drawing Lesson, Part II, made at Crown Point Press in 1978, are about learning how language communicates, and in effect describe how drawing in printmaking is different from drawing directly.

Aspects of Steir's art may be seen as diaristic and autobiographical, but the approach functions as a means of working, not a cause. Extremely conscious of the weight of language, both visual and verbal, Steir on several occasions has clearly explained her intentions in making art: "I think it's a desire to transcend the limits of a single human being, and a desire to make multiple human beings into a single being. The urge for art for me is the urge for language. . . . The mark-making that I do in the paintings, in the drawing, in the prints, has not to do with self-expression, but with a kind of human expression."[3]

In Steir's early work representational elements were often included, flowers in particular, but they functioned more readily as signs than as representations. In one of three lithographs in the Wish series, *Wish #3—Transformation*, 1974 (colorplate 62), a gray scale, a color scale, a ruled system for containing images, areas of black on white, of white on black, of line, of tone, of geometry, of nature—all tell of the artist's attention to the means of making art as content for art.

Steir has maintained a deep concern for history, a love of the art of the past, and a need to express this sense of continuity in her own work. She has spent considerable time traveling and living in Europe, studying closely the rich art-historical heritage more abundantly available there than in the United States: "All artmaking is research, selection, a combination of thinking and intuition, a connection between history and humanity."[4]

Abstraction, Belief, Desire, 1981, and *The Tree after Hiroshige*, 1984 (colorplates 60 and 61), attest to the manner in which the etching processes liberate Steir's search for meaningful form. Both of them comprise multiple image zones or panels, which Steir has likened to the chapters of a novel.[5] In *Abstraction, Belief, Desire*, especially, by structuring her ideas in this expansive format, Steir had mandated that references be made back and forth between panels and that comparisons between them be formulated; this process both reinforces content and presents potential conflicts. She has established an overt, if arcane, symbolic language, involving a number of coded messages, some of them contradictory. For example, at the top of each panel is a graded color scale, yellow at the left, blue at center, red at the right. But the dominant color in each panel is different from these color cues—in the left panel, it is red; at center, yellow; at the right, blue. Each panel is also inscribed with a word. On the left panel, it is FORM, perhaps paralleling the first word of the title, *Abstraction*; and the geometric imagery is essentially flattened. The central panel, ILLUSION, paralleling *Belief*, is composed of geometric volumes with contradictory, or illogical, light cues. At right, the panel inscribed MYTH (*Desire*) is structured by figurative representations. Included there are a self-portrait and other images of presumed art-historical reference, for example, the sunflowers so closely associated with Vincent van Gogh.

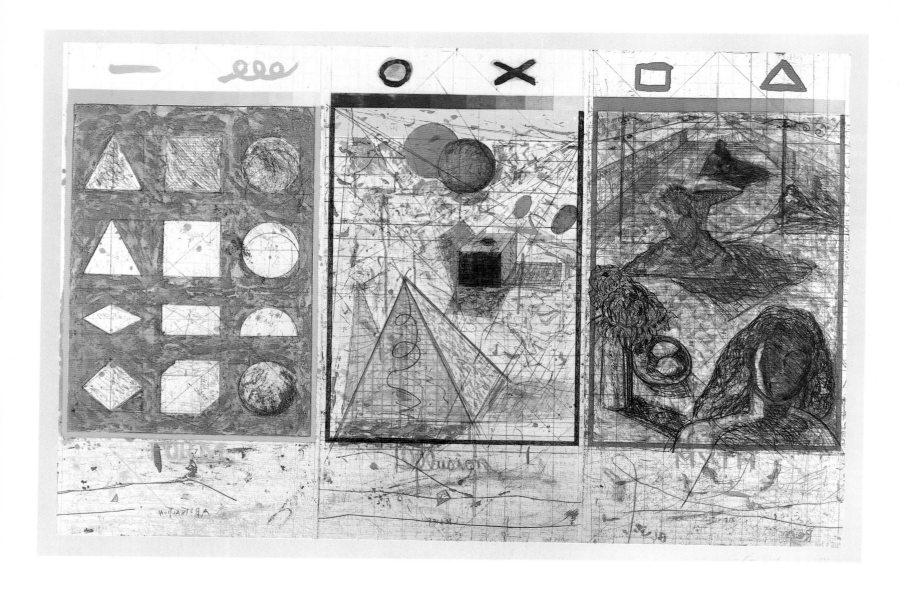

Colorplate 60

PAT STEIR

Abstraction, Belief, Desire

PAT STEIR

The Tree after Hiroshige

Colorplate 62

PAT STEIR

Wish #3—Transformation

In 1982 Steir was the first artist to participate in the Crown Point Press woodcut project in Kyoto, Japan, and the image of the left panel of the print she completed there, *Kyoto Chrysanthemum*, refers to *Abstraction, Belief, Desire*. Steir's dialogue with Japan continued, as is evident in *The Tree after Hiroshige*. The print is exemplary of her references to other artists' work. Indeed, Hiroshige's tree, in *A Garden of Apricots*, a woodcut from *One Hundred Famous Views of Edo*, 1856–59, was reinterpreted by Van Gogh decades before Steir took it up, placing the subject in yet a more complex art-historical context. The print is related to Steir's painting *Cherry Blossoms (in Winter)*, and in both painting and print she has added two panels of foliage to Hiroshige's spare vertical image, converting it to a horizontal piece.[6] Given the subject and its original source, the division of the image into panels further suggests a relationship to Japanese screens.

The explosive color lines that accrue to read as form and shape bear little resemblance to the elegant control one associates with Hiroshige's art. Steir's art-historical references are not an exercise in stylistic mimicry, but convey the energy gleaned by studying past art, usually with some recognizable references to it in aspects of style, color, subject, and so forth. This may most fully be seen in her twenty-three monotype self-portraits completed at Crown Point Press in 1985, among them *Self after Self by Van Gogh*, and in studies that are tied to Edvard Munch, Henri Matisse, Chaim Soutine, and others.

These connections with the art of the past and with her own past art are part of what Steir has referred to as "research about connections. The connections are about the components of everything in the universe, whatever that question is that makes us remain religious in a way. Awe, I think the word is awe. . . . I'm taking pieces out of the chaos to investigate them, so they can be seen."[7]

1. Robin White (interviewer), "Pat Steir," *View* 1 (June 1978), 14.

2. Elizabeth Broun, "Pat Steir: Prints," *Form, Illusion, Myth: Prints and Drawings of Pat Steir*, exhibition catalogue (Lawrence, Kansas: Spencer Museum of Art, 1983), 8. The catalogue includes a bibliography.

3. White, "Pat Steir," 3.

4. Pat Steir, quoted in "Expressionism Today: An Artists' Symposium," *Art in America* 70 (December 1982), 75.

5. See "Pat Steir, in Conversation with Kathan Brown, Director, Crown Point Press," *Pat Steir: Etchings and Paintings*, exhibition catalogue (Oakland, California: Crown Point Gallery, 1981), n.p.

6. The Hiroshige, Van Gogh, and Steir works are reproduced in Joan Simon, "Pat Steir: Drawings," *Form, Illusion, Myth: Prints and Drawings of Pat Steir*, exhibition catalogue (Lawrence, Kansas: Spencer Museum of Art, 1983), 26–27.

7. Quoted in "Pat Steir, in Conversation," n.p.

CHECKLIST

Abstraction, Belief, Desire, 1981.
Sugar-lift and open-bite aquatint, hard- and soft-ground etching, and drypoint on Arches 88 roll paper (from three plates).
Edition: 35.
Sheet size: 42⅜ × 60¾ in. (107.7 × 154.3 cm).
Printed by Hidekatsu Takada at Crown Point Press; published by Crown Point Press, Oakland, California.
Lent by Crown Point Press, Oakland, California

The Tree after Hiroshige, 1984.
Open-bite aquatint, etching, and drypoint on Arches paper.
Edition: 30.
Sheet size: 32¼ × 43 in. (81.9 × 109.2 cm).

Printed by Peter Pettingill at Crown Point Press; published by Crown Point Press, Oakland, California.
Lent by Crown Point Press, Oakland, California

Wish #3—Transformation, 1974.
Lithograph on Arches Cover paper.
Edition: 50.
Sheet size: 31¾ × 32⅜ in. (80.7 × 82.3 cm).
Printed by David Panosh at Landfall Press; published by Landfall Press, Inc., Chicago.
Lent by the Mount Holyoke College Art Museum, Gift of the Mount Holyoke College Club of Chicago

INDEX

Page numbers in italics refer to illustrations

■

PHOTOGRAPH CREDITS

■